Quentin Blake

Bloomsbury Continuum
An imprint of Bloomsbury Publishing Plc

50 Bedford Square	1385 Broadway
London	New York
WC1B 3DP	NY 10018
UK	USA

www.bloomsbury.com

Bloomsbury, Continuum and the Diana logo are trademarks of Bloomsbury Publishing Plc

First published 2016

British Library Cataloguing-in-Publication Data
A catalogue record for this book is available from the British Library.

ISBN:	HB:	9781441130075
	ePDF:	9781441116840
	ePub:	9781441168832

2 4 6 8 10 9 7 5 3

Printed in China by RRD Asia Printing Solutions Limited

To find out more about our authors and books visit www.bloomsbury.com. Here you will find extracts, author interviews, details of forthcoming events and the option to sign up for our newsletters.

Quentin Blake

In the Theatre of the Imagination

AN ARTIST AT WORK

Ghislaine Kenyon

BLOOMSBURY
LONDON · OXFORD · NEW YORK · NEW DELHI · SYDNEY

For Nick, Anna, Tom, Will and Joe, and for Christopher.

Contents

16 December 1932	Quentin Saxby Blake born, second son of Evelyn and William Blake, in Sidcup, Kent.
1943–50	Attends Chislehurst and Sidcup Grammar School. Writes and draws for the school magazine and while still at school has cartoons published in *Punch*.
1951–3	National Service in the Royal Army Educational Corps. Illustrates *English Parade*, a literacy textbook for army recruits.
1953–6	Reads English at Downing College, Cambridge (Exhibitioner). Illustrates two editions of *Granta*, then a student magazine.
1956–7	Postgraduate Certificate in Education at the Institute of Education (London University).
1957	Studies as a part-time student at Chelsea School of Art under the guidance of Brian Robb.
1959–60	Becomes an illustrator and cover artist for *Punch* and the *Spectator*, and produces book jackets for Penguin Books.
1960	Publishes his first illustrated children's book: *A Drink of Water* written by John Yeoman, published by Faber & Faber.
1965	Appointed part-time tutor in the Illustration Department of the Royal College of Art.
1968	*Patrick*, the first book of which he is author and illustrator, published by Jonathan Cape.

| 1972–6 | Four exhibitions at Mel Calman's Workshop Gallery: *Invitation to the Dance*, *Runners and Riders*, *Creature Comforts* and *Water Music*. |

1974 Begins first collaboration with Russell Hoban, illustrating *How Tom Beat Captain Najork and His Hired Sportsmen*. Also begins long-lasting collaborations with Michael Rosen and Joan Aiken.

1977 Appears on BBC TV's *Jackanory*, narrating and illustrating his *Lester* stories live.

1978 First collaboration with Roald Dahl, *The Enormous Crocodile*, published by Jonathan Cape. Their collaboration, which includes *The Twits*, *The BFG* and *Matilda*, lasts until Dahl's death in 1990.

Becomes Head of Illustration at the Royal College of Art.

1980 *Mr Magnolia* published, which wins the Kate Greenaway medal. Appointed RDI (Royal Designer for Industry).

1982 Publication of Roald Dahl's *The BFG* by Jonathan Cape.

1983 Awarded the Dutch Silver Paintbrush for the illustrations to *The BFG*. Dahl wins the Silver Slate Pencil for the text of the same book.

1984 Retrospective of his work as an illustrator mounted at the National Theatre.

1991 Becomes trustee of the newly established Roald Dahl Foundation (now Roald Dahl's Marvellous Children's Charity, of which he is the President).

1994	Commissioned to illustrate the early Dahl titles which had been published before the Dahl/Blake collaboration began, including *Fantastic Mr Fox* and *Charlie and the Chocolate Factory*.
1999–2001	Appointed first Children's Laureate for a two-year term.
2001	Curates and produces illustrations for *Tell Me a Picture* at the National Gallery, and *A Baker's Dozen*, thirteen contemporary children's book illustrators, at Bury St Edmunds Art Gallery.
	First Quentin Blake cards produced by Woodmansterne. Children's book *Un bateau dans le ciel*, produced in collaboration with 1,800 French-speaking children in six countries. This was subsequently published in English as *A Sailing Boat in the Sky* by Jonathan Cape.

2002	Wins the prestigious international Hans Christian Andersen Award.
2002–5	Curates *Magic Pencil*, an exhibition of contemporary British children's book illustrators, for the British Council. It tours to Newcastle and London and internationally. A facsimile version of the exhibition tours to over a hundred venues in more than thirty countries.
2003	A major retrospective, *Quentin Blake – Fifty Years of Illustration*, opens at Somerset House, London, and then tours in the UK.
2004	Illustrates Michael Rosen's *Sad Book*, which wins the 4–11 category in the English Book Awards.

Wins the Bologna Ragazzi Prize.
Appointed Patron of the Prince of Wales' Charity, *Arts & Kids*.

Created Chevalier des Arts et des Lettres in France for services to literature.

2004–5 Exhibition *Quentin Blake at Christmas: Four Aspects of His Work*, at Dulwich Picture Gallery.

2005 Curates the exhibition *Quentin Blake et les Demoiselles des Bords de Seine* to celebrate the reopening of the Musée du Petit Palais, Paris.

Curates an Arts Council touring exhibition, *In All Directions: Illustrations and Transport*, in collaboration with the House of Illustration.

2006 Exhibition *The Theatre of the Page* at the Eric Carle Museum, Amherst, USA.

First commission for work in a healthcare setting. Invited by the Nightingale Project to make pictures for a ward for older adults.

Curates *Frabjous Beasts: Strange Creatures in the Work of Ten Contemporary Artists* at the Holburne Museum, Bath.

Produces mural illustrations for South Kensington and Chelsea Mental Health Centre; St Charles' Hospital, Ladbroke Grove, Mental Health Unit; Alexandra Avenue Health and Social Care Centre, Harrow; and Beatrice Place, Kensington and Chelsea.

2007 Creates a five-storey-high wrap for a building in St Pancras, part of the King's Cross development in London.

Appointed Patron of the Nightingale Project.

2007–8	Exhibition *Snozzcumbers and Frobscottle: The Roald Dahl Illustrations* at the Seven Stories Centre for Children's Books, Newcastle, touring to the V&A Museum of Childhood, Bethnal Green in 2009.
	Exhibition *Quentin Blake in Kelvingrove* at Kelvingrove Art Gallery and Museum, Glasgow.
2008	Illustrates *The Boy in the Dress*, the first of two book collaborations with David Walliams.

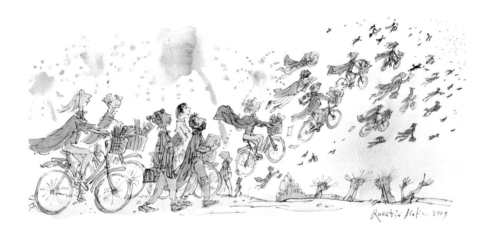

2009	Produces *An Informal Panorama* – a giant frieze for the University of Cambridge's eight-hundredth anniversary, showing its greatest alumni.
	Produces mural illustrations for the Gordon Mental Health Centre, Vincent Square, London; Northwick Park Hospital, Harrow; the maternity wing of Scarborough Hospital; and the Armand-Trousseau Children's Hospital, Paris.
	Collaborates with the House of Illustration on a programme for the Teachers' TV series *Inspirations: Quentin Blake: The Power of Illustration*.

2009–10 Exhibition *Il Mondo di Quentin Blake* at Museo Luzzati, Genoa, in collaboration with the House of Illustration.

2010 Mural illustrations for the Unicorn Theatre, Southwark.

A collection of fabrics and wallpapers based on his illustrations designed for Osborne & Little.

2011 Awarded the (last ever) Prince Philip Designers Prize.

Installation of a large scheme of work to illustrate a new maternity hospital in Angers, France.

The exhibition *Quentin Blake: As Large as Life*, a celebration of his work for hospitals since 2005, opens in Compton Verney, Warwickshire and tours the UK until 2014.

2012	Wins the Eleanor Farjeon Award for his outstanding contribution to the world of children's books.
	The exhibition *Quentin Blake: Drawn by Hand* opens at the Fitzwilliam Museum, Cambridge.
2014	*Quentin Blake: Inside Stories* is the inaugural exhibition at the new London home of illustration: the House of Illustration in King's Cross.

Quentin Blake is an Honorary Doctor of Cambridge University, the Royal College of Art, University of the Arts, London, London University Institute of Education, the Open University, the University of Northumbria, Loughborough University and Anglia Ruskin University. He is a Senior Fellow of the Royal College of Art, an Honorary Fellow of Downing College, Cambridge, the University of Brighton, the University of Cardiff, and the Royal Academy of Arts, and a Freeman of the City of London. He was appointed Officier des Arts et des Lettres in 2002, and Chevalier de la Légion d'Honneur in 2014. In 2013 he was knighted for his services to illustration.

'And what else were we born to do, but imagine freely?'
Howard Jacobson, *Guardian*, 20 June 2015

Introduction

 'Clever, shy, delightful, but . . . also uncontroversial,' said the *Observer* reviewer describing the Quentin Blake who was cast away on the BBC's *Desert Island Discs* programme in 2006. Perhaps this critic, like most people, expected the man whom another newspaper called 'beyond brilliant', the man who gave such vibrant life to Roald Dahl's extraordinary characters, quite apart from his own supremely inventive creations, to have a similarly colourful personality and back-story (as Dahl undoubtedly did). And yet the man on the radio, and also the person described by the timeline above, does not have such a past. Yes, you read the names of the many distinguished authors with whom Blake has collaborated, the dates of key publications and important exhibitions, and a large number of national and international awards and honours, which recognize all these achievements; and yes, all these are evidence of a phenomenal work-rate. But apart from the birth-date, the Blake CV is unpunctuated – because they often have never taken place – by the kind of life-events found in most such documents: there are no marriages, separations, births of children; no serious illnesses or sudden deaths; no tough menial jobs; no exotic foreign adventures or any veering from the metaphorical (and literal) line that he started to draw for himself at a very young age. And as far as personality goes, in an untypical excursion into autobiographical description, Blake said of himself: 'I'm a very detached sort of person. All the whoopee! goes into the drawings.'[1] At the beginning of Lewis

Carroll's *Alice's Adventures in Wonderland*, the heroine wonders 'what is the use of a book . . . without pictures or conversations?' This book has plenty of the former and even some of the latter, but the question could legitimately be asked: what is the use of a book about a person whose life is one, as Blake once described it to me, 'where nothing much happens'?

At first encounter Blake may indeed seem uncontroversial: there is a kind of self-protecting containment hiding the surprises, but when you watch him on a stage, catch his quiet but hilarious and oblique asides, you find a person who is as many-hued and unexpected as his work; the colours are sometimes subtle, but definitely worth examining. The most extraordinary things about him are of course what is going on in his head, what he sees, imagines and thinks about, what he says, and above all what he produces. And what is also so striking is how seamlessly his life seems to weave through all this creativity. So this book is broadly about some of the things that go to make up Quentin Blake, artist. It is a book which often takes place in the present, or even in the future tense, because he is alive and his diary and his head are full of projects – I do not want him to say to me, as another cultural figure once did to the producer who made a surprise seventieth-birthday radio programme about his life and career: 'Well, that's the obituary then'. As with artists of all kinds, Blake is a person for whom the work he is doing today is paramount – he has never been satisfied with a successful formula, and his limitless capacity to reinvent, to seek and find in his imagination new answers to new questions, is also a strong theme of the book.

Perhaps it is partly because of this (there may be other reasons too) that Blake's distant past seems to be much less interesting to him; somehow it is less attached to his own story of becoming than is often the case with successful people. The roots of a starry career may be found in a combination of genes, family circumstances and environment, as well as education, and success can come either because the child grasped hold of the opportunities offered, or, if these were few, found others further away from home – Blake does speak a little about the latter route. But although he has almost perfect recall of most of his many thousands of drawings, he claims only a few childhood memories and talks about those that he does have very sparingly, and not in a causal way. There are no early stories such as that found in a recent book about Blake's creative contemporary Sir Harrison Birtwistle,where the composer connects his creativity both with his father ('a dreamer, full of ideas and fantasies') and with a childhood spent above his parents' bakery: he was given dough to play with in his high chair and 'the idea of turning raw material into something else was part of the appeal'.[2]

Being the age he is, Blake lived through the Blitz, played with shrapnel, has a vague memory of distant burning on the London horizon, and was evacuated to Devon, which he didn't enjoy, apart from walking on the beach collecting the fish discarded by the fisherman (this started a lifelong interest in eating fish, he thinks). In some ways he is a very typical product of the 1944 Education Act: he had a decent primary education and went on to a grammar school where he was taught by one or two teachers he still talks about with fire in his eyes. But, on the whole, his accounts

of his early life are laconic and, ironically for a visual artist, almost without colour. It's as if the images that keep emerging from Blake's head have overrun these memory spaces: as he says, he often doesn't know where his ideas for his drawings come from. And in any case, he is not interested in biography: as the psychoanalyst Adam Phillips says of Freud, he knew that 'biographers (speak) on other people's behalf'[3], and I have respected the fact that Blake doesn't want this. There is something about any attempt to analyse a person's life that he feels is both intrusive and likely to fail: as he said approvingly in a *Mail on Sunday* review of a biography of fellow-illustrator E. H. Shepard[4]: 'The charm of the book rests in the *untreated* [my italics] nature of the first-hand evidence'. One purpose of including as many illustrations as I have in this book is that they often are the first-hand evidence. They have their own life, and they I will, hope, speak to the reader in a language that is quite separate from the text.

The life in Blake's work is out of the ordinary: something the writer and former *Punch* archivist Amanda-Jane Doran has described as a 'diffident magic'. Blake has always retained his highly recognizable drawing style – research carried out with young readers in the 1990s and early 2000s showed that he was both the illustrator whose style was most familiar, and the one whose name was best known. But the style can wear so many guises: contemporary – as it did when he made designs for the designer David Mellor's cutting-edge kitchen shop in Sloane Square in the 1960s, in the work for an Eating Disorders Unit in a hospital in 2013, or the project at Angers Maternity Hospital in 2009 (as a midwife described it in an email to Blake: 'so pure and modern') – or traditional, in the context of some of the Folio Society volumes which he has illustrated over the last decade, or just timeless, as in the greetings cards and many of the non-illustrative works which he has been making recently. And with this style he has established a career quite unlike that of most of his peers in the illustration profession. He has moved in a long, unbroken scratchy line from simple cartooning to category-defying works to be seen in galleries, hospitals and other public places. All these things happen in contexts, and through interests that often take him away from the studio (even though he draws there every day), so the first part of this book looks at the man and his work in a framework of the big recurring themes of his life. These are, alongside drawing literature, education and France, and:the largely metaphorical topic of flying.

Over the last 15 years Blake has described his creative output in books which he describes as a three-part 'running commentary'.[5] What he has not written about very much, however, because he is either too modest, or because he really doesn't know about it, is the effect that he and his work have on other people: his readers, the visitors to his exhibitions, the people who go to his talks or see his work in hospitals or health centres; and so the second part of this book, which I call 'Why the art of Quentin Blake can make you feel better', attempts to fill that major gap.

It seemed to me that Blake's philosophy of living and working is most perfectly expressed in his work, both in words and in pictures: in Part 3 we will dive a little more deeply into two children's books from different parts of his career, *Patrick* and *Zagazoo*. There is a postscript too, where I have handed the microphone to Blake, for

a first-hand account of the projects that are keeping his drawing hand and drawing brain occupied for the next year or two.

What motivated me to write about the UK's best-known and best-loved illustrator? Like many people, I got to know Quentin Blake through his work, first as a primary school teacher in the late 1970s when I used his illustrations to animate my own teaching, and then re-discovering it with my own children. In that sense I am an audience member. But I also have a working friendship with him, ever since I once impulsively asked him to illustrate a children's guide to the National Gallery, where I was then running the education programmes for young people. Although I didn't know it at the time, it was entirely typical of the ungrand person that Blake is universally agreed to be that he took my phone call personally and agreed with little hesitation to work with someone he didn't know, even if the institution (at the time directed by Neil MacGregor) was a venerable one.

We followed that with a more ambitious project, a jointly curated exhibition called *Tell Me a Picture*: this was a venture that Blake decided would be the centrepiece of his year as the first Children's Laureate (1999–2000). Thanks to his practical inventiveness and his imaginative approach to the National Gallery's collection, it proved to be highly successful and popular, with over 250,000 visitors. It was also a bold move (and one that reflected my own views about the way that people see art) to set children's book illustration alongside iconic examples of 'fine art'. Over the last few decades Blake has promoted the value of illustration in its primary context; that is, to enrich text, or to communicate a message or a narrative without text. But in this and other exhibitions he also made the important point that people's engagement with the everyday art of illustration can be a bridge to their understanding of more apparently complex or demanding works.

Very early on I became aware that working with Blake involved me in much more than carrying out my curating role efficiently. In addition to the formal progress meetings, there would be the long phone calls whose initial subject might be the exhibition, but which would then roam off, delightfully, into other realms of mutual interest: art or literature or France. In those days the fax was a preferred method of communication for Blake, but his were never the dull documents that the office machine normally served up. They would be hand-written, of course, but also elaborated with cheering drawings and flourishes. I would come away from these exchanges with the sense of a person whose life and work is an indivisible unit, full of complementary, singing colours.

Other projects followed, notably in France where Blake – continuing in the vein, which he terms 'beyond the page' – produced work for hospitals in Angers and Paris, and also curated an exhibition for the then newly refurbished Musée du Petit Palais in Paris, *Quentin Blake et les Demoiselles des Bords de Seine*. My role was as a consultant/producer: I dealt with the organizations, acted as a sounding-board for ideas, and occasional interpreter, though Blake's French is excellent. We often worked on the projects at Blake's house in the Charentes-Maritime in south-western France but the work was somehow always interleaved with activities that seemed equally important:

walking, cycling or driving to favoured nearby spots, shopping in the market, or visiting local friends. I was able to observe the work/life co-operation at close hand and for sustained periods and, slowly, I began to see a connection between this process and the art that he makes. I started to understand that here there was a kind of commitment to the art of living a full life in the moment, which is not the same as living an exciting one. This I saw matched and fed into his absolute dedication to the art of drawing. I wondered whether this might, at least in part, be because Blake does not have a life-partner (although he does share his large West London flat with his friend and collaborator John Yeoman), nor children. As someone deeply rooted in the earth of large-family-with-career I have watched Blake's different, untrammelled situation and have found the opportunities and insights it seems to offer his art both intriguing and illuminating.

Another aspect of Blake's life-work to which I was drawn is his profound involvement with what educationists today call learning and teaching, but which he would probably still think of as education. We were both trained as teachers but both see that it was not so much the training that formed us, but rather a deep-rooted understanding of the role of first-hand experiences in effective learning. Good teaching can facilitate this, and like many fortunate people, we have both experienced such situations. But real learning can also happen much more independently, from early childhood onwards, when a person is encouraged or at least allowed by family to follow a consuming interest; sometimes, as in Blake's case, an interest that seems to come out of nowhere. Blake did have what would normally be described as a very good formal education (grammar school, Cambridge, the Institute of Education) but all along he never stopped doing the thing he most wanted to do: to draw. And he didn't go to art school, so, artistically, he is something of an autodidact.

In researching this book I have interviewed a wide range of people who have come into contact with Blake over the years: ex-pupils, students, artists, colleagues, friends, relatives and acquaintances. In some ways I was hoping that I might meet a different Quentin Blake to the one whose portrait I hold in my own mind. Here I was disappointed, although perhaps also slightly relieved. The opinions on and stories about Blake and his work are remarkably coherent – my interviewees overwhelmingly describe a gentleman with immense, original talent, and a person of great generosity: to family, friends, colleagues, students, fellow illustrators, schools, charities and untold numbers of worldwide fans. As the critic Julia Eccleshare told me: 'I've never heard anyone say anything unpleasant about Quentin, EVER!' In this single sense, then, perhaps Blake is uncontroversial. But as my interviewees all also confirm, the surprises are always there: Blake the hilarious thesp, especially as mimic, witnessed by only a few lucky people; Blake the artist of the sensual, of work which has nothing to do with children or children's books; Blake the scholar, quoting aptly from nineteenth-century works in English and French; Blake occasionally bad-tempered and depressed when caught in unpredictable situations, mainly connected with travel; Blake the most individual of dressers, with a taste for white shoes . . . and so this book is also about his capacity to startle, both in life and in work.

The other arm of the research, reading what has already been written about Blake, has yielded a similar (in some ways frustrating!) consensus. Academics and journalists in the fields of children's literature and the visual arts, who write about Blake's books or exhibitions, or his place in the canon of children's literature, pay him great respect, (although interestingly he is less visible on the other side of the cultural divide that exists between the UK and the USA). In general, illustration as a reported-on and reviewed art form has only a small place, and the amount of press space generally devoted to children's books is equally restricted, as is a common critical language around book illustration; but the number of laudatory column inches dedicated to Blake over the last 40 years is evidence of the great regard in which he and his work are held. It could be argued that what appears in the press, especially the book reviews, show an understanding that Blake's work is powerful, but there is often very little attempt to analyse the reasons why it does what it does so well. I hope this book will begin to rectify this situation.

There is one significant exception to the general enthusiasm, though, which I mention, firstly, because it appeared in the *London Evening Standard* and so may have been relatively widely seen, and secondly, because it claimed something very fundamental about Blake's work, which needs a response. The waspishly literate art critic Brian Sewell in reviewing an exhibition of Blake's work at Dulwich Picture Gallery in 2004, found 'sameness' in his work, and 'calculated comedy'. Sewell did concede that there was accomplished draughtsmanship and admitted that he himself was an ignorant critic of the work, having graduated directly from Beatrix Potter to 'the trashy novels' that his mother read. However, this entertaining but unsubtle tirade could not have got Blake more wrong, both factually and critically. This book is de facto a reply to such misapprehensions.

So, in sum, here is neither the biography, which someone else will write one day, nor the artist's monograph, which an art historian will produce when Blake has eventually completed his work. It cannot be dispassionate because there is in it admiration both for the work and the person. But there is I hope a genuine understanding of Blake's creative spirit, based on many conversations and observations, a grasp of the work's unique content and execution, and also of its singular effects (and the effect that he himself has) on people and environments outside the studio. It is a not uncritical view of a snapshot portion of Blake's vast output: the illustrations to over three hundred books, including his own texts, the paintings, the prints, (even one or two sculptures), and thousands and thousands of drawings, some published but many not. As such I hope it will contribute to a proper evaluation of the place of Quentin Blake in the canon of artists whose work has made a difference in the world.

Part 1

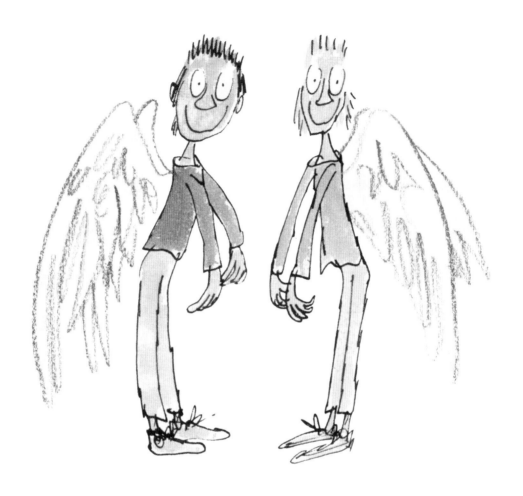

Art in all directions

1 Drawing, drawing, drawing

Drawing is "a way of reasoning on paper".
Saul Steinberg

The heart has its reasons that reason knows nothing about.
Pascal

To get to know the real Quentin Blake we must begin with a visit to his studio – artists' workplaces often seem to reflect and reveal character and work in a way that few other rooms can do. For example Peter Blake (they are not related) , works in a highly organized and categorized space, surrounded by his life-collection of objects and works of art. The space seems to echo both his neat appearance and his quiet, concise way of speaking, as well as the eclectic sources for his art. Quentin Blake's studio could not be more different.

First, the studio is there in the middle of his home – unlike many artists, Blake doesn't go out to work. When he started out as an illustrator he couldn't afford for the studio to be anywhere but in his flat, but even after he could, he realized that it had its advantages: he often revisits work in the studio in the evening, or even, exceptionally, at 5 a.m. And because he has at various times so often also been working away from the studio, giving talks, visiting schools or hospitals, for example, coming back to the studio-at-home is part of the pleasure of being home again. This is the first and perhaps most important example of his undivided approach to work and life. The studio itself is a high-ceilinged, south-facing room on the second floor of a late Victorian mansion block. It looks out onto a peaceful and spacious private square in south-west London;

Book cover for *The Birds* by Aristophanes

French doors lead onto a narrow balcony where, when you visit, you may sometimes catch sight of Blake, contemplating from amid the flourishing pot-plants, and then beaming and waving when he catches sight of you. Back inside the room two entire walls are taken up with shelves and boxes holding many of the 300 books Blake has illustrated so far, including disturbingly unfamiliar copies of Roald Dahl's *Matilda* in Japanese or Dutch. The other walls are blank, apart from an overmantel mirror into which are stuck personal photographs, postcards and drawings; on the opposite wall, some aged ink splodges, which skitter across the white expanse much as Blake's own drawings do on paper. But most of the surfaces are covered – the floor with boxes of his newest books, or with piles of less new ones, or with the many plan-chests which hold his current work. There is also a trestle table, a long low table, and three seats for working and meetings: a barstool, a wooden chair and an ancient Eames chair, its white seat-cushion bulging like a hernia out of its leather cover. Most of the surfaces are covered too: the low table with yet more books, this time other people's, the chairs with documents, letters, magazines and drawing 'failures', as he terms them, which also spill over on to the plan-chests. The reassuring (the drawings, his own books, the postcards) mingles with the more uncertain, the yet-to-be answered letters, unread books, decisions still to be made, projects-in-waiting.

But there are two highly ordered and purposeful spaces here. The trestle is home to the artist's tools: the pens, brushes, delicious little blocks of watercolour paint and water jars are all exactly where Blake knows they will be when he turns from the light-box on which he works and which sits on another plan-chest, at right-angles to the trestle.

Today, pale blinds keep out the worst of the sun, and, amid the jumble of surfaces and things, the focus is on a figure in a navy-blue cardigan standing hunched over the light-box. For a few seconds we hear only two sounds: a breathing, heavy with concentration, and a scratching, the contact between a possessed pen-nib and the uneven surface of watercolour paper. An act of drawing is taking place and we hold our breath.

This chapter will watch Blake drawing, because, in his mind, this is where his life-story begins: his earliest memories are connected with either looking at drawing, or doing it, and drawing is something he has been doing practically every day of his life since childhood. This chapter will explore what, how, when, where and why he draws. Drawing is of course the vehicle for his kind of illustration – he doesn't paint much or photograph or collage or make film or animations – but, alongside book illustrations, Blake has always made drawings, which do not answer a professional brief. These range from phone doodles (although he doesn't like or use that word because it's what fans always ask him to do) to large works which inhabit a happy kind of artistic no-man's-land, somewhere between illustration and fine art.

Let's return to the studio where he spends part of every day, to the man and to his light-box.

This is a technique he has been using for over thirty years and this choice of it as a working method is key to any understanding of his work. He stands at the light-box – it is a way of keeping alert, in charge of the activity, really seeing what is going on. As he says: 'I'm fairly sluggish and inactive, but everything, pretty much everything I draw I draw standing up . . . and in a way it's like some kind of sport.'

If his drawings are for a picture-book, the process is, briefly, that he starts by creating a *chemin de fer*, a storyboard for the whole book, which then gives him a clear sense of how each double-page spread is going to work, both on its own and in the context of the whole book. For each of these spreads he will make a rough. The way Blake usually approaches these is to start with 'the situation'; how a character is reacting to an event such as this encounter from Russell Hoban's *How Tom beat Captain Najork and his Hired Sportsmen*, perhaps with a surprised expression, or one full of expectation or disappointment. Impressively, right from this moment, and probably also because he has done it for so long now, he always seems to have an instinctive knowledge of how everything is going to fit on the page.

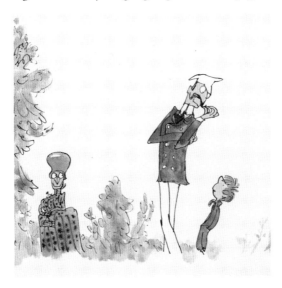

Having settled on the rough that works best, he places it on the light-box, followed by a sheet of watercolour paper, by preference the French Arches Fin (cold pressed) brand, which he buys in great bulk, sometimes from Green & Stone's in the King's Road ('but they never have enough!' he sighs). The light from the box allows just enough of the rough drawing to penetrate the watercolour paper, so that Blake can use it as a kind of cue for the final drawing: as he puts it, 'You're drawing it as if for the first time, again'. There will be some connection to the original idea, but to Blake this process preempts the deadening effect of direct copying. He has a great need for the constant two-way engagement between hand, brain and imagination to be clear and unobstructed. This in turn produces in the drawings a spontaneity, which people who don't know read merely as rapidity. Yes, the final drawing may have taken a matter of minutes, seconds even, but this definitive version is the result of the ten others that preceded it, and, in a broader sense, of the 75 years of constant practice that came before those. Of course, not everything works every time. Blake is highly self-critical, he knows how to 'slaughter (his) darlings' as the composer Benjamin Britten once described the process of rejecting favoured ideas that do not ultimately serve the final form of a work. 'Sometimes' he says, *I spend all day doing a drawing and at the end I think that's not right and I do it again, and I realize that one is better. But sometimes the second version tells me what's right about the first one. If the less good one is good enough I can sell it at my dealer's, Chris Beetles, but there are still some that are so bad that I have to tear them up. My studio has a very big waste-paper basket!*

Blake's 'mistakes' are always where the line has gone wrong somehow, and this has to be right because lines are his medium: a sequence of lines that create the actions and set the scenes, to which colour is then added; somehow where colour is concerned though, he uses it unerringly and spontaneously:

I don't have a set of rules about colour and how you use it, I don't think leaves are green, or tree-trunks brown. Colour can add depth, emotion and atmosphere. I don't know how I do it, it's instinctive; some people do roughs in colour for books but I only ever do black and white – I busk the colour.

This sense of busking is also involved in another kind of drawing, unrelated to books, which Blake calls his 'discoveries'.

These are works whose origins Blake claims often not to know: 'it's like encountering somebody for the first time; you come to know them as you draw them . . . you arrive at the edge of their story . . .' Here he works directly onto the watercolour paper, often using, say, 'dangerous' and 'unpredictable' media such as watercolour pencils and water: 'You draw the picture and then you go into it with water on a brush and then you've got a minute or two to bring it off, or not.' Or with pen and ink, where all erasing is impossible (though Blake does admit that in some cases he administers a white paint 'plaster' to an accidental blotch, when the drawing in question is to be reproduced). In both these types of drawing it is clear that

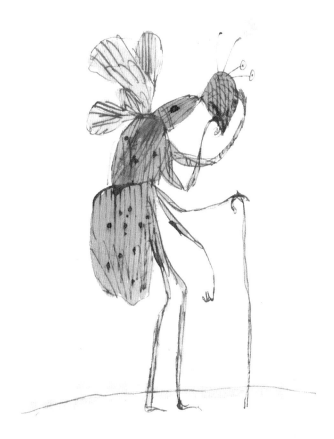

operating in the uncertainty of the moment is the only safe way for Blake: it is only when he has a sense of not knowing the ending that his self-willed pen can get going.

Less unpredictable in terms of the technique, but with an equally unknown outcome, are a series of drawings Blake has called 'Characters in Search of a Story'. These are made with a chinagraph pencil and Blake describes the process:

I may start off with a general sense of what the next character may be, though sometimes I have no idea at all. I begin by drawing the eyes, the nose, one side of the cheek. As the drawing proceeds I begin to get a sense of what kind of person this is and what I should emphasise: they may get older, or younger; just occasionally they change sex. And it's also possible I suppose, the nature of drawing being what it is, that I may put in characteristics that I'm even aware of. Later on I may realise that some of them have elements of people I know or have met, though I don't put them in consciously ... they are invented on paper and it's there that I get to know them.[1]

I think Blake is genuinely surprised at the way his visual memory and his unconscious operate for him – perhaps for an illustrator used to working to the brief of a text or something else, the contact to his inner world that these kind of

free drawings permit is even more immediate and powerful. There is another telling manifestation of the way that his whole being works unconsciously through his hand and pen: Blake usually works alone in the studio but when, on a rare occasion, he was observed drawing some little characters by a friend, she said afterwards: 'Did you know you were making all the faces?'

Since Blake is mainly drawing in his studio and not on the move, in cafés or stations, streets or countryside, it is also clear that most of what he draws must emerge more or less fully formed from the imagination. As we will see in the chapter on learning, one of the few situations where Blake has actually drawn from life was when he attended life-drawing classes in Cambridge and then at the Chelsea School of Art. Even then, it was the drawings that he did 'away from the model', when he got home from the class, that he felt more satisfied with. He does carry around little books with blank pages, but these are not so much sketchbooks in which to draw what he sees around him, as notebooks, where *ideas* for drawings might be recorded, alongside to-do lists and other work-related thoughts. Comparing these early ideas with their final expressions in books or other forms, it is astonishing how little they change – this is another highly practical example of what Blake calls 'the instinct to do the right thing'.

He seems to have operated away from the model from the very beginning: in the 1944 issue of his school magazine, the *Chronicle of the Chislehurst and Sidcup County School for Boys*, there is a drawing by the 11-year-old Blake called 'After the Game'. Blake now feels a certain embarrassment about his early output: even though seeing these drawings in print was an important stimulus to his career as an illustrator, he doesn't want any words or pictures which don't make the Blake grade to be in the public realm and so it is not reproduced here. Of this one he says: 'It's not a good drawing – I wasn't interested in football, and I got the studs in the wrong place!' But let me describe it instead: it is small, drawn with what looks like a soft pencil and shows three boys in the school changing room. It has a classical feel, with each boy monumentally and separately engaged in a different activity; the central figure taking off his shoe is almost an updated *Spinario*, that Hellenistic sculpture-type of a boy removing a thorn from his foot (a version of which is in the British Museum). The drawing is divided by the horizontals of a bench and the verticals of the coat stands, roughly at the pleasing ratio known as the Golden Section (the ratio of the longer side to the shorter side). At the age of 11, Blake was not aware of this ratio, nor, he says, had he ever looked at the work of Piero della Francesca or Georges Seurat, both of whose works these silent, sculptural figures recall.

The smooth drawing style (which Blake now describes as 'wooden') is most unlike the dynamic one that he was soon to develop, but there are many elements in this childhood work that have become as important and characteristic as his spluttering pen and animated dramatis personae. This changing-room scene was not drawn from life – Blake thinks he probably did it at home with the basic materials available there, and that he was recalling something which was memorable, perhaps because it made an impression: boisterous team sports, new football kits, smelly changing rooms. Second, it is a scene of ordinary life, the stuff of the art of illustration. In 1944, when

most boys of his age, if they were drawing at all, would probably have been doodling fighter planes or soldiers, Blake chose to draw an everyday event. What this drawing also shows is that Blake was interested in figures in movement – at 11 he could already do this with Blakean accuracy, which is not so much anatomical correctness as physical authenticity: the way in which he knows how to capture a pose such as a boy balancing unsteadily on one foot to undo his shoelace, or a boy easing his football shirt over his head, cautiously, because it is still buttoned up, in the way of lazy 11-year-olds. Both movements suggest an artist recalling *how it feels* to be doing them himself, while in the act of drawing them. This drawing also has a precocious sense of composition.

Although, according to Blake, he is never thinking about organizing his drawings while doing them, he realizes when he looks at them afterwards that he has in fact composed them. In this work the figures are placed in a line, frieze-like, but not in a straight line, and at different depths in the picture space. The group is also broken up, by the vertical of a coat stand, with one boy to the right and two to the left of it. Balance and harmony are achieved by the height of the bench crossing the verticals at the Golden Section, and by the pleasing echoing of the angled legs of the central and right-hand boy. Finally, and this is a strong Blakean trait, he includes a few details, very carefully selected from his memory and placed to suggest the essence of the scene, in this case 11-year-old schoolboys in a school setting: the discarded goalie's glove in the foreground, where we notice it; the open book, dropped face down on the bench; the wrinkled sock; and the satchel propped up against the wall. Not many, but each one articulate and additive, helping the viewer to imagine being there too. The studs on the boot may be inaccurate, but we totally believe in the scene . . .

All the elements of this early drawing tell us something important about an activity (if it can be called that) that is absolutely central to all Blake's work: something that the literary critic James Wood calls 'serious noticing'. Wood applies this term to the way that really skilled novelists manage to look at the world and see and select the details that will most aptly tell the story. As Wood says, 'the details are the stories; stories in miniature.'[2] I sometimes think I see Blake consciously 'noticing', watching these details of life, on a train, say, or in a café, but he would say that the process was completely automatic: it seems that noticing and selecting in order to imagine and create is just Blake's default state.

Where he draws

This naturally gifted draughtsman drew first at home, then at school in the art-room, and then, when he was able to buy a home of his own, in the studio, and most of what he drew came from his head. But there was one period when he did draw from life, proof that he could really do both. In his *Punch* days in the 1950s he would occasionally stand in for Ronald Searle, as theatre illustrator, working alongside the critic Eric Keown. Searle had taken over this role from G. L. Stampa in 1949, and, in Blake's view, he had complete mastery of the genre, magically combining caricatured

physical likeness with the actors' attitudes from the production in question, making them instantly recognizable to the readers. (Blake's favourite eightieth birthday present was a Searle drawing of Bud Flanagan.) Blake did a few three-week stints of this kind on occasions: 'They were a bit of a nightmare,' he says, as they usually involved working late at night after a First Night at the theatre in order to deliver early the next day. Blake enjoyed the process, though he feels that his own efforts were less successful than those of his hero, Searle.

This drawing, made on the first night of the London production of the musical *Annie* in 1978, shows Stratford Johns as the soft-hearted Oliver Warbuck, Andrea McArdle as the orphan Annie, a well-captured Sheila Hancock as the devious Miss Hannigan, and Sandy, the stray dog. The drawing has all the fluency that Blake had acquired by this time and he could obviously achieve likenesses, but there is something perverse about him having to reproduce a situation created by *another* director. It is worth remembering that in 1978 Blake was also producing illustrations for Roald Dahl's *The Enormous Crocodile*. Somehow it is as if, when freed from the need to stay close to reality (unlike in such theatre drawings), and liberated from the tiny spaces of cartooning, a wellspring of movement, colour and humour is released which gives rise to drawings such as this one and many thousands after it. It is interesting that in the end it was not the reportage aspect of illustration that most excited Blake, even in the field of theatre, which, as we have seen, he felt very close to. Instead, first in book illustration and then later in works that Blake calls 'off the page',

such as his projects for healthcare settings, he seems to have found the proper outlet for his natural inclination towards creative story-making.

Ironically it is now on the stage where Blake is often to be seen drawing. For the last 15 years he has been using a visualizer, a video camera which displays documents onto a screen, allowing large audiences to watch his hand magically bring forms to life onx the page. Of course Blake has drawn in public in many different settings for years: his approach in these situations is always generously pragmatic. He has drawn on all fours on the floor when there was no easel, on white- and blackboards in schools, on flipcharts and on glass; he famously once used a friend's lipstick to draw with when his own dip-pen went missing just before a performance at the Cambridge Union.

But by far his biggest audiences for live drawing were for the BBC TV's children's storytelling series *Jackanory*. The 31 *Jackanory* seasons (September to March) ran uninterruptedly from 1965–96, five days a week for 15 minutes, and the programme was designed to encourage children to read (though early critics panicked that it would deter them from doing so). Blake would have appreciated this aim, as he did the roster of all the best-known actors of the period who appeared on the programme, and who told stories ranging from fairy-tales to classic and contemporary children's books. Children of all ages and abilities were catered for, so that 600-word picture-books alternated with minimally illustrated 'chapter' books. Imaginative actor/book combinations included Alan Bennett/*Winnie the Pooh*, Bernard Cribbins/*Alice in Wonderland*, Margaret Rutherford /*The Tale of Mrs Tiggywinkle*. And, in a rarer slot, there was Quentin Blake/the *Lester* stories).

A clip from 1976, now on YouTube, shows a slim young man with dark, longish but receding hair and a serious face (he only smiles twice, fleetingly, once at the beginning and once again, almost with relief, at the end. Blake says that this was mainly because his intention was to tell the story, not to perform it.)

A chunky black marker pen in hand, he moves across a screen-filling stretch of paper, simultaneously drawing and telling the story of Lester, a spiny creature with big eyes – a cross between a dragon and a dog was Blake's idea – and his friends, the flap-eared and hopeless Lorna, and Otto, a toad-like thing, who doesn't move about

much. Blake looks very slightly ill at ease, as if unsure who or where the TV-land audience is, but his delivery is clear and direct. It is only as his hand starts to move that we relax, finally reassured that a performance is in fact taking place. As the pen makes contact with the paper we have no idea, because he often doesn't tell us, what he is drawing. He might start with a foot, or a circle that could become either an eye or a roller-skate wheel, and so he keeps us watching and waiting for each denouement. The lines flow unerringly, and Blake has an implicit understanding of the space on the page and how each figure relates to the next one – it is only when less experienced illustrators try drawing like this that it becomes clear how much skill is demanded.

Blake was in his early forties by the time these *Jackanory* programmes were made, and they demonstrate how sure his drawing technique had become by this time. When, in the studio, or with the help of the visualizer, we watch him at work today, 40 years later, we see the same gestures, and of course we recognize what has become his unmistakable style, his rapid visual 'handwriting'.

What he draws

What is not the same, though, are the *subjects* he is now drawing and their potential audiences. Of course he can and still does produce amusing hybrid creatures when drawing in front of family audiences at events such as the annual launch of the Big Draw, of which more later. And he is still illustrating books – a couple of projects a year at least. But up until about fifteen years ago, the vast majority of his work had been light-hearted; indeed, people who are mainly familiar with his greetings cards and, perhaps, the Dahl books, often refer to him as a cartoonist. I started by wanting to make people laugh,' he freely admits, and even the work not aimed at children – his sixth-form drawings for the school magazine; his work in the Army Education Corps; the early *Punch* cartoons and covers; the Spectator and Radio Times work; the ephemera such as designs for menus made for the Royal College of Art – these are essentially drawings in the major key. So are the book covers and illustrations for adult fiction and non-fiction, the titles such as Patrick Campbell's *How to be a Scratch Golfer* and *Brewing Up in the Basement*, or Evelyn Waugh's *The Loved One*; Malcolm Bradbury's clever first novel *Eating People is Wrong* and the companion volumes to the BBC's Popular *Gardeners' Question Time* programme. But Blake also adds tellingly, 'Waugh's *Helena* [his only historical novel] was an exception and I was glad to get it.'

Increasingly over the last few years, though, Blake has been developing another side to his art, which has called for a different kind of drawing, often larger in scale and in an emotional register that is very far from those cover images, greetings cards and children's books: the ones he calls 'discoveries'. Some of these newer works have been part of commissioned schemes for hospital and other healthcare settings and we will look at these in Part 2. But there are others, which are not commissions, which seem to fit no category and which are not strictly speaking illustrations. These are sets of drawings whose origins are often inexplicable to Blake, although sometimes after he has completed a few in one set, he does begin to have ideas about them. Looking back at them as a group of works, they do have threads in common. They are often

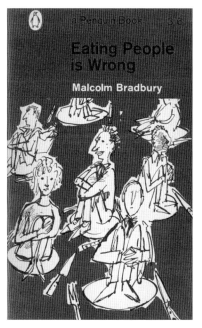

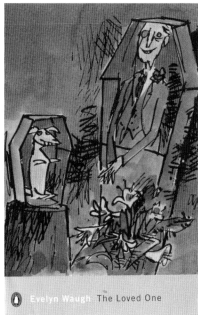

drawn on A2 or even A1 sheets, and the figures are sometimes quite large, taking up much of the picture space. There is usually a pair of figures, humans or perhaps a human with an animal. These are spare images, almost without incidental detail, and the scenes are set either in a barely suggested landscape, or in unspecific interiors. Let's look at a few of them a little more closely.

The first is a lithograph from the *Girls and Dogs* set, which was made for an exhibition at Marlborough Fine Art in London in 2012, and followed a series he had done called *Children and Dogs*, which were included in an exhibition at Dulwich Picture Gallery (though interestingly rather ignored by the critics of that show).

On a bare hillside, with a suggestion of urban decay on the horizon, we are confronted with two figures: a scruffy, adolescent, barefoot girl, her hair in her eyes, sits on the ground beside an oversized hairy dog, with blank eyes and a panting tongue, whose pose echoes the girl's. At first we notice their sprawling limbs, messily, beautifully drawn with the lithographic pencil, the girl's arms lightly echoing the contour of the hill. Then, at their feet, we notice pens and sheets of paper strewn about. The dog has his paw on one page with some orange splodges and the girl fingers another, perhaps peeping at a drawing on the other side of the paper that we can't see. It feels as if we are inside a moment in a story, because we want to account for the situation: where are they? Is the ruined building a bit of picturesque decay, or the result of some conflict? Is the girl dressed so lightly because it's warm (the orange glow on the horizon might suggest that)? Or are these the clothes she has been left with after some disaster? Is the dog's size symbolic, and if so of what? And how does the art fit in? Such questions invite us to take part in the experience; the picture's oddness won't allow us to be detached. So we attempt some speculative answers,

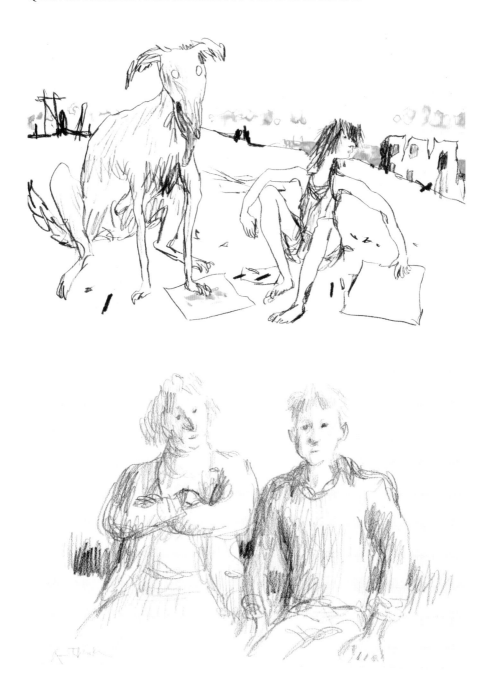

which might help us to construct a meaning for ourselves: perhaps, on the whole, the atmosphere suggests disquiet rather than summer holidays. The dog is potentially a threat, but actually its attitude is rather companionable and the girl doesn't seem to be afraid. And they are both apparently artists, or at least art is a connective factor. Perhaps they have even drawn each other, or perhaps the scene is related to another

Blakean trope, that of the young woman pondering an artistic career. There may also be something about art's ability to confront the things we don't do so easily in real life. This theme seems to be one that underlies much of Blake's more recent work. Perhaps that is exactly what his art has done for him.

The second image is an apparently more straightforward one from the series *Companions,* also made for the Marlborough exhibition

Here are two figures again but this time, at first glance, as if posed for a double portrait. The work is made using a chinagraph marker, a kind of greasy wax pencil, and the lines are soft and lightly executed, very unlike Blake's more usual scratchy engagement with paper; this gives the work a ghostly fragility which also demands our attention. On the left is an older woman with arms folded across her broad chest, who seems half to address the audience, while at the same time casting a sidelong glance at the boy next to her. He sits stiffly, his torso slightly inclined towards the viewer, whom he looks at uncertainly. There is a sketchy indication of a bench or sofa behind them, but this is all the information we are given about who or where they are. It is more puzzling because two figures posed facing the viewer normally suggests portraiture; and the work has the quality of a snapshot, in which the photographer has captured a fleeting moment, which is expressive of the relationship between the two people. The woman, perhaps the boy's mother, with her folded arms and the dark shadow behind her, seems disapproving. But maybe also uncomprehending. Is the boy a confused adolescent? Is he almost asking the audience for help? Is this an autobiographical picture, we might wonder? Even if it isn't, we may sense that the artist has a great empathy with the situation.

The third image, from the same series, shows two more figures who seem to appeal to us, only more directly this time.

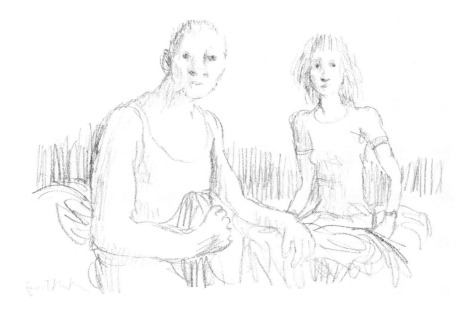

Who are these two? A couple, perhaps, she hollow-eyed and perplexed, he, half-dressed and clutching what might be a few clothes, both staring out at us. This is almost like photo-journalism: one could imagine a pair of refugees, holed up in a camp, or victims of some natural disaster clinging on to their few remaining belongings.

And yet Blake has confirmed that these are not portraits of living people, but of characters which surface from his imagination. When these works were exhibited at the Marlborough Gallery, a critic said, 'It is hard to believe that all of his works spring from unconscious ideas. More explanation from the artist would be beneficial'.[3] Her words are interesting because they imply that artists do or should always work at a conscious level, that meaning should be obvious, and that if it isn't, the artist has a duty to try to explain himself. Blake's work, especially in this format, is more demanding of his viewers than that; it asks them to complete the work themselves, imaginatively. The nature of the drawing is sparse, the ratio of pen-strokes to expanse of white paper small; but at the same time all that whiteness also works as a kind of freedom that we, the audience, have to be part of the picture, to make our own stories in this beautifully allusive space. Such drawings work differently from book-illustration, but they can have the same inclusive effect.

Also called *Companions* but this time in French (*Nos Compagnons*), these animal–human pairings were shown at the Martine Gossieaux Gallery in Paris in 2014.

Quentin Blake

Nos compagnons

GALERIE MARTINE GOSSIEAUX
56, rue de l'Université 75007 Paris - Tél. 01 45 44 48 55
Ouvert du mardi au samedi de 14h30 à 19h.

Du 10 avril au 2 octobre 2014

These are noisier and more provocative images, inviting the viewer in with their strangeness, and with a slightly unusual (for Blake) sense of materiality here: what it is like to touch fur and scales.

As Blake says in the introduction to the catalogue:

The interest for me lies in drawing the movements and gestures of the young women and their companions and suggesting their varied relationships. One of the attractions of drawing is that it lends itself easily to metaphor – so you might think of these beings even though scaly or hairy, as pets, children, brothers, boyfriends, perhaps even husbands. You will know best.

Blake is by no means alone in this interpretative generosity towards his viewers; the Portuguese painter Paula Rego is well known for her figurative work with a very high degree of implied narrative, which also invites viewers to improvise the story for themselves. In Rego's case, she readily admits that her paintings are autobiographical in that they do relate directly to her own experiences, but this is at a remove, so that her characters are symbolic rather than portraits. I have known her to tell a different story about the same painting on different days, and so she makes the point that, in her work at least, there is never a single truth. Blake's works in this vein, freed from text, are a real departure and he continues to have new ideas for them, which seem to have increasing psychological depth and insight. He is currently working on a set he calls *Vehicles of the Mind*.

These small images (A5 size) have often been drawn when Blake has been out and about, travelling or in a café, and there are over a hundred and twenty of them so far, so perhaps they are significant. Blake himself suggests that there are so many because they are a sort of game – he frequently produces two or three new variations to give to his friend Linda Kitson (who owns the originals) when he next sees her.

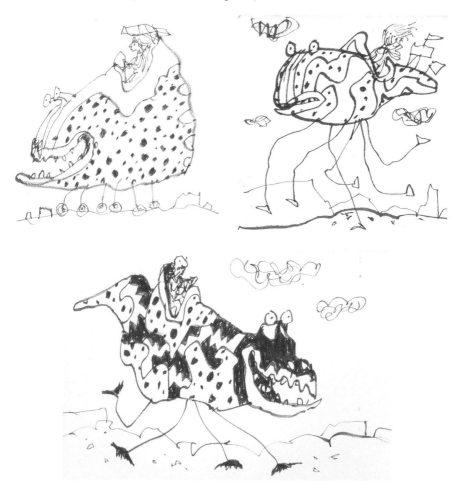

They are at first disturbing: Blake has used a thick-nibbed black calligraphic marker pen and the lines are much bolder and more aggressive than those we normally associate with him. The roughly drawn creatures might initially remind us of some of those monster-composites that have cropped up in Blake's work at least since the 1970s: a piranha-like fish with horns, a dinosaurial head on the torso of a flying horse. But then we become aware of strange spindly lower excrescences, which often end in wheels, and we see that these monsters are also vehicles, menacing juggernauts, which are being driven by small figures.

Many of the drivers are female, but there are also some men, possibly even a few self-portraits among these (not by intention, comments Blake). Several of the vehicles have more than one driver, and, surprisingly, they all sit more or less confidently at the steering wheels, sometimes with hair or jaunty scarf streaming behind. There is a strong disconnect in size between these powerful bug-eyed creations and their small drivers, making the pictures bristle with meaning. In this case, however, when asked, Blake is more forward with an interpretation than he sometimes is: the vehicles may stand, as he first saw them, for the sick mind, or, as he has later commented, as situations that seem in some way unmanageable: many are great black ugly careering things ('what does a psychosis look like?' he asks), some seem themselves to be experiencing distress (so is the subject the vehicle or the driver or both?), but they are also capable of being controlled, or at least handled, by their drivers. In this sense they have a characteristic, hopeful, Blakean feel to them. But this kind of up-front personification of an illness or of serious personal difficulty is also new territory for him. The invention of these works, Blake says, comes from nowhere that he recognizes, but the drawing of them and the choice of drawing tools are confident and sure, and they seem to me to have unusual and powerful depth. 'They may be', as Linda Kitson once told Blake, 'the best things you've done so far.'

Books: close-matching

The way in which Blake chooses and uses his tools and techniques to suit each work is always highly thought-out and has applied to everything he has drawn from early on. He realizes now that his first cartoons were made with a pen that was too smooth-nibbed for the kind of edgily articulated style that he was after. It was really only when he discovered scratchy Waverley nibs, and later, over the last 20 years, unique reed and quill pens, that his style adapted itself to the unpredictable nature of such tools and he was able to find the 'handwriting' which is so key to his recognizable style. His illustrations are often elaborated with watercolour or ink washes (many of his children's books, for example, *Clown*, the *Mrs Armitage* trio, *The Green Ship*, the *Arabel* and *Captain Najork* books) and some work is purely colour; for example, the watercolour of *Woman with a Book*, the watercolour pencils for Big Healthy Girls, or the watercolour pastels of *Punch* covers, for Blake almost the most pleasurable tool of all.

When he is illustrating a book Blake always adjusts his drawing style and materials to the needs of the text: here his collaborations with the author Roald Dahl (1916–90) are revealing, because they demanded something new from Blake. Their first was *The Enormous Crocodile* (1979), Dahl's first picture-book and a story which felt harder-edged than those Blake had worked on up until then.

At the same time Dahl's characteristic 'lack of introspection' was also quite welcome (Blake thinks that *Danny the Champion of the World* is the only work of Dahl's children's fiction that has a different feel, and this is because it contains autobiographical elements). Blake describes the first collaboration:
It was very interesting as a task to do, because it's a kind of caricature, and that's where Roald and I met very much. In a sense, what he wrote was like what I drew in the degree of exaggeration and comedy in it. But it was a bit fiercer. And the character of the crocodile

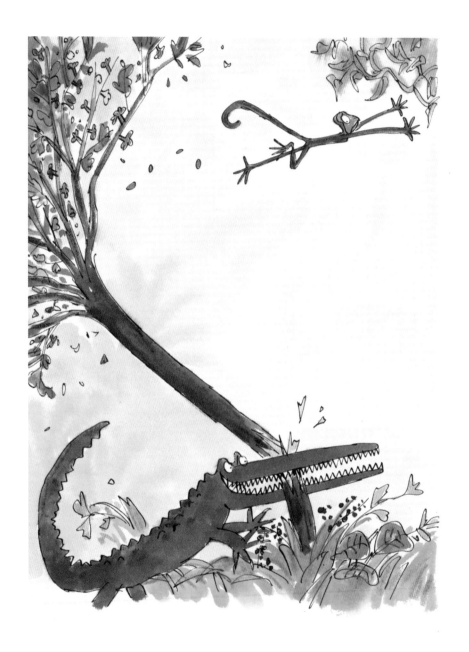

was interesting to me, because he's a sort of embodiment of evil, and I thought [it had] a little bit . . . of Richard III in it somewhere, but [also] a lot of stage villains . . . The other thing that it reminded me of was the crocodile in Punch and Judy . . . it's that kind of convention, I think. And of course the thing about it is that if you look at what I've drawn, I mean I started off drawing crocodiles . . . but it's not a real crocodile . . . In Roald's words, it says he had hundreds of teeth . . . Crocodiles don't have hundreds of teeth, they have teeth here and there in a rather random sort of way. But mine has . . . And because it's not a real crocodile, but it's got a sort of evil look in its eyes, it becomes something a bit different . . . in a way, it becomes this sort of cartoon character . . . So it has its own life.

Because I had to draw those teeth . . . I was drawing with a much harder pen-nib . . . Most of what I do is coloured with watercolour: I do a black-and-white pen drawing and then I colour it in watercolour, but in there you'll find that there are inks as well, which are much brighter . . . more intense colours. So that in a sense the creatures become heraldic . . . not naturalistic . . . they're part of a fable in a sense . . . the crocodile disguises itself as a tree . . . as a bench, and that's why it can't quite be a real crocodile, because they're not so good at those things. [4]

A similar thing happened with *Revolting Rhymes* (1982) and *Rhyme Stew* (1989), Dahl's attempts to restore the dark side to what he considered were sanitized versions of well-known fairy-tales (often from the Grimm brothers) familiar to most children. The text of both these books, but especially the second one, are, if anything, grimmer than some of the Grimm originals – for example in 'Hansel and Gretel', Dahl goes as far as describing the smell of the witch burning in the oven. Blake did however manage to mitigate Dahl's graphic verse with illustrations such as these two on the next page:

Apart from some marginal illustrations in sepia, Blake chooses a framing device for the plates, separating the image from the text, and the pen contours are more precise than they often are in his work, somehow making the drawing seem less graphically real. These images were originally commissioned as black-and-white drawings, but there was a later editorial request for coloured ones. Faced with the prospect of doing them all again, and with typical practical inventiveness, Blake cast around for a quicker solution. Because they were already well known to him, Blake was able to turn to the hand-coloured lithographs of the nineteenth-century French illustrator Gavarni. Gavarni's colours are pale tints, and when Blake added these to his black-and-white drawings, the images took on what Blake calls an 'old-fashioned' feel, and the shading is in an obvious, waxy black crayon, again distancing the reader from reality. The horrible decapitation in the text is shown in this picture in the most unnaturalistic way possible, where gravity and gore play no part – in fact, Blake says, the idea for the *coup de grâce* came from a *New Yorker* cartoon by James Thurber.

In Dahl's gruesome reinvention of *Goldilocks*, where Baby Bear ends up reclaiming his porridge by eating the girl who has eaten it, the scene is at first sight rather charming and domestic, until we notice the discreet remains on the floor.

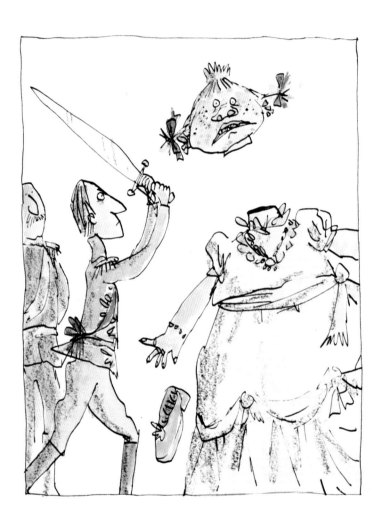

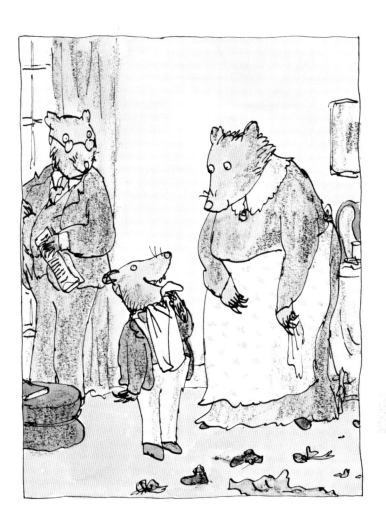

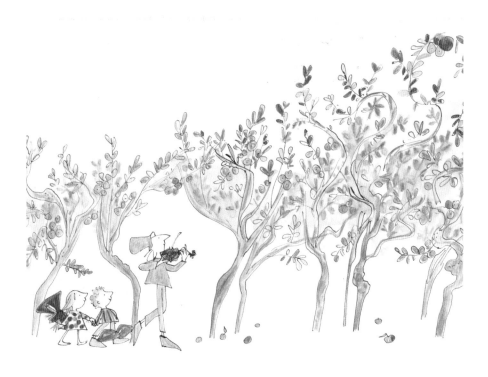

Much as we understand how children thrill to an element of nastiness, these texts today seem to me to cross the line into gratuitous horror, for the way in which they further distort tales which already have quite dark features. Perhaps Dahl's blackness works best for children when it is more associated with the caricatural absurdity of books such as *The Twits*.

Sometimes the medium itself will even give rise to the book. Take *Patrick*, the first of Blake's independent books, published in 1968. Up until then, apart from the *Punch* and *Spectator* covers, Blake's commissions had all been for black-and-white drawings and he felt somewhat pigeonholed into this medium. He felt ready to do a book in colour and the moment was right because the 1960s was the decade in which cheap techniques for full-colour printing were being developed. So he came up with a story which *had* to be in colour. This wonderful early book, a tale about the healing power of music (and art), moves back and forth from the naturalistic world to the magical one. For the real world of markets and fields, Blake fills the pen and ink drawings with muted earth colours, using watercolour pastel and water; but when the hero Patrick plays his magic violin, everything changes from dull to bright: the colours must become intense and non-naturalistic. So the trees are soft watery green at the bottom, and at the top they are saturated primary colours.

The same idea applies to *Angel Pavement* (2003), a book which came out of a piece of exhibition merchandise. *Magic Pencil* was an exhibition of children's book illustration curated by Blake and Andrea Rose as a British Council touring exhibition and which visited London's British Library in 2002–3. The exhibition shop sold pencils with multi-coloured points, which Blake started to use himself and then, with habitual ingenuity, he found a way of making these new tools the star of a picture-book. In *Angel Pavement* the two angels, Loopy and Corky (who are based on two of Blake's best friends), need to seem human so as not to alarm, and so they appear as all the other characters. But their wings are drawn with the multi-coloured pencil, as are the magical drawings in the sky that Sid, with their help, is able to produce. So the imaginative use of a new tool enabled Blake to suggest different levels of reality on the same page.

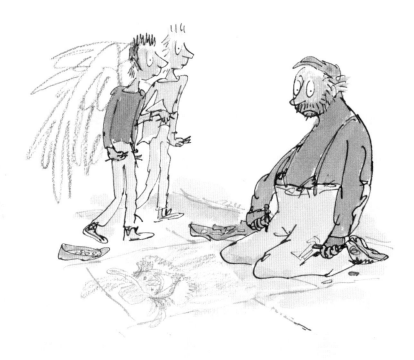

In *Monsters*, one of several powerful collaborations between Blake and Russell Hoban (1925–2011), and first published in 1979, the narrative centres on the child John's drawings of monsters. Blake's solution for this new challenge was for the story illustrations to be drawn in pen and watercolour, while John's monsters are made authentically with basic felt-tips, on the kind of scraps of paper families have lying

around at home. Because the sheets of sugar paper and torn-out pages from notepads are printed on the page, they have the effect of appearing more real than the other illustrations, which, without spoiling the book, is the point of the story. Blake says he had to relearn to draw like a child for this book (although I wonder if he ever did draw that way), even trying, unsuccessfully, to use the pen in his left hand to achieve this effect. As with *Angel Pavement*, the added message, which is delivered by the childish drawing, is to remind children, parents and, today, very much also primary-school teachers – who themselves increasingly lack confidence in this area – that children can and need to draw.

Lastly, there is the kind of illustration that Blake calls 'more realistic'. These are drawings that are neither openly caricatural, such as most of the Dahl illustrations (although *Danny the Champion of the World* is an exception), nor as heavily freighted with symbolism as those that often give rise to his own texts, and that carry so much of the meaning of the book. Whether in full colour or with a more limited palette, in these realistic drawings Blake illustrates very specific moments from a story. These might be the more obvious ones such as the denouement of each of the La Fontaine *Fables* or the high point of individual adventures in *Candide*, and Blake makes them speak back to the text, echoing it in its detail but providing a context, both physical and emotional, which helps the reader to engage imaginatively.

The texts that have summoned this kind of drawing from Blake are mainly the picaresque-type works such as Voltaire's *Candide*, and folk-tales or fables with stock characters (shepherds, kings, trolls, widows, merchants, misers or animals of various kinds). Usually nameless and without distinct personality, the characters operate inside plots with high doses of magic, morality and justice, and with the predictability that goes with these. These plots can be lengthy and intricate; perhaps, in times when they are no longer the only stories on the block, when they are read silently rather than listened to around a fire, they really do need a kind of realistic treatment that gives them flesh and colour. And they need illustrations that will help readers find their way, allowing them to rest a little on sometimes dizzying journeys through lands, time and even space. We can look at a few examples of these and meet a Blake who absolutely understands how to assist and encourage readers through this kind of text.

Quentin Blake's Magical Tales (text by John Yeoman, 2010) is a volume of folk-tales from around the world, some of which previously appeared under the title *The Princes' Gifts* (1997). The book opens with 'The Blue Belt', a Norwegian folk-tale, in which a young orphan boy finds a magic belt that gives him unearthly strength, enough to defeat 12 snarling lionesses. The boy eventually outwits some trolls, as well as the King of Arabia, the father of the princess who he marries, but who is locked up by her father in a house under the sea. The reader will now understand that this is an episodic rather than a repetitious tale, and Blake's tactic is to punctuate the text with four images, each serving a slightly different purpose.

In the first, a three-quarter-page image, the boy is shown as a tiny, blue-belted figure next to a brutish troll who has just roasted an ox outside his hut.

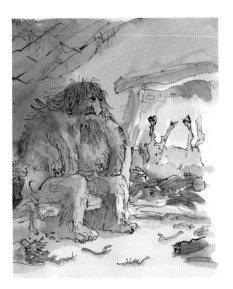

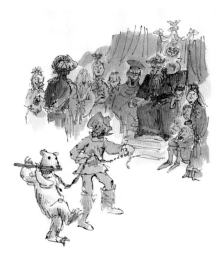

Here the boy has not yet discovered his strength so the drawing helps us identify with the powerless child, faced with potent adversity, in the fashion of fairy-tales. This is followed by more than two pages of text, during which seven different events take place, including the boy's marriage to the princess and their two separate trips to Arabia. In the last of these the boy devises a plan to rescue the princess, which involves buying a bearskin and collar and chain – though we don't yet know why. By this time the reader may need to pause for breath and so Blake obliges with a full-colour plate in which the boy, now convincingly disguised as a white flute-playing bear, is brought before the delighted king.

In this image the king is a proper king with a crown, seated on a big gold throne, and the surrounding courtiers are suitably dressed in oriental clothes. The bear turns out to have a dangerous side to anyone who dares to laugh at him and this is shown in a half-page drawing on the penultimate spread, where he chases the princess's servant, who has been foolish enough to giggle at his antics.

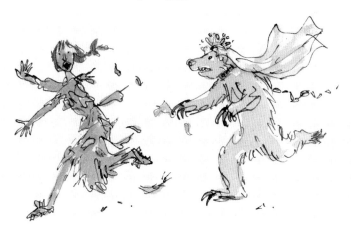

This is a serious chase: Blake's drawing of the tattered bits of dress in the bear's substantial and dark claws and the servant's terrified face points up the drama, injecting a heart-gripping moment into the more discursive text. For the last image Blake does not choose the more dramatic final scene of the story where the boy smashes his way into the princess's underwater prison: instead he hints in a more gentle fashion that everything will go well.

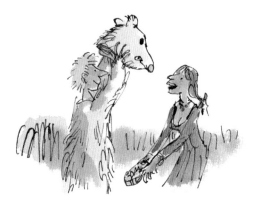

This half-page picture shows the couple, with the bear removing his bearskin head to reveal the boy, now tall and strong, to the delight and relief of the princess. The drawing in this last image is executed in bolder strokes and the figures are close up to us – we have moved from the fairy-tale world of the boy and the troll to something we recognize much more intimately.

The Winter Sleepwalker and Other Tales (1994) is a collection of modern fairy-tale-like stories by Joan Aiken. Containing many fairy-tale motifs such as magic, both the dark and light kind, and some of its archetypes – witches, and so on – we nevertheless also come across elements that don't belong to the tradition: here there are characters and places with names: for example, a witch called Mrs Hatecraft, the village Furious Hill, and polacanthus, a type of monster; there are people of the modern world like postmen, head teachers, chiefs of police and shopkeepers, as well as millers and princes, and there are evocative descriptions of place, such as this one from the story that gives the book its title: 'Every day Alyss walked in the woods by herself, flashing like a sunrise among the dark trees. She loved to be alone, and listen to the calls of birds, or the deer and wild pigs that grunted and snuffled, the foxes that barked into the forest'.

In 'Over the Cloudy Mountains' Blake responds in another way – he uses the poetic as the basis for a different kind of reality, something he also does when he imagines this library scene: 'The Head Teacher was in the school library. Here, so many books were kept, in so many high shelves, that the room looked like a huge honeycomb'. This may be a fantasy library in both drawing and text but the light bathing the two figures seems to me to be a wonderful kind of lyrical comment on the power of books. Blake's illustrations for *Winter Sleepwalker* occupy an unusual place

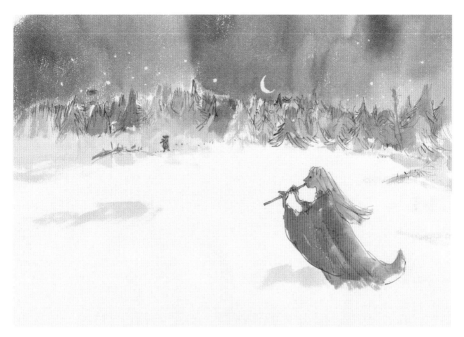

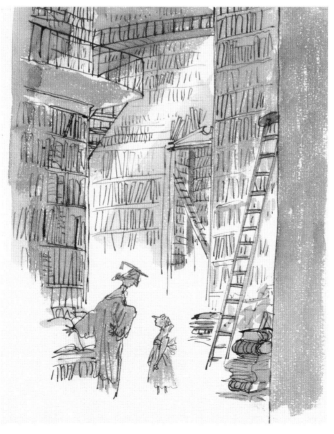

in his oeuvre – landscapes appear where they wouldn't normally and the coloured inks he uses take us into the real, emotional world of the imagination.

In Voltaire's *Candide ou l'Optimisme*, which Blake illustrated for a Folio Society edition, the situation works a bit differently – for one thing this is not a work for young children: Blake says, 'For a young audience there may be occasions when you might want to be less dark or less explicit, but once you are addressing an independent reader he or she is no longer someone you have to think about specifically.'[5]

To put it in context, this satirical novella or *conte philosophique* of 1759 is taught in every secondary school in France – it belongs to the canon of Western literature, and so it would be important for Blake to find the right tone in which to illustrate this new edition: in fact, although not originally planned, it was later published by Gallimard (Folio) in France. The book is divided into 30 short chapters, each of which describes the progress of the young hero Candide. Banished from his edenic chateau for sexual misconduct, he wanders the world and discovers a place full of pain and hardship, eventually learning that the doctrine of optimism preached by his tutor Dr Pangloss is an unsatisfactory guide, and that a more practical approach is required.

In this fantastical work, Voltaire not only parodies the stock adventures and romance of eighteenth-century literature, but he also includes religious blasphemy and subversive political commentary, and, along the way, throws in truthful insights into human behaviour. Blake's solution to this many-levelled challenge was a series of 15 colour plates, all in the same square format, plus several more black-and-white vignettes. The illustrations are remarkably close in spirit to the work: the regular shape of the plates echoes the schematic form; the costume is historical, and the scale of humour echoes that of the text in a very specific way, from belly-laughs to wry smile. As Blake says: 'Candide inadvertently running through an important cleric with his sword is farcical; while the garter-dropping marchioness has to be real enough to be seductive.'[6]

Voltaire's genius in mixing the most absurd farce with the deepest human understanding, such as for example the Guinean slave's speech to Candide, is, to my mind, matched by his younger contemporary Mozart's (in, say, the opera *Cosi fan tutte*, where preposterous disguises rub shoulders with the most heartfelt love music ever written). This is also Blake's special talent and, when you look for it, evidence of it is to be found in almost everything he does, whether in an ephemeral greetings card, or a book illustration, or an exhibition work. It is surely one of the reasons why *Candide* appealed to him, and why, if such classics are to be made palatable to young (and not so young) modern readers, his humane kind of visual bridge-building is such a worthwhile and effective tool.

Blake has particularly enjoyed these recent Folio Society projects, and not only because of their high production values – in addition to the three described above, he has in the last 20 years illustrated *Don Quixote*, *The Hunchback of Notre Dame*, *Voyages to the Moon and Sun* and the *Fables* of La Fontaine. And he recently completed the drawings for a deluxe edition of Apuleius' *Golden Ass*. With the exception of *The Hunchback*, these texts for adults are all either in or related to the picaresque genre, those fantastical adventures of an anti-hero, who might be an innocent such as Candide

or a doer of good such as Quixote, or a seeker after magic like Lucius in *The Golden Ass*. They are tales that sometimes include inset stories (that is, told by characters in the story, as in the Apuleius), and early science-fiction elements, as in Cyrano's *Voyages to the Moon and Sun*. They have a strong sense of irreverence for the pompous and the important, and also often of comedy. We can see the attractions for an illustrator such as Blake: an abundance of dramatic, comedic and fantastical episodes to choose from, and, as he says in his introduction to *The Seven Voyages of Sinbad The Sailor*, which he illustrated in a retelling by John Yeoman in 1996, also the opposite:

Isn't this what we find so attractive about these stories – that though they are so extraordinary, there is in them somewhere an element of truth? (Just as I was doing my pictures of the Roc I met someone who told me that in Madagascar there are traces of bones of birds far larger than anything we have seen…)

So, for Blake these are natural choices, the kind of works he has illustrated from the very beginning when he and John Yeoman produced *A Drink of Water*, that first collection of folk-tales. He knows that by selecting texts to illustrate which are broadly descriptive of action rather than of thought, mood or feeling – in other words, of the external rather than the internal – his drawings can be supremely additive. He also shares with many of the protagonists of these tales a sense of what he describes as 'ill-founded optimism'.

All of which puts him in a very strong position to give these sometimes two-dimensional figures and their adventures a truly human touch.

Occasional drawing

Since drawing is what Blake does naturally, almost like breathing or walking, he also draws for purposes beyond the professional. Drawings as telephone scribbling, the proverbial table-cloth doodles, decorations for faxes and letters, drawings as explanations, demonstrations or plans, and those that are the kind of singular, priceless gifts that only artists are able to offer to their friends and relatives. Drawings such as these two images made for Sir Christopher Frayling, one for his wedding and the other for his last dinner as Rector of the Royal College of Art, or this design for a friend, Jake Wilson's wedding invitation. Wilson explains that he and his wife-to-be were to get married

in a Temperate House in Leamington Spa, a kind of glass house filled with tropical plants, and as soon as we saw it we thought, all that's missing is some cockatoos… So I eventually summoned up the courage to ask Quentin if he would draw some specially for our wedding invitation, and was stunned when he said yes straight away. Then when we thought about plain type going with this beautiful drawing, it didn't seem right, and so I wrote back very nervously and said, would it be possible for him to do the lettering too? And he spontaneously produced three different layouts! Although on one level it didn't surprise me that that's how Quentin does things, I was still amazed that he took such care over something he was doing out of the kindness of his heart.

In much more spontaneous but equally benevolent vein, here is an example of a fax

Christopher
Frayling and
Helen Snowdon invite you to their
WEDDING PARTY in the
Senior Common Room Royal College of Art
Kensington Gore London SW7
Monday 14th December 7–9

RSVP 12 Macaulay Buildings Widcombe Hill Bath Avon

Katie
or
Jake
15th October 2011

drawing, in this case a reply to a letter from two librarians inviting him to curate an exhibition at the Bibliothèque de la Cité in Geneva. The message is in Blake's perfect French and the graphic reads, 'the heart says yes, the head too'.

The next images are not exactly occasional drawings, but a series of images which Blake was commissioned to make for the offices of Hoare's, the private bank, and so unpublished and unavailable to the public other than Hoare's employees and clients. The bank has a tradition of decorating meeting-rooms with thematic pictures, and when two spaces were earmarked for conversion to such rooms the bank asked Blake to come up with an idea and some drawings. His plan was *The Ledger Room* (describing the contents of the shelves in some of these rooms), and the nine drawings all relate to this theme, serving as 'the answer to a question', as Blake often describes his work.

Blake's response to this commission is typically imaginative: his cartooning instinct helps him sees the potential humour in ledgers, his knowledge of history and of literary illustration gives him a ready-made repertoire of suitably costumed employees, and the picture of one of the bank's founders is just a smart transcription of a painted portrait also hanging in the room (with added ledgers).

Drawing about drawing

Lastly, a coda about how Blake's drawings can also get other people drawing. Encouraging everyone to draw – those who don't believe they can as well as those who may have left it behind in their childhood, and everyone in between – is a mission for Blake; he is always involved in big-picture activity of this kind, although perhaps 'mission' is a rather dynamic word to describe his subtle tactics. In Part 2 we'll see how his encouragement comes indirectly, through his wholehearted support of the Campaign for Drawing; and more immediately when he draws in public, or talks about drawing. But Blake's particular teaching gene, the one that 'shows not tells', is strong and always in operation, so there is another way in which he urges people to draw, and that is to make drawing or painting a theme in his own work. He does it in picture-books such as *Angel Pavement* and the illustrations to Hoban's *Monsters* where drawing is the subject. But it is also there incidentally in many 'off the page' works for health settings, on banners, greetings cards and other pieces of communication. In all these slightly different situations the message is a similar one: that drawing, with pencil or brush, is a skill, but one that everyone can learn, and that it is a consuming pleasure which is good for you and your wellbeing.

As well as being enchanting things for readers, gallery-goers and hospital patients, Blake's drawings are canonic for many illustrators and other artists, now from several generations – and those who know him personally, even those who don't, see him as the benevolent godfather of illustration. There are of course some imitators who understand how effective the style is but have been unable to substitute Blake's practice, experience and ideas with their own equivalents, and so have not developed their own individual 'drawing handwriting'. And then there are those who have managed to find their voices completely, like the illustrator/author/ graphic novelist/ filmmaker Joann Sfar and most of Blake's former students, who went on to make careers in illustration, such as Emma Chichester Clark, Angela

Barrett and Anne Howeson. Sfar's tribute in words and pictures in his own work *Caravan* (seen in the chapter on France) echoes and represents many thousands of illustrators who also comment on and 'like' Blake's work every day on social media, or in the letters and drawings that they send him personally, such as this card from illustrator Yasmeen Ismail.

Perhaps the most touching of these came in a large parcel which arrived for his seventieth birthday in 2002. As surprising and delightful as the mysterious package that turns up in *Zagazoo*, though fortunately not alive, inside was an old wooden paintbox, full of handmade birthday postcards from 70 Australian picture-book creators. Apart from Shaun Tan and a couple of others, Blake knew very few of the contributors to this unique birthday present, but each card was an artist's warm tribute to another artist, telling little proofs of how Blake's drawings now have a life beyond their own life.

2 Learning, teaching, learning

He was the first teacher to show us that the truth might be relative, that our opinion mattered, and that life was multi-textured.
Julia (Martinez) Stanton, ex-student at the Lycée Français de Londres

Use the big gears of unconscious learning; show, not tell.
John Richmond (haroldrosen.blogspot.co.uk)

One of the virtues of literary studies is that they lead constantly outside themselves.
(From Joe Moran, 'F. R. Leavis, English and the University', *English* [Oxford Journal], January 2002)

Quentin Blake may be the UK's best-loved illustrator but he could also be seen as one of its most effective if unconventional teachers. I learned this first-hand myself when, as a very green primary-school teacher in the 1970s, I used the series of *Monster* books,[1] which he illustrated, to teach my year 2 class to read. Martin was a timid little 6-year-old with beautiful brown eyes and a speech disorder; he really wanted to learn to read but he was defeated by the then-current techniques of phonics and 'look and say'. It was the purple figure of Monster lumbering into his life that did it for him.

The text in these books was based on children's responses to the illustrations, and they are compelling little stories. Monster is a creature who arrives in a city, makes friends with two children, and, over the 24 books of the series, experiences with them the city as a child does. The books are really self-help manuals for small children: Monster is at first inept at dealing with the situations which his new life presents to

From *The Rights of the Reader* by Daniel Pennac

him, but he is helped by the children, who, being children, understand his position. Sometimes though, Monster proves to be quicker thinking than they are and so he is also useful to them. His appearance is described in one sentence at the beginning of the first book: 'Monster is not ugly like other monsters; he's kind of tall and his head is skinny.' Blake takes these 17 words and creates a living character, whose usefulness to children (and so to early child readers) goes well beyond the implications of the text. In Blake's imagination Monster is ungainly, with flat, clodhopping feet, his small head vaguely dinosaurial and small-brained; his purple figure towers above the children but his expressions (the skilful placing of two dots, the angle of the tiny line that is his mouth, and the flapping hand gestures) range from confused or upset to delighted. They echo exquisitely the feelings of a child, who, when confronted by an unfamiliar situation, at first feels fear and then, with adult reassurances, relief. And because Monster is also a big person in difficulty, the smaller people feel bigger and more confident because they can help him. As the French primary-school teacher Annie Simon, who has used Blake's books in her classrooms for many years, remarked to me, 'Blake's characters are all a little crazy, and the child who feels a bit marginalized (in other words, every child, at one moment or other) recognizes him or herself in them.' So in the drawings for these books, produced early in his career as a children's book illustrator, there is already rich evidence of Blake's characteristic empathy with his subject. The *Monster* texts teach children to handle new situations in a practical

way, but the illustrations teach them about dealing with their feelings, and with young children that perhaps is where the learning really starts.

For Martin, the day he saw Monster struggling to make a picture or to read a book at school, something changed in his head. He loved and identified with this purple character, at first so hopeless, but who later becomes a proper problem solver. Martin would look at the books, drinking in the illustrations for hours before he could decode a single word. And then one day he could.

This chapter is about an understanding that Blake has had, from very early in his life, about how people learn and how this learning is often only loosely connected with formal education. His engagement with the learning process plays out, playfully, in all aspects of his work: the short time he spent as a schoolteacher, his 25 years as tutor and then Head of the Illustration Department at the Royal College of Art, and in the many talks and lectures he has given to school, college, university and general audiences. But mainly Blake helps people learn through activities that are not primarily didactic, through the drawings he does: illustrated books for both children and adults, images for public places such as theatres, hospitals, and the walls of museums; more recently also through the exhibitions he has curated at home in the UK, in Europe and the USA.

To return to our timeline, Blake went to a solid local primary school, Lamorbey CE in Sidcup (now Holy Trinity Lamorbey CE Primary) in 1937, and then a respected local secondary, the County School for Boys, Sidcup (which became a grammar school in the wake of the 1944 Education Act). Here an enlightened English teacher, J. H. Walsh, pointed him towards Downing College, Cambridge, where he went as only the third successful Cambridge entrant from his school, as an Exhibitioner in 1951. Downing was at the time known as a college with a focus on Law and Science, but more than anything in this period it was where that giant of English teaching, F. R. Leavis, held court and helped 'Downing English' to become a significant experience for all who were exposed to it.

Later, Blake went to the Institute of Education in London to train as an English teacher. Exams were passed, each stage equipping him well for the next one, and Blake benefited from exposure to distinguished teachers and academics. This was a not untypical trajectory for an intelligent middle-class boy growing up after 1944, and Blake is grateful for his secondary education which offered him access to the kind of culture he later realized was lacking in his home environment: 'Grammar school was practically the only source of cultural input . . . I got more or less everything from there.' I'm not sure that this is a criticism of the offer at home, in a way it is another comment on self-aware learning, recognizing what you need as a learner away from the home framework, and I would not feel at all certain that he would have become a greater artist if he *had* grown up in a string-quartet-playing, gallery-going home.

However, much of his cultural input at school did not emerge from the curriculum, nor (with a few exceptions) did it come from most of the teaching he experienced. Instead, discoveries about drawing and the theatre, two subjects that excited the artistically awakening Blake, often took place in different contexts. This was sometimes through people who were not teachers, and perhaps most

of all through his own visual curiosity. The theatre may be a good place to start looking for clues about the nature of his learning experiences, since it is something that Blake himself frequently connects with his own art: 'these drawings are like something happening, there is some sequence of time implied in them: an arm may be as much the description of a gesture as a depiction of anatomy. It's a sort of little theatre'.[2]

Learning (teaching) through the theatre

Blake discovered the theatre, as many lucky people do, through performing school plays. At Chislehurst and Sidcup, these were extra-curricular activities, in part the province of the eccentric headmaster, Dr C. R. McGregor Williams, who also performed in them ('he was good as Toby Belch, not Mark Antony, though,' says Blake drily). Blake remembers, that 'We used to do Shakespeare: which was a very good thing . . . organized by McGregor Williams (or Mac as he was known) . . . a bizarre character, very full of himself, but he did think you *should* do Shakespeare, which was a redeeming feature.' Blake now sees how useful these performing opportunities were to be to the notion of illustration as a 'theatre of the page': 'when you're on the stage you really understand what happens'. And this was in spite of not being given significant roles: 'I don't think I'd got the presence to do it, or I thought I hadn't; I did things like Gratiano in *The Merchant of Venice*.'

Perhaps it was Blake's reserve that prevented him from getting the star parts, but later, while doing National Service in the Royal Army Educational Corps, he did play one lead role. While preparing to teach English (literacy) to young recruits, Blake was sent on a 12-week training course at Gerrards Cross. Here he encountered Major Archie Wavell (1916–53), the son of Field Marshall Viscount Wavell, a Viceroy of India, and compiler of *Other Men's Flowers*, a best-selling anthology of his favourite poems, published in 1944. Wavell *fils*, a kind, educated and literary man, was an important figure for Blake, (who was clearly affected when only a few years later Wavell was killed in Kenya during the Mau Mau Uprising): 'He knew how to teach, how to organize that course, he talked about Shakespeare and the army, the Bible and the army, it was interesting . . .' Wavell encouraged his staff to put on a soldier production of Ben Jonson's *The Alchemist* ('that's what he was like') and Blake was cast as Subtle, the fake alchemist who is one of the three leads in the play – a demanding role which, he says, he 'almost' learned in 12 weeks. It was performed in front of an audience, which on one night included the actor Alec Guinness. In one of Blake's few stories about his parents, he says that they also attended a performance, but, he continues, they were at first greatly disappointed: it seemed as if their son was not in fact on stage that night – they had failed to recognize him in his bald wig. It is tempting to wonder whether the Blake on stage was also unrecognizable to them because his acting skills allowed him to become a person they had never seen before.

The Alchemist is of course a comedy. The notion of Blake the comic is highly visible in his art, as we have already seen, but it is also there in a quieter but equally hilarious side to his life and seems to have been so from early on – Blake's father is

said to have had a very dry sense of humour; perhaps it came from there. Certainly two memories from other people who Blake knows well confirm this side to his character. The first is from the Rahtz sisters, Julia and Madeleine, daughters of Roland Rahtz who taught at Blake's school and lived opposite him. They are several years younger than Blake and Madeleine remembers him as someone who was always 'clowning'. When they were at primary school, Blake, then a teenager, was known as '"the funny man" . . . because he had such an expressive face and if the ball accidentally got kicked over the playground fence, there was always a response'. According to Julia, 'We always thought of him as somebody who would amuse us . . . he once came on holiday with the family, he was in his late teens and on one occasion he was holding Jean's (Mrs Rahtz's) hand and bending down double pretending to be her little boy, for my benefit of course, because I was walking behind!'

The second much later story is told by Jane Stanton, one of Blake's students from the RCA, and now Head of Design at the University of Derby. Stanton remembers a student trip to Paris when 'a whole restaurant became helpless with laughter at his impression of a frog trying to get out of a bucket . . . the frog act made me realize that Quentin was exactly like his drawings, the animation that he was acting out'.

Perhaps it was partly because he remembered how much acting can give otherwise reticent young people a sense of self-confidence (it's always easier to be brave when you are someone else) that Blake used it as a teaching tool during his brief period as part-time English literature teacher at the Lycée Français de Londres in 1964.

Although Blake does now recall the following event, it is not with the enthusiasm of former Lycée student Gilles Dattas, now an artist and part-time security guard at the Musée du Petit Palais in Paris. Over thirty-five years later he recognized Blake, at the time working on an exhibition at the museum, and approached him. I happened to be there and recorded their conversation:

GD: You used to read us stories, no other teachers did that, they were all very set in their ways, [it was] very Cartesian . . . a very French school. And we did a school play . . . it was Julius Caesar.

QB: I was thinking about it the other day, because everyone knew their lines! I was quite worried, because it was a very short version, but even so quite a lot to learn. For the assassination we had three kinds of blood, various different people brought their own versions of home-made blood . . .

GD: And they put it in water pistols! Yes! And they were wearing bed sheets and we all sort of clung together while Julius Caesar was getting stabbed and one of them had this water pistol spraying the bed sheet with red ink.

This chance conversation says a lot about how good teaching works: Dattas's breathless description was a spontaneous memory – it is fine evidence of the impact that the original event had on his 10-year-old self: the (for him) unusual opportunity

to perform in a play, and the drama of a production for which the student-performers were also creatively involved in dreaming up and making fake blood. And Blake's surprise that the students had managed to learn their lines at all reminds us how unaware he is (probably, along with most teachers) of what a motivational effect one small intervention can have on students.

And in the cinema

But perhaps Blake's most important theatre-related experience took place not on a stage but in the cinema. He was taken on a sixth-form outing to see Marcel Carné's 1945 film *Les enfants du paradis*, then in its first London showing at the Academy Cinema. *Les enfants* would probably feature on many aficionados' list: it was voted best film ever in a 1995 poll of French film critics and cultural professionals. But for Blake it was not only the epic romance, played out over the three hours, between the mime Baptiste (played by the famous actor-director Jean-Louis Barrault) and Arletty's mysteriously beautiful courtesan Garance. It was more a sense of the theatrical and how theatre related to the kind of drawing he was already doing that most filled his head on his return to Sidcup. In the film, itself a tale about popular theatre in nineteenth-century Paris, there is a little sequence which imprinted itself deeply on Blake's consciousness:

That scene where he [Baptiste] is sitting on a barrel outside the Théâtre des Funambules in clown's costume, with his arms and legs hanging down as though he were a puppet, until the moment when he is able to come to life, as it were, and act the story of the little pick-pocketing incident which has taken place in front of him. That moment, with all its accompanying atmosphere . . . represents for me that mime element which is an important part of illustration. [3]

This is also a good story about learning: as the contemporary composer John Woolrich has observed: 'You don't choose your influences; tastes aren't arbitrary – they point to something in your own creative personality'. [4]

In the end it was not acting on the stage or the screen that became the vehicle for Blake's creative personality, but he did take from theatre an understanding of the elements it has in common with illustration, and which make illustration such a compelling art: character, costume, the right props, timing, knowing how to keep the reader in suspense, and he knew that when you understand all those, you can play all the parts *and* be the director, which in his own works he absolutely is.

Blake's youth and early professional life were dotted with theatrical situations from which he could learn: from plays as literary texts and vehicles for the enjoyable and self-defining activity that acting can be, to the notion of mime as a narrative medium, to the role of the director who must compellingly conjure the vision of the text. The fruits of this learning are there in the teacher he became, the quiet but inspirational classroom performer, and they are there in the way that he learned to incorporate theatre into drawing.

Learning drawing

As far as his own early experiences go, Blake feels sure about the first one: he remembers becoming aware of what good drawing was almost before picking up a pencil. For his fourth birthday in December 1936, his parents had given him the *Chicks' Own Annual 1937. Chicks' Own* was a weekly children's comic with strip cartoons as well as simple written stories, and he remembers one strip that beckoned to him in a particular way:

The hero was Rupert, a little yellow chick. He had a red beak; his friend was to the same design but black with a yellow beak. There was a curious convention about the beaks: normal beaks seen in profile, they became a nose and a mouth seen head-on. The chicks were child-sized, and went to a school where their friends were other animals such as Teeth-y Croc-o-dile and Stri-pey Ti-ger, who were not much bigger than they were.

The interesting thing to me, in retrospect, is that I am sure that I was aware already that some of the drawings were better than others. Many were flat and anaemic, but those for the Rupert stories had satisfyingly substantial forms; the wheels on Rupert's train really looked as though they would go round, and the bowl of pudding they found in the pirates' cave really looked worth eating.

Blake believes that the artist who signed the Rupert stories, A. White, may well have been influenced by the French illustrator, Benjamin Rabier (1864–1939), probably best known in this country for his image of a red cow's head which chortles out from boxes of *La vache qui rit* processed cheese. With this memory and the later reflection on it Blake validates his own critical judgement, by suggesting that the artist whose works he picked out at such an early age was someone with a good artistic (and, even better, a French) pedigree.

We will never know whether this precocious critical faculty fed into Blake's own early efforts at drawing, but it is clear that he did draw well, and from a young age. He remembers drawing at primary school, where he recalls making what must have seemed very sophisticated scenes of people looking in on other scenes (at the time considering these works 'proper drawings'). He would probably disagree, but this is an astonishing early appreciation of what artists themselves do.

He also draws at home and famously, a visiting relative said, 'You'll find he doesn't say much but he does draw a lot'. Of course most small children, offered suitable materials and encouragement, will happily draw a lot, as Blake understands very well. He sometimes describes children's drawing as one of 'unidentical twins', the other being words. In an interview with Joann Sfar he says:

the verbal and the visual, they're growing up together and when you reach a certain age, the visual one become worthless and is pushed to one side and the verbal one becomes important . . . that's the one that teaches you to get a job ... how to fill in forms, but what's important is to get those in balance. [5]

How did Blake, then, manage to keep the two in balance? It is worth asking how and why he looked after the visual twin despite his academically (verbally) oriented school education: a creatively unadventurous primary curriculum and a secondary school where in order to do art at A-level you might have to give up chemistry, something which exasperated the teachers of boys such as Blake, who had good academic prospects. But Blake had the fortune to connect with someone through the school, though one who was not actually a teacher, the painter and cartoonist Alfred Jackson. He was married to Blake's Latin teacher, who had shown her husband some of Blake's drawings, and Alf had been impressed. As a result the 13-year-old Blake was invited to spend time with the Jackson family. 'Alf', he says,

would play the violin. He was a small, very sort of bright-eyed man, smoking a pipe, and the ash would drop on your drawings ... I realise now that it was a tutorial actually. He would go through your drawings ... he would talk about Michelangelo or about who was in Punch *that week, or about Modigliani, or someone like that. He took it all perfectly seriously, on the same level, and it was he who said to me, 'Do you ever have any ideas?' I thought, ideas? And what ideas meant was joke ideas ... Because ... that was the strange thing, that drawing was also mixed up with funny things ... as well. When I went to that school, I was friends with two boys and we were a sort of society and I think it was called the 'III', Idiotic Inventions Incorporated. And we had a book that we drew things in, you know, how to make blancmange fingers ... stick your hand in a basin full of blancmange ... I thought I'd better have some of these joke ideas ...* [6]

Jackson suggested that Blake should send some of the joke ideas he did manage to come up with to *Punch*. It was also Jackson who knew that when the drawings Blake sent in were repeatedly returned to him with the art-editor's comment 'sorry, not quite', this was actually a positive response. Such encouragement eventually persuaded the 16-year-old Blake to request a meeting with this person, at the time Russell Brocklebank, which was granted. Brocklebank agreed to publish his work and congratulated Blake 'on being the youngest-ever contributor'. As we have seen, Blake doesn't claim many memories from this period of his life so it is significant that he mentions place (strong emotional memories are so often physically located) when he describes reading the words of the acceptance letter: 'I was standing at the bottom of the stairs at home ... they paid me seven guineas. I didn't have a bank account so when they paid me I didn't know what to do with the cheque.' Blake carried on contributing to *Punch* for years and he recognizes that his time there was an important stage in the development of his style – he remembers that a later *Punch* art-editor Kenneth Bird once told him that his rough drawings were better than his finished ones: after that, Blake says, in paradoxical spirit, he worked very hard to get spontaneity into his final drawings.

Stanley Simmonds was a teacher at Blake's school. He taught him art during his last two years, but, significantly for Blake, was also an artist, 'a real proper painter'. He had studied at the Royal College of Art and recognized Blake's talents, giving him the kind of technical support, advice and familiarity with the work of fine artists that

he needed at the time ('The art-room was really a kind of cultural centre,' remembers Blake). Blake, as we have seen, chose Cambridge rather than art school, and this may have been disappointing to his art teacher: according to the school's biographer, Charles Wells, Simmonds fought hard against one headmaster's 'relentless drive for academic laurels',[6] arguing that art was the most academic subject of all if properly understood. It would not be surprising if Blake also absorbed this thinking at some level, even if he did consider his own cartoon drawings flippant and unserious.

In any case, Blake had found his own answer to his Higher Education quandary:

I had this dilemma which was: did I go to an art school or did I go and read English at university, and I thought, I can sort of remember the logic of it, I thought, if I go to an art school I might stop reading ... but if I go to Cambridge I shan't stop drawing, which is effectively what happened.

Was this the sole logic of his decision to apply to study English at Cambridge? In the early 1950s, an English degree would have led very naturally to a schoolteaching career and perhaps Blake (and his parents) would have preferred a course with a guaranteed job at the end. But it is also true to say that the choice of a literature degree was to provide Blake with a major supporting column for his art: his natural feel for and understanding of text were enriched by the intense and close study of it that his Cambridge degree offered him. This engagement provided him with his acute perspective on how to illustrate text, which moment to illustrate, which moment not to, because the words can do it better.

By the time he did go to Cambridge, Blake had of course already embarked on a career in illustration: he was a published cartoonist, his drawings having appeared sporadically in *Punch* for several years. His reputation had even preceded him in Cambridge: Nicholas Tomalin, a couple of years ahead of Blake, and later a journalist and married to the biographer Clare Tomalin, invited him to draw for the Cambridge journal *Granta*. He did art-edit and illustrate a couple of issues, but Blake isn't sure these drawings were 'very good' and when he was at Cambridge he seems to have kept his drawing self largely hidden. 'We didn't know he drew, he never talked about it,' two of his contemporaries, Jean Gooder and Ann Newton told me. Perhaps Blake was unsure about how the humorous, light-hearted drawings he was producing at the time would be viewed:

I think I thought that going to Downing was a bit like going to a monastery or something, because things were taken seriously, to a disadvantage, the atmosphere invited you to take things seriously [and] the drawings I was doing in Punch *weren't at all [serious]; it wasn't hard to feel embarrassed about them because they were small and superficial ... I thought they would think they were frivolous.*

(The tables were turned 60 years later though. In 2012 he was invited to speak to an international Leavis conference at Downing; his interviewer, Downing Fellow the

Reverend Bruce Kinsey, told me that he thought that most of the Fellows were 'totally in awe' of Blake, and shy even of asking questions . . .)

Blake carried on with these 'superficial' efforts, anyway. He seems to have had a strong sense even at this time of how his own particular learning-style worked: he started with simple cartoons and magazine vignettes and, because he was strongly self-critical as well as able to take criticism from others, he learned how to make them better. At the same time he was also clearly ambitious to develop his drawing skills. He began to take life classes at the Cambridge School of Art (now part of Anglia Ruskin University). Life-drawing was the one element of artistic training that Blake undertook semi-formally and its effects are key to the way his art works, a continuing theme in other chapters. Life classes have been almost the only drawing situations in which Blake has worked from a living model. Until well into the twentieth century life-drawing, from nude models and, before that, the plaster cast, was the beating heart of an artist's training. At its most effective it developed in the learning draughtsman the ability to represent a subject which is both the best-known image but at the same time the most complex to represent: the lines of a human body change direction myriad times, its proportions are always unexpected, and the subtleties of skin, hair and eye textures are endlessly elusive. These Cambridge classes, and, more importantly, those he later took at the Chelsea School of Art, gave him a fundamental understanding of the way the body is constructed and operates. Armed with this he was free to work away from the model, as we shall see later, allowing his figures to emerge fully formed from his imagination.

Blake's literary imagination was of course also being stimulated by seminars with Leavis, and to a lesser extent the teaching of another tutor, Harold Mason ('you felt it was a privilege to be there'), even if he had reservations about Leavis's teaching style: 'in a sense he was telling you the answers; I don't think he was interested in the rest of us (who weren't going to be literary critics); there was no interchange as far as I was concerned'. What he did get was the close critical engagement with the work of the Leavis pantheon such as T. S. Eliot and D. H. Lawrence. The intense reading involved in these studies must have had an effect on Blake, but in fact Leavis did not introduce Blake to Dickens, the novelist no doubt most relevant to his future work. In the 1950s there was only one work of Dickens, *Hard Times*, that Leavis thought worthy of close attention. Blake comments:

there is a great chapter about it in [Leavis's] The Great Tradition, *but everything else is effectively marginalized. It wasn't until 1972 that the Leavises [F. R. and his wife Queenie] together published* Dickens the Novelist, *which makes elevated and well-argued claims for his genius. Leavis's stance tended to be that of putting the less perceptive to right, so that perhaps it was a little strange that he didn't explain what had kept him so long, since by then Dickens in general was being taken seriously by many. There is even a chapter by Queenie about the illustrators of Dickens; extremely interesting even if she perhaps didn't feel herself ready or perhaps wasn't able to discriminate the particular genius of Cruikshank.*

F. R. Leavis in Cambridge

Here Blake demonstrates his own deep familiarity with Dickens' illustrators: Phiz (Hablot Knight Browne) working in the traditions of Gillray and Rowlandson and then Cruikshank, and he had already encountered them before going to Cambridge. It is understandable how the work that Dickens' illustrators were doing for his texts might have appealed to Blake. Blake shares with Dickens a sense of character and situation, which is based on intense observation, and it's here that he finds the contingent humour, pathos or tragedy. The capacity of illustration to dramatize or stage narrative on the page is what Blake himself claims for the art, and what most people recognize in his own work.

After Cambridge, the Institute of Education and the Lycée, Blake was getting enough work illustrating books and magazines to be able to leave schoolteaching behind. the *Spectator*, the *Listener* (the BBC's weekly magazine, which appeared between 1929 and 1991), *New Society*, and covers for Penguin books, including the novels of Evelyn Waugh, Kingsley Amis and Malcolm Bradbury, these were all vehicles for his emerging illustration skills.

But the great variety of demands made by these commissions – he had to imagine and then draw subjects ranging from the Nuremberg War Trials to Lolita – made him anxious to refine the skills he had begun to develop at the Cambridge life-drawing classes. He had come across the work of artist and illustrator Brian Robb (1913–79), initially through his copy of Sterne's *Tristram Shandy*, which Robb had illustrated, and Robb, then a tutor at Chelsea College of Art, agreed to meet Blake and look at his work. Robb must have seen that Blake understood how illustration worked by this

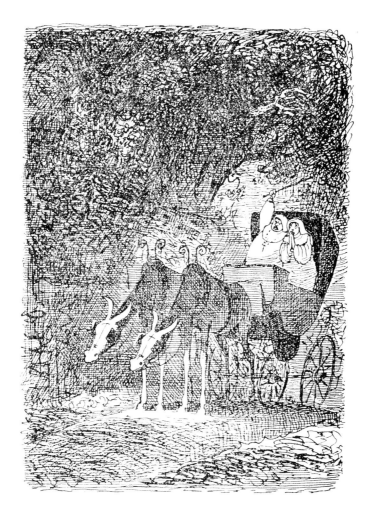

Illustration by Brian Robb from *Tristram Shandy*

time so didn't need to invite him to join his illustration classes. But, instead, Blake asked whether he might continue with life classes there, which Robb happily agreed to, and a couple of days a week for 18 months, Blake was to be found in the life studio, painting as well as drawing and making lithographs. Although, as Blake says, most drawings produced in the life class are 'neither good nor attractive looking'[8] and are not finished works, he feels that the exercise taught him above all that he could also work away from the model. He describes going home after life class and inventing 'some more life-drawings (and oil paintings) from memory'.[9] These were of two kinds – a type of pen-and-ink drawing that show Blake's enthusiasm for Picasso at the time, and much larger oil paintings executed with decorators' paintbrushes.

Blake seems to have a close relationship with these drawings and paintings from the 1960s.

They do contain several persistent and key elements of his work: the sure but free, scratchy lines, the emotional rather than naturalistic use of colour, and, above all, a sense of narrative created by small but articulating details. In this image the model poses, poised; but, at the same time, her attention (and so, ours too) is claimed by the two purple birds, fluttering in the right-hand corner. It's the slight turn of the model's head, immediately legible from the scantest of pen-strokes, and the splash of purple, which miraculously ask us to become involved: we understand in a second that sitting still is demanding and imprisoning, while the birds are delightfully free. It is clear, then, that setting up a situation was something that Blake was naturally drawn to, even at this early stage in his career.

Brian Robb had led Blake to these classes; this mild, pipe-smoking man with a waistcoat and bow-tie was not obviously heroic, but his opinions seem to have defied his appearance and he does seem to have been a kind of hero for Blake.

Says Blake,

Brian was most immediately and evidently a gentleman, and so he was. [This is what most people also say about Blake.] *But not only that, it was no doubt easy for some to imagine that he had the limitations that went with the suit. He had taught with Graham Sutherland, Henry Moore, Ceri Richards, Prunella Clough, and was a member of the London Group. Perhaps it is better simply to record one or two moments that have stayed with me: we were looking at portfolios before [RCA] entrance exam interviews, and in the young woman's*

*portfolio [there were] drawings of mid-air crashes, people falling out of aeroplanes and (do
I remember this right?) also a photo of male genitals. We liked the work and even we must
have been a little doubtful of Brian's reactions; we turned to him for his comment: 'Possibly
the most gifted student we have ever interviewed.'*

*On one occasion, when he was shown some illustrations by the Quay twins to the
Marquis de Sade, quite sufficiently explicit, with the enquiry 'What do you think of these?'
(This was in connection with* Ark, *the RCA magazine, and the question clearly meant:
'Can we print them?') Brian looked at them for a moment. 'Charming drawings, charming
drawings.' He was answering an art question.*

Blake's discovery of Robb as a person he could learn from is one demonstration
of Blake's wide-ranging intelligence: one side of it is exemplified by what he calls
'the instinct to do the right thing'.[9] This seems to be based on a good degree of
self-awareness combined with an unflinching sense of purpose; he knows how to
analyse the proposition in front of him, looking both at its intrinsic value and at
how it might serve his own project, and he often does this with rapid certainty.
Robb's career showed Blake how his own skills might develop, how illustration can
live a fruitful and symbiotic life with fine art, and this has become one of Blake's
principal concerns over the years. The teaching opportunity that Robb offered
Blake also provided him with a beneficial learning process for himself as well as for
his students.

Teaching

Teaching in (and out of) the classroom

Before Blake embarked on his teaching career at the Royal College of Art, he had
already tried out schoolteaching. Blake feels that his short spell as a schoolteacher was
not a significant stage in his life. He did not especially enjoy his teacher-training year
at the Institute of Education (1956–7), finding the experience 'disappointing' in the
sense that the ideas he met there were not at all new to him. He acknowledges that
his tutors at the Institute were strong and influential: they included James Britton,
Nancy Martin and Frank Whitehead, and he remembers that Harold Rosen was also
around (father of author and Blake-collaborator Michael Rosen). These tutors were in
the vanguard of post-war secondary English teaching, whose ideas about curriculum
were that it should start with the experience and culture of the learners, that language
was the means by which meaning is constructed, and that effective learning is
a collaboration between teacher and learner, and between learner and learner –
principles that Blake certainly did adopt in his own teaching.

Perhaps Blake felt that he wasn't learning anything new at the Institute, because
he had already experienced such teaching at school and at Cambridge: in the same
way that the four-year-old Blake had a sense of what made a good drawing through
comparing the drawings in *Chicks' Own Annual*, he knew what successful teaching
looked like (and what it didn't look like) through observing his own teachers. At
Cambridge he had found Harold Mason's way of fostering intellectual appetite, and

his interest in engaging with students' ideas, a more effective model than Leavis's monologue seminars. He remembers Mason saying to him: 'You got in by knowing nothing' – I hope what he meant was that I didn't get in by knowing the answers.' This sense of learners being able to find answers for themselves, sometimes by unconventional routes, marks his own intellectual history strongly and is perhaps one of the reasons why teaching a rigid curriculum in a school setting was not, in the end, for him. At this young age he understood the theory that the educationist Sir Ken Robinson was later to describe, first in his 2006 TED talk 'How Schools Kill Creativity', and later in his book *Creative Schools: Revolutionizing Education from the Ground Up* [11]: 'We're all born with immense natural talents, but by the time we've been through education far too many of us have lost touch with them.'

Blake found the teaching practice in the Eltham (South London) school he was first assigned to 'difficult' and claims 'not to have been very good at it'. Certainly he would not have been interested in or good at the authoritarian behaviour typical of many of his contemporaries and which guaranteed a relatively trouble-free classroom existence. By the time he did start to teach English at the Lycée, which he only did part-time, for a year (1964), he had already made the decision to 'draw for a living': in fact, while still at the Institute of Education he had been offered a job as assistant art-editor at *Punch*. He turned this down, because, with his usual self-awareness, he was sure he did not want to be exclusively associated with one publication and that a freelance career as a book illustrator was already beckoning. The schoolteaching was, he says only a steady back-up income which would allow him to do the illustration work in which he was more interested.

However, as we have already seen in the *Julius Caesar* memories of Gilles Dattas, the evidence of some of his Lycée students suggests that for them he had more talent than he himself remembers. Several speak of a teacher who stood out from his colleagues, who were working within a very formal French school curriculum. Julia Stanton remembers:

In those days Lycée teaching was all dogma and recitation, even at the youngest ages. We sat at our desks all day and listened to the teacher, did dictée *after* dictée*, and learnt by heart all the little boxes in the textbooks. It was a very classical education; we learnt from our literary elders and betters, and we absorbed their lessons as* 'idées reçues'*. Imagine then the amazement of our first class with Blake. He sat and read a short story (or perhaps a passage from a book?) by D. H. Lawrence, one in which a coal miner dies in the pit, and the wife is left to contemplate his lifeless body. He then asked us what our thoughts were about the piece he had read. Our thoughts? Our feelings? This was a whole new concept to me at the time, because I had been taught very categorically what to think and feel for the last eleven years, especially at school, and no-one, but no-one, had ever asked the students about their perspective on anything.*

Charles Beauchamp, an artist specializing in carnival arts and self-confessed school idler, has memories of a teacher with a sense of performance:

He certainly made a mark on me as an individual and his way of teaching was unorthodox and most welcome because the Lycée was extremely academic in many ways ... anything in the creative field ... was slightly frowned on ... there was always this element, 'what's Mr Blake going to do next?' Once he made a dunce's hat; it was just a simple cone but he'd decorated it and he decided he was going to use it in our class. We were supposed to have revised ... but if you hadn't, he'd ask you to come up, and he would say he felt that the hat 'would suit you on this occasion' ... but it was done in such a humorous way, it actually helped to make a better atmosphere ... these were real surprises ... you never knew what was coming.

Are there perhaps distant little echoes of the decorated dunce's hat in Beauchamp's own playful carnival costumes and props?

Teaching at College

School teaching was not in the end a route for Blake, but his links with education began to strengthen in other ways. His connection with Brian Robb had a second important outcome: Robb had in 1962 joined the staff of the Royal College of Art, replacing Edward Ardizzone who had taught lithography, which was in those days based alongside illustration in the Department of Print Making. Needing extra help in what was a small but new and expanding Department of Illustration within the School of Graphic Design, he first asked Blake to set a project with his students. At the end of the project Blake gave what was known as a 'crit', an appraisal of each student's work in front of the rest of the class, after which Robb invited Blake back to his office, and on the spot invited him to join the staff as a part-time tutor. Blake recalls his reactions: 'I didn't know what that was ... I didn't know anything about teaching in art school ... but I thought for about five seconds and said yes'.

So, indirectly, Blake became a teacher at the RCA because of a sense of needing to learn more – it was by chance rather than design that he ended up as Head of the Illustration course there. At the time there was, of course, no teacher-training for Higher Education so Blake would certainly not have been the only untutored tutor. He does have as keen a sense of his limitations as of his strengths and his comment sheds light on his decision-making process: he knew that it would be the right course to take, even though he knew he didn't have skills he believed must be necessary. It is also indicative of something many colleagues and friends mention: a kind of courage that Blake has when facing situations outside his experience; a willingness to face the unknown, including the feared unknown.

The RCA in the mid-1960s must have been a curiously disjointed place: the old, predominantly male guard still in place, but confronted with a demographically and gender-mixed student body fired up with the counter-culture. As the design critic Rick Poynor puts it, the Department of Graphic Design, as it was then called, still bore many traces of its 1948 origins:

*In the early days, under Guyatt [Richard], the department was still working out what
graphic design education should be in the post-war era. Guyatt and his staff brought
a strong pre-war illustrative, fine art tradition to their teaching. They could all draw
beautifully and had great technical skills, but when you compare their bookish work … to
hard-edged continental modernism, it might have looked rather twee. Good as it was, it
wasn't work that reflected the urgent conditions of the contemporary world.[12]*

Robb belonged squarely to this bookish world and Blake was his protégé. As
we have seen, by now Blake had, along with most of his fellow RCA tutors, his own
established career. He had illustrated several books including a few for children. He
had developed his own characteristic drawing-handwriting and already had a deep
understanding of the way text relates to imagery on the printed page. But he was
coming up against confident postgraduate students, often with four years of art-
school experience behind them. Many had different artistic goals to his; they worked
in varied media including photography, and some did not even describe themselves
as illustrators. As a part-time student at Chelsea, Blake had perhaps encountered
something of the art-school atmosphere; he made friends with John Flemons, then
vice-president of the student union, who gave good parties and invited Blake to draw
the cover of a theatre programme. But at the RCA Blake was, artistically speaking,
relatively unconnected to the students he first taught. As he says:

*I anticipated my arrival at the RCA with a drawing of myself in a letter to my brother. I
think I was saying: 'Now have you all sharpened your pencils nicely?' And the spirit of it
wasn't entirely distant from the truth. Certainly the young men who were in the middle of
their course were mostly very assured in the fashionable illustration of pop-art exemplified
by Alan Aldridge, who took over the design of Penguin covers at the time. Among them
were Adrian George and Philip Castle, who had already assumed the nom de plume of
Marvin Rainbow and was by then carrying out a good deal of commercial work. They
were all perfectly polite but I don't imagine that I would have had much to say that would
seem important to them.*

For these and perhaps also some social reasons, the first year of teaching such
students must have been something of a challenge: the artist Linda Kitson, who
arrived in Blake's second year, says that some of these people did make him feel
'very ill at ease, he didn't really know what he was doing'. And as Blake admits,
'You plunged about a bit … I knew something about education but most of it
didn't apply.'
Somehow, with an element of bravery, Blake passed through this experience
and remained undamaged by it. Although he was the teacher, his own survival and,
soon afterwards, his true flourishing, came from his ability to keep learning. He had
to learn to interact with the foreign bodies that these students were; he had to, and
did, learn about their artistic (and general) world-views, and he probably learned
that his best teaching tool was himself and his sound judgement: his unthreatening

personality, his acute feeling for literature and for the literary, not to mention his drawing skills, by this time fluent and sure – all these earned him respect, even from students whose work could not have been more different from his. Dan Fern, who also arrived at the RCA in Blake's second year and was eventually to succeed him as Head of Department, remembers Blake as 'feeling his way' with these, to him, 'different' students. He recalls how several of the students had difficulty in connecting their own styles with the work of a cartoonist: 'It wasn't to be honest the sort of work that any of us related to; we were cool, hip, wanting to be fashionable and he was very much in the mainstream.'

Nevertheless Fern and a small group of students seem to have been able to see through to the person behind the style, and there they met another kind of education. These recollections from ex-students, now either practising artist/illustrators or artists, or teachers of those subjects, are illuminating. From a distance of 20–30 years they are able to pinpoint the difference that one teacher made to their subsequent working lives, and to identify some of the key qualities of all truly successful teaching.

In Dan Fern's words:

Quentin was my tutor and a couple of times I'd been round to his flat . . . so that already said something about his approach to teaching – this was the first time I'd been invited round to a tutor's house . . . it was the first home I'd been in that belonged to someone really cultured . . . the books, the prints on the walls, the original paintings, the rugs on the floors . . . I remember thinking this was wonderful . . . and this was the first time I'd drunk wine and so everything was strange and a bit exotic . . . Of course Quentin made us feel completely at home . . . and the sharing of his private life with his teaching was impressive, and later on when I was teaching that was something to pick up on.

Fern adds:

Teaching isn't just about handing on information, it's about setting an example in all sorts of other ways . . . it's difficult to say precisely what I learned from him, perhaps it was just gentle steerage and guidance. I can't remember him (Blake) saying any specific thing, which made me think, Oh I've got to do it that way. I thought at the time that I wanted to illustrate children's books, you know, big and attractive picture-books. In ways that I can't quite describe, he steered me gently away from that; he didn't feel that was right for me and it wasn't.

By the time Russell Mills, a multi-media artist, arrived for his RCA interview in 1974, we meet a Blake who has really found his teaching voice. The interview took place in the Henry Cole Wing of what is now the Victoria and Albert Museum, where the Illustration Department was then located. The interview panel was a large one and included Blake:

The one thing that really struck me during that interview was Quentin Blake; they'd asked me lots of questions and they said, 'What do you want here?' and I said I just want to carry

on doing what I'm doing, just exploring ideas and making lots of mistakes, and Quentin Blake said, 'Well if we accept you we'll allow you to do whatever you want and we'll enable you to do it better' and I thought, well, that's all I can ask for.

However, having been accepted, Mills arrived at the RCA to find that Blake was to be his personal tutor: 'I was really angry because I was an angry young man, this was just before punk and I was rebellious, into Dada . . . and I'd been given this children's book illustrator!' Mills soon changed his mind:

At the first meeting we cleared that up. We immediately connected and I think it was because he'd been to Cambridge to study English . . . the starting point for all our conversations usually came out of some aspect of that, of literature, because I was pretty well read . . . the authors I really liked, Quentin really liked as well, funny ones like Cervantes, Rabelais, (Sterne's) Tristram Shandy, and I was able to talk to him about things he maybe knew less about like Beckett, Alfred Jarry and that more Surrealist stuff . . . It was a cultural exchange that always went on between us . . . his way of teaching was usually by asides, they were usually very subtle and they didn't sink in till later . . . that's what made him such a good teacher I think. He would listen and listen and listen and then he'd respond in a way that was tangential, that would knock you sideways . . . and it would be exactly the right thing to say . . . I was getting work before I left the college, and the phone would ring and it was a publisher looking for work and they were asking for me and Quentin would say, 'Fantastic but don't do it' and I'd say, 'Why not?, and he said, 'You're not ready, if you go out with your work as it is now, you'll just be asked to do more of the same, over and over again, do you want to do that?' And I said no, and I've definitely never wanted to be like that, to be stuck or constrained by anything. He put it into words for me. He often did that.

This is confirmed by the illustrator Steven Appleby, who wrote in a review of Blake's book *Words and Pictures*: 'Quentin was my personal tutor and I have never forgotten the subtlety, tact and thoughtfulness with which he talked to me about my work, always treating me as if we were equals . . .' [13]

Another ex-student, Jane Stanton, remembers:

Quentin Blake was a very enabling person; that was his teaching style. Although they might have sometimes seemed quite frivolous, in some of the events we were involved with there was always a deep-seated learning thing . . . Going to Sissinghurst, I didn't know anything about Bloomsbury, and Quentin would engage people about the historical side, literature meets history meets culture meets painting.

Embedded in some of these interviews with past students is also an awareness that they too had contributed to Blake's successful career at the RCA. Looking back, they see that they were offering him an art-student experience he hadn't really had, as well as a connection to their own cultures, not always familiar to Blake. They taught him the importance of a working life 'in common', the necessary counterpart of the

solitary one in the studio; as Dan Fern puts it: 'The life of an artist is something that's shareable and should be shared'.

A shared world was certainly what prompted Blake to agree to contribute to a (very) short-lived student journal called *The Geek* in 1977. The cover describes it as Volume 4, number 8, although, as Blake says, there was only ever one issue. This slim black-and-white publication is of interest because it is a neat illustration of the diversity of techniques and styles with which Blake's students confronted him, from the reportage drawings of and a poem about cardiac surgery by Anne Howeson, to Russell Mill's assemblage piece called 'De Selby Footnotes' (which illustrates an esoteric fictional character which is referenced in a postmodern novel *The Third Policeman* by the Irish author, Flann O'Brien).

Blake's own contribution, 'Other Worlds', is a selection of hand-written and illustrated extracts from two works by Cyrano de Bergerac: *Voyage to the Moon* and *Comical History of the States and Empires of the Sun*. Operating in a different sphere from those of his students, who were all more influenced by a Modernist aesthetic, Blake's piece is also notable in his own story because it was the first time that he illustrated the works that were eventually to appear in the Folio Society edition nearly twenty years later – these being the books he says he most wanted to illustrate.

Illustrations from *The Geek* by Anne Howeson and Quentin Blake

Outside the curriculum

This experience of teaching points towards several truths, the first of which is corroborated by many other ex-students: that the curriculum that Blake learned to deliver was not primarily skills-based. As a postgraduate institution the RCA was of course taking on students who had in theory already 'learned the grammar', although according to Sir Christopher Frayling (who taught humanities at the RCA alongside Blake in the 1970s and was later to become Rector), this was by no means always the case. The 1970s were of course also, notoriously, the great era of non-teaching, when students were squirrelled away in womb-like studio spaces, visited occasionally, many remember, by tutors on breaks from their drinking duties in local pubs. Frayling recalls a student complaining to him that his tutor's sole communication with him that year was the five-word sentence, 'Can I have a light?'

But Blake would have certainly had drawing skills to offer, and he already knew a great deal about how to make the relationship between text and image sing most sweetly on the page. By 1978, when he was appointed Head of Illustration, he was also able to pass on valuable information about illustration as a profession, such as, for example, how to negotiate with publishers. Ex-student and now prize-winning illustrator Emma Chichester Clark says that two of the most important things he taught her were 'to say the words: a thousand pounds' and 'to do roughs', the bit of technique which Blake felt would make a big difference to her production. Blake is also remembered as the professional who generously offered his students professional opportunities. On top of all his other commitments he was what today

might be called an employability manager. Ann Howeson, an artist and RCA tutor, remembers: 'He asked me to be involved in a real project. He asked me to paint a caravan with him, for Puffin . . . I don't think he was so famous then, but it was the fact that he asked me . . . that felt like a vote of confidence.'

But what most struck Frayling as a teaching colleague was Blake's (to him) free-spirited teaching style, a style from which he also learned:

I co-taught with him a session on a magazine . . . it was called Ebony, *and it was for black readers and it was quite before its time when you think it was 1972, and we simply held up the magazine together, stood in front of all the Graphic Arts students and went through it, page by page, looking at the typography . . . the photographs . . . the illustrations, and doing what Quentin used to call 'thinking on the wing about it', which was sort of riffing really.*

Blake, according to Frayling, was uninterested in teaching theory separated from the practical; he was a 'what if? Let's imagine . . .' kind of person, and it was this more whimsical, lateral approach to the subject, delivered in his 'quiet, ruminative way' that seemed to hold the students. Ann Howeson shares this view: describing Blake's occasional recent visits to her teaching seminars, she says, 'It's the intimacy again, he makes everything seem possible, when he talks, he goes into anecdote and it feels like a conversation.'

So, seen from both his colleagues' and his students' perspectives, what Blake taught both groups was far bigger and more enduring than how to do illustration. Instead it was the product of a kind of dawning understanding that what he most had to offer was his own cultural knowledge and professional experience filtered through a light-hearted, wise and empathetic world-view. Included in the Blake package was a profound understanding of the relationship between image and text and a sense of history, which, for these students immersed in the contemporary world of the 1960s and 70s, perhaps seemed novel, even a little thrilling. He learned that this proposition would be most useful to those students who realized how they might apply it to their own personal projects, however much these might differ from Blake's own one. And out of this came the ability shrewdly to evaluate students' individual artistic voices, and to help them identify the form in which they would best be heard; lastly, he understood, as all great teachers do, that it was the whole of his person that was the pedagogical instrument, rather than someone else's theory or methodology; the combination of his expertise (his licence to teach) with his capacity to see where his students were heading, and an appreciation that exhortation or correctives were more effectively delivered through quietly indirect asides than through confrontation or head-on address.

Beyond the school curriculum

This is a consistent theme. In one unbroken leap we can leave an RCA studio in 1974 where a couple of long-haired, album-cover designing students are listening to Blake talking about humour in Rabelais, and arrive – the year is now 2000 – in a theatre in

south-west France where 400 excited primary school children are watching Blake draw characters from much-loved Roald Dahl books. This is learning outside the classroom, and Blake, by this time the world-famous author or illustrator of over two hundred and fifty children's books, with a house in France, has a well-formed disposition to be involved in this kind of education. These projects that he was involved with provide really rich evidence of his quietly playful engagement with young audiences and teachers, and how he was himself discovering more about the learning process as well as offering the audiences unforgettable experiences.

Here he is, then, in the middle of a two-hour session in which he uses a visualizer. All 400 children can thus watch (and hear) every stroke of the fat marker pen, which squeaks across the paper and brings to life the ghastly and fascinating Mr Twit, the very Dahlian anti-hero of *The Twits*. Mr Twit's signifying feature is a repulsively unkempt beard, teeming with trapped food. Blake doesn't start with the beard though, instead he draws an eye and immediately has the children guessing the identity of the emerging drawing. This demonstration of active learning was particularly appreciated by one of the teachers present, who was also responsible for inviting Blake to France as part of a wide-ranging children's literature project. Pascal Bourgignon remembers thinking that this was real teaching – a combination of the theatrical (darkened theatre with a single figure on the stage), the slightly magical (a disembodied hand producing something recognizable out of a few lines) and the familiar (Mr Twit). All of this, he says, 'reactivates their (pleasurable) memory and knowledge of the book, and at the same shows them the importance of typical detail in the creation of character, whether visual or literary'. And all without using a single word.

The project in question was an ambitious one which came to be called *Un bateau dans le ciel* (A Sailing Boat in the Sky), of which more later. The idea for Bateau had actually come out of a relationship Blake had already formed some years previously with Rochefort public library, whose librarian had invited him to create an event there. Blake was to draw the contours of a large dragon to which children would add their own details. A local primary-school teacher, Jean-Marc Sandeau, was asked to bring his class of 6-year-olds to the event and to prepare them for it by exploring picture-books by Blake. Like all good teachers, Sandeau is always eager to seize opportunities for his students. In his words: 'I thought it was a shame there was only this dragon, and I got the library to invite him into my class.'

Sandeau and his partner Annie Simon, as well as Geneviève Roy, were all teachers who were using the revolutionary method, for France at that time of using 'real books' (as opposed to reading schemes) in the teaching of reading. The 'real books' movement had been widespread in England in the 1980s but was relatively new in France (one of its main proponents, the teacher Marie-Joëlle Bouchard, was writing in the 1990s). Sandeau constructed an ambitious project in which he and his class created their own 'Quentin Blake book' using characters from many of Blake's albums, who then appeared in an original story. This culminated in Blake's visit to the school when he was presented with the book (the library had produced a few bound

copies available to readers). Sandeau particularly remembers Blake's response: 'He realized that this book meant a lot to the children and he spent at least two minutes (a long time!) reading it. He read it, he laughed, he could have thought it was just children's work, but he was really respectful.' Sandeau's colleague Annie Simon elaborates:

He doesn't have a lot of experience of children but children are always appearing in his books, and he knows them, sometimes better than parents who have had ten of them in their own family! He sees every aspect, he's always observing and listening and so he has empathy, which is also so important in his books.

The other part of the project involved the school dinner-ladies creating a lunch based on Dahl's *Revolting Recipes* (which the children had been working on) in a local social centre. Blake entered into the spirit, trying the doubtful-looking dishes and staying at the school until beyond the end of the school day.

This was a true two-way creative relationship: Blake's books sparking off brave, imaginative and diverse school projects which gave him the kind of illuminating feedback about the afterlife of books that most authors welcome.

Perhaps it was this experience that prompted Blake to accept the ambitious idea of a collaboration between himself, the teachers from the Charente-Maritime, and what turned out to be 1,800 French-speaking schoolchildren from around the world. Its end-product would be a children's book, later given the title *Un bateau dans le ciel* by its publisher, Alain Serres , in which Blake would illustrate a text derived from children's ideas on the chosen theme of '*l'humanisme*'. Blake remembers that for five seconds he inwardly questioned the notion of such a philosophical theme for a book for 8-year-olds, but he was soon informed that it was actually to be a book encouraging humanitarian values in the face of current problems such as racism, bullying and pollution. He remembers the rewarding sense of having helped to create something with schools, but whose effects went well beyond the walls of the classroom.

The success of the project was later celebrated in Rochefort and La Rochelle by a series of yet more inventive events culminating in a spectacular parade in honour of Blake, again created by Jean-Marc Sandeau and his Rochefort colleagues. This took place in a space which forms a magical natural stage opposite Rochefort's seventeenth-century Royal Rope Factory.

In a marvellous, mixed-age extravaganza, children appeared as Blake characters such as Mrs Armitage, some carrying joyously coloured cockatoos from the book of the same name. Yet others tossed up into the air wonderful floppy clown puppets (after Blake's own favourite among his books, the textless *Clown*) which appeared above the wall as if by magic. The fact that Blake still keeps one of these puppets at his home in France says a lot about what this day meant to him, and several people who were there describe being moved to tears by this public homage. The occasion was, to be sure, a celebration of Blake's art, which had inspired the work in the first place,

but also of his presence, the generous amount of time he gave to the project, and the permission he had de facto given to French teachers to knock down the fences of their rigid curriculum.

I also saw tears, including on Blake's own face (a rare public occurrence) at the final event in La Rochelle. This was yet another transcription, this time of *Bateau dans le ciel*, which became a piece of musical theatre, performed by many of the local children who had helped create the book. This setting free of a book from its pages, like the flying boat that is its subject, was for him a moving recognition of how his work can unleash creative power in others. And the emotion of the day was crowned when, at the end of the performance, a six-year-old boy, on being told that Quentin Blake would be appearing on the stage, gasped, 'Quoi? Le vrai Quentin Blake?' (What? The *real* Quentin Blake?)

The real Quentin Blake has also appeared countless times in British schools – in his eighties he is still an active contributor to the life of his local primary school, Bousfield, attending the annual leavers' assembly and regularly donating works and books. During his tenure of the Laureateship he realized he would have to curtail these visits since the demand would have filled his diary every day of the week. But being Laureate gave him the platform from which he could promote his views on the value of children's books as tools for learning of all kinds: British children's books are, he said, 'among the world's best . . . books are primers in the development of the emotional, moral and imaginative life – a celebration of what it is like to be a human being'. The page in the issue of the *Times Educational Supplement* of 14 May 1999, from which this quote is taken, had two tellingly juxtaposed headlines: the one on the article about the new Laureate titled 'Drawing on the wealth of experience' was accompanied by a photo of Blake reading one of his books with a group of children,

who are poring over the pages. The other headline read 'Heads fear they will miss their targets' and dealt with a survey of primary-school head teachers, which revealed their anxiety about meeting the national targets set for literacy and numeracy. Without venturing into the territory of the wrongs and rights of education policy since 1989, this seemed a neatly expressive binary – the idea that education can be definitively measured versus the notion of the often unpredictable and ungraspable way in which children actually learn.

Quentin Blake is the latter kind of learner/teacher. Perhaps there is not such a distance between the five-year-old Blake pondering the quality of the drawings in *Chicks' Own Annual* and the 70-year-old artist who has watched and unconsciously committed to memory the hunched pose of a sad person, and who draws it, months or years later, in *Michael Rosen's Sad Book* and tells us something about ourselves; or the man who illustrated Voltaire, a literary French author, and built a bridge to him for English readers; or the person who invented Mr. Magnolia to teach very young children to count. This is learning and teaching dissolving into each other.

Despite his own relatively privileged and formal education, in the end it does seem that it is Blake himself who has probably been his own most effective teacher. He clearly always realized what he needed to know when it came close to him. He is a learner who grabs with great certainty at the passing opportunities; in this respect he is, to use the poet Keats's terminology, more like the flower than the honey bee: 'Let us not therefore go hurrying about and collecting honey, bee-like, buzzing here and there impatiently from a knowledge of what is to be arrived at: but let us open our leaves like a flower and be passive and receptive'.[14] He receives these things and simmers them (he would probably use the French word '*mijoter*' for this) and offers them to his audiences in the works which so closely represent his person.

As for those he has taught, they are now far more numerous than the handful of Lycée pupils and the few hundred RCA and other Higher Education students – they are every one of his readers and gallery visitors. As the teacher Annie Simon said to me, with deep understanding of the powerful work that the best teachers of all kinds are capable of doing: 'I think if you took all of Quentin Blake's books you could solve every problem in the world with them.'

Lending his name

There is a nice coda to this story of Blake's life in learning and teaching:

On 24 October 2002, the weather in Berlin was cheerful – Kyle, a storm-system, was beginning to drift away northwards, to be replaced by a small area of high pressure ('*ein kleines Hoch*') called Quentin.

This was the same moment when another benign Quentin, Blake, appeared in Berlin, although the affected area was limited to a primary school in the southern suburb of Dahlem. The occasion was a big one for the school, though: a new 'State Europe School' had been opened, where teaching is bilingual, in English and German, and it was celebrating its naming day. Part of an ambitious project to create bilingual schools after the fall of the Berlin Wall, this one had been affiliated to a state primary, the Erich-Kästner School, named after the best-selling author of *Emil and the Detectives*. Now it had a new site and needed a name with a more Anglophone connection. Keeping the children's author link seemed to be sensible (although, like Blake, Kästner in fact wrote for adults, including a wonderful book of poetry to cure every condition, *Doktor Erich Kästners lyrische Hausapotheke – Doctor Erich Kästner's Lyric Medicine Chest*), and the name would be decided democratically by all the staff and children of the school, voting for their favourite author writing in English. This turned out to be Quentin Blake and he was a good choice for many reasons, first the fact that he was alive (other contenders for the name included Roald Dahl).

It is not a coincidence that four educational institutions or places of learning (so far) have asked Blake to associate his name with theirs. Today most public buildings which bear the name of living people do so because of the large financial contributions they or their family trusts have made to the organization; welcome and necessary as these are, naming opportunities have a high premium, and are readily for

sale. But the Quentin Blake-Grundschule, the Quentin Blake Building at Chislehurst and Sidcup Grammar School, the Bibliothèque Quentin Blake (the newly refurbished children's library at the Institut Français de Londres), and (not a building, but based in a college) the Blake Society at Downing College, Cambridge have all been given the Quentin Blake name because these organizations seem to want to connect with something more than a donation. They understand what the values of Blake's work and his person can bring to places of learning, undidactic and unconnected to official education policy as Blake's stance undoubtedly is.

The Quentin-Blake school on that October day had planned a grand two-part Quentin Blake-fest. It was the kind of shared-experience event that primary school teachers who have some freedom with the curriculum and a lot of imagination can excel at: an occasion with input from everyone to honour Blake but with much reward for the participants as well. It started in the VIP lounge at Tegel airport with a welcome from a crowd of expectant children, dressed as characters from his books, with their parents and teachers. This was followed next day by a naming-ceremony attended by the British Ambassador and various city representatives, at which Blake spoke, planted a tree and presented the school with a drawing of the logo designed by him.

Each class had prepared a performance based on one of Blake's books, including a version of *Mrs Armitage* in which a teacher with a terrifying resemblance to the character pedalled onto the (outdoor) performance space, complete with a Breatspear lookalike dog in the basket.

Theresa Heine, the teacher who led the naming project, remembers:

Quentin's warmth and friendliness, the way he gave everyone his complete attention, from the British Ambassador down to the small child wanting his autograph, was amazing. No other name could have been a better choice and it was with much emotion we bade him farewell. The staff and children had had an extraordinary experience, and although it must have been quite exhausting for Quentin, he remained upbeat and smiling!

It was exhausting, and although Blake would prefer not to fly anywhere, and Germany is not natural territory for him ('You can't sniff it, like you can France or Italy,' he says), out of typical loyalty he has returned to Berlin twice since then, bringing more pictures; each time new generations of children get to know the person behind the name of their school and an archive is added to, which will communicate to future students what the current head teacher Angelika Kuntzsch calls 'the school's "Quentin Blake spirit"'.

This spirit was surely one of the factors that prompted the Institut Français de Londres to propose that their newly refurbished children's library should be given Quentin Blake's name.

The Institut felt that the unique way that Blake promotes literature to young audiences through the medium of illustration, together with his generosity towards the library (described in Part 2) in terms of his time and his art, not to mention the way in which he embodies a strong Franco-British bond, made him an obvious choice for the honour. The Blake name and a Blake artwork will appear at the library in London's South Kensington in late 2015.

The bond between young people and visual art was the motivation behind Chislehurst and Sidcup Grammar School's appropriation of the Blake name. This was, as we know, Blake's secondary school but it no longer occupies the modernist building at Crittall's Corner, which it did in the 1940s and 50s when Blake was there. In the 1960s, after Blake had left, it moved to Hurst Road in Sidcup, serendipitously more or less opposite Blake's childhood home. This location is better suited to a school: it's a generous site, secluded from the unrelenting traffic fumes of the A20 which swirl round Crittall's Corner. It has good sports facilities and many new buildings and is a school which still offers the broad curriculum that Blake enjoyed when he was there. When the time came for a new art and technology building, the then-Head Dr Joe Vitagliano thought that the alumnus whose name belonged most fittingly to the building was Blake. Of course many schools now turn to alumni for support in new capital projects, but in this case the offer came after the building and was unconnected to fundraising. As such it was a way of recognizing Blake's contribution to the wider world rather than just to the school.

Not long afterwards a group of humanities students at Downing College, Cambridge decided to start something called the Blake Society – an arts and humanities society which would connect students with the arts in college through talks and events. They too looked to an inspiring alumnus for a name and he naturally did more than this, and also drew them a logo. The Annual Blake Society Dinner is something Blake makes a point of showing up to, even though it means dusting off his version of a dinner-jacket. Blake says that for the inaugural dinner in 2010 he had mistakenly (and touchingly) believed that undergraduates would no longer feel obliged to dress up in dinner suits and black ties and he turned up in a lime-green cotton number . . .

Blake is clearly always warmly welcomed at these events and, as a Blake Society blogger writing in 2013 about the other famous Downing alumnus called Blake (George, the spy) said: 'He was also (I think) at Downing before Sir Quentin, but perhaps we ended up being named after the better Blake?'

3 Speaking, reading, writing

The French ambassador's gracious residence in Kensington Palace Gardens. A gala fundraising evening is taking place in aid of the new children's library at the Institut Français (in 2014, while England is busy closing libraries, France is still doing the opposite). Black ties, the chef's latest artful canapés, smart French chatter, and the items to be auctioned, a Dior watch, an opportunity to pilot a plane, nice vintage wines, all laid out to raise the temperature of desire and the cash. And then there is Quentin Blake, shuffling to the microphone, managing to make even formal dress look informal, apart from the sharp bow-tie, which, he says, the assistant in the Jermyn Street shop knotted especially for him. In yet another gesture of generosity he has agreed both to speak in the cause of children's libraries (and so inspire donations from the assembled wealthy) and also later to live-draw, and to donate the resulting picture to the auction, all without a fee. It is a rare example of Blake actually using a text to speak from: as I have witnessed many times, his speeches are at once completely worked out and completely freewheeling: 'Friends,' he begins, 'I'm not sure if I'm too nervous or too relaxed, but I know I feel slightly embarrassed because I'm aware that most of what I have to say to you, you will know very well already.' This is a good self-deprecating start which the audience likes. He continues:

'The Storyteller', drawing for 'Life Under Water: A Hastings Celebration',
Jerwood Gallery, 2015

Although a 'bibliotheque de jeunesse' may be relatively small and cheerful it is nevertheless extremely important. It's an amazingly effective implement of education because it invites children to make their own explorations into reading, pursue their own tastes and initiatives – it's like a machine that creates its own energy.

The audience can imagine this Blakean machine – it would be some combination of Mrs Armitage's bicycle with Captain Najork's womble-run – and Blake goes on to talk about the particular benefit which books bring to children, and you feel that he is actually describing his own books:

Roald Dahl describes in Matilda *some of the effect of the wonder of books, the access to new worlds. I think we need to say that they also have – and I feel I want to say this in French – an* aspect philosophique. *They speak of the way people live and by implication how we ought to live. An apparently simple album,* mine de rien *(roughly speaking 'you wouldn't think so' in English), will have some moral dimension, however simple.*

And then, for a few minutes, the drawing. Another of his favourite flying books, which allows him to conclude with, 'I suppose you could call it a "*livre magique*" – but then all books are magic.'

10 pm La Résidence
16 octobre 2014

These words, leavened as always when Blake is in French company by impressively authentic French phrases, are delivered with undemonstrative conviction; the appreciation is warm. The whole speech seemed to be something that came 'directly

from the heart and touched everyone in the room', as one audience member described it to me later.

Quentin Blake is world-famous as an illustrator: his style is recognizable (and widely imitated) and his drawings embody in readers' minds many favourite children's books from several decades. But this chapter is about another Quentin Blake, the man of words, the stylish communicator in speech and text, and the constant and wide-ranging reader, who can also read aloud. This identity seems both to underpin his visual output and to set him apart from many of his fellow illustrators.

Speaking is what we learn to do first with words, and some children do grow up absorbing the speech of their wordy and articulate parents. But Blake was not raised in such a home, nor did he come from a large talkative family; he seems to have been a rather silent boy. Effectively an only child, his brother Ken being 11 years older, he didn't really experience domestic sibling chit-chat; one imagines him as self-contained, with a lively and strong imagination; perhaps a child who didn't need to relate to the people around him all the time. This way of being is sometimes confused with shyness – an adjective which people often attach to Blake, even today; but that word has an adolescent connotation, a fear of ridicule behind it, which I don't think describes him accurately. Reticence may be closer – those who knew him at the RCA say that something like this was in evidence in the early part of his teaching career. But Blake's friend the artist Linda Kitson, a student of his who later taught alongside him, says that things changed quite quickly: 'When you're a teacher, as I was with him, you become very fluent and articulate and interested; being a teacher compels you to be articulate . . . and therefore to live up to the students' expectations.'

And it was not only in the teaching context that Blake found a voice: as Kitson says, early on 'in meetings with Robin Darwin (then RCA Rector) and Brian Robb (Head of Illustration) he never opened his mouth . . . but then at a later date when I was a tutor with him he was brilliant at meetings, never florid, but very much to the point and Brian and Darwin would look at Quentin expectantly for an answer . . .'

By the time he became Head of Department in 1978, this ability to lead people through confident and strong argument was becoming evident: Kitson describes a departmental meeting which took place during the turbulent period of Jocelyn Steven's Rectorship of the RCA, when a proposed restructuring had made the staff anxious and the atmosphere poisonous. Blake had been asked to stand in as Professor of Graphic Design and had to handle all of this:

It was a very contentious moment when a lot of the staff were worried about their jobs and feeling insecure and I remember, as a colleague, one moment when we were waiting in the corridor for a meeting and people were 'stabbing each other in the back'. Quentin led this meeting and at no point was there any room for grumbling, because he took it forwards, through interest in the work at hand . . . The whole thing was on his shoulders, and he just rose above it, and it's interesting that this very, very shy person became the person that people turned towards, to settle (the difficult) issues. He created an atmosphere in which disagreement seemed inappropriate.

Today, in any gathering outside his close circle, or in meetings, Blake is often the last person to speak. It seems to me now, having observed him in many such situations, that this is not because he is reluctant to say something, or to say anything, or to appear too prominent; it is rather that he listens with attention to what others have to say. When he does speak, it is after having taken everything into account: he speaks only when something can be added to the picture. When he does, though, his quiet and un-emphatic responses are always acute; he doesn't flannel, and the room always heeds him.

When he talks to crowds, however, when he is performing on a stage, another Blake emerges: someone who always appears confident and who speaks with knowledge of his audiences as well as of his subject. Whether in a solo talk about his work, a 'drawing talk' where he uses a visualizer and talks a little while drawing, or in interviews or speeches on behalf of other people, he has developed an engaging but low-key and inclusive style which immediately puts audiences at their ease. He knows that there is no ready-made speech which will be right for every one of the great range of national and international audiences he addresses, from the French bankers at the auction, to 400 five- to eleven-year-olds in a Berlin primary school, to the university lecturers and specialists at an F. R. Leavis conference in Cambridge, to the police and young gang members at a community project in Harrow Police Station – his addresses are always about and for the audience as well as himself.

He knows that self-teasing or irony can be a bridge to audiences, as we saw in the speech at the French Ambassador's residence. In 2013, in the vast lecture hall at Anglia Ruskin College in Cambridge, where Blake was addressing several hundred enthusiastic and star-struck illustration students, he started: 'Well, I've just been signing a lot of books and I've probably lost my voice, and all my energy too.' But at the recent launch (October 2014) of *The Five of Us*, Blake's children's book with an underlying theme of disability, he replied to the Tate Publishing Director's superlative-strewn description of him with the words: 'I agree with all of that.'

In his public talks Blake is also a great acknowledger of the role of others in his own success, something that artists working in the collaborative art forms such as theatre, film or opera are used to doing, but which is much more rare with visual artists. And this attitude is reflected in Blake's use of language: he so often avoids the first person singular, preferring the plural 'we', the inclusive 'you' or the distancing 'one'; he almost implies that there is more than one person standing at the light-box in the studio. In the talks he gives, there is also always a stronger focus on the matter-in-hand than on himself; if it's about drawing it will be the what, the why and the how of drawing, rather than any element of autobiography.

Blake is also aware that audiences come to these events with expectations – after all, to many he is not just the face behind his illustrations, but an emblem: a person whose work triggers and embodies important childhood memories: when images such as these appear, large, on a screen in a darkened room, audience-members are carried back directly to early reading experiences, where pictures were such a key part of the enjoyment and understanding of the text. To parents in the audience,

who may also be grandparents now, Blake's talks about his work evoke intimate and precious moments of sharing a book with a child. When adults and children read Blake's works together, the experience is so powerful because, as with all great children's literature, the works so clearly appeal to the child in all of us rather than to children in particular.

Often, readers come up to Blake after these talks, or at book signings, of which he has now done many hundreds – 'It's not the hand that gets tired,' he says, 'but the smile.' Readers come up to the signing table and beam at him: 'You illustrated my childhood!' they say, unaware of how many others in the queue bring him the same message. To such people it is as if Blake has been addressing them personally since they first read his illustrated books.

The symbolic value of Blake's public appearances to this fellowship of readers with a shared affection for his images and words cannot be underestimated. I think

Blake has taken this fact on board relatively recently; it is delightful and still surprising to him and it may be another reason that he approaches these occasions with such a generous spirit.

Lastly, there is a private Blake who is a really fine conversationalist. A man who listens and responds to his interlocutors with a curiosity and interest which is more than polite, but also someone whose own mind is both a great storehouse of commentary and anecdote, and a rapid responder to new situations: from vivid descriptions of an author's or artist's style, to acute observations – 'that baby crying over there is really asking a question to which there is no answer' – and these all framed by expressions which say as much as the words: a small furrowing of the brow, a tiny lip-curl.

Speaking-reading

Quentin Blake sometimes indulges in an activity that is halfway between public performance and private reading: reading aloud. Here he gives the text a new life off the page, just as Dickens did so successfully in the nineteenth century and as many thousands of authors do at literary festivals and bookshops up and down the country today. The difference, though, is that these authors read and so promote their own words in public, while Blake reads other people's texts, to an audience of one, in the intimacy of a sitting room. Works by Arnold Bennett, E. F. Benson, Willa Cather, Evelyn Waugh, all reappear animated by Blake's intelligent reading style. He is so good at it for at least two reasons: first, like Dickens, he has acted, with enjoyment, as we have seen in the chapter on teaching. Second, as we have also seen, drama is incorporated into Blake's illustration work; his books are 'stagings' in which he himself 'plays all the roles, and directs and produces as well'. Normally when he reads aloud, there is only one listener, but this number was recently multiplied when Puffin books, aware of his interest, invited him to be the reader of their audio-book of Dahl's *Esio Trot*.

He did this recording with enthusiasm, delivering it almost in one fluent take. As his one-time Dahl colleague Amanda Conquy says, 'He really is a frustrated thesp.'

Blake's talent for reading aloud can be also understood in the light of his education, in which the canon of English (and some international) literature was such a feature. Both at grammar school and especially at Cambridge he benefited from the kind of teaching that focused on style: Leavis's 'dating' classes encouraged him to get inside literary language, to follow its patterns of narrative and dialogue so closely that when he reads aloud, it is with great understanding of the way text works. The combination of an actor's sense of timing with this literary grasp of text is an unbeatable one for anyone lucky enough to hear Blake reading.

As a reader, Blake is a greedy consumer: as he says, 'I have got into the habit of reading lots of books simultaneously. I get halfway through the first, then become fascinated with a second.' In his twenties and thirties he read old and new works by authors such as Henry James, Kingsley Amis, Graham Greene and Evelyn Waugh. Victorian literature figures very highly too: although Arnold Bennett was not in the

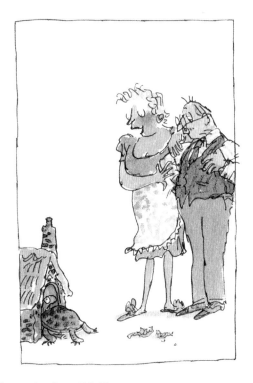

Illustration from *Esio Trot*

Leavis canon at Cambridge, Blake is a great admirer, and he also goes on reading Dickens, the journalism as well as the novels. 'An enormous book of Dickens' was his choice for *Desert Island Discs*, although he found it hard to choose between that and a volume of poetry by Byron or Alexander Pope. But, as described in the chapter on France, today he is just as likely to be reading a French novel by Simenon or Balzac, in French, naturally. Early in his career as an illustrator Blake's personal reading choices were also supplemented by the contemporary novels he needed to read, because he was designing their covers; David Lodge's early works are an example. 'Illustrators,' Blake says, 'are all hybrids of one kind or another and I think that learning to be a reader, knowing something about how writing works, was important to me. It has meant that I'm one of not many illustrators ready to illustrate other people's work as well as their own.'[1]

From the 1970s Blake had also been illustrating twentieth-century classics by authors such as Orwell, Waugh and Stella Gibbons for the Folio Society. This publisher produces what Blake calls 'well-produced reading copies': editions of the canon of world literature, often with newly commissioned illustrations, they are finely bound, sometimes slip-cased hardbacks; the antithesis of e-books. For Folio, Blake has illustrated works by many diverse authors, but in particular since 1991 he has illustrated some of the great authors of European literature: Cervantes, Victor Hugo, Voltaire and La Fontaine. His illustrations for some of these volumes are

perhaps the purest expressions of his identity as a literary artist. For example the seventeenth-century Cyrano de Bergerac's *Voyages to the Moon and Sun* – a kind of early modern work of science fiction. Unlike most illustrated book commissions, where the author and illustrator are put together by the publisher, in this case the illustrator chose the author with whom he wanted to collaborate, because he admires him so much. In his words:

The one I was most pleased with was a book by Cyrano de Bergerac ... I think most people only think of Cyrano in relation to that play (of the same name) by Edmond de Rostand which gets made into films and operas and things of that kind. But Cyrano himself wrote three books, or two and a half books ... one about voyages to the moon, one about voyages to the sun and one about visiting the land of the birds. And I'd read it in a French paperback and it's full of ... things to draw. I suggested it to the Folio Society and I was very pleased that they took it on ... They had a tradition of having about ten pages of illustration in a book, but, I said I wanted to do it because there were a lot of drawings I wanted to do. And they said, 'We'll pay you the ... maximum fee that we pay for a book, but you can do as many drawings as you like.' So in fact ... the book has about 100 drawings in and it probably treats Cyrano in a slightly, or very disrespectful way! It's like a precursor of Gulliver's Travels *and so you get things like the countries the hero goes to by being fired off like a rocket. There are places where the people actually don't wear any clothes at all or they're a completely different scale to us, or where they think the hero is a monkey and they put him with other monkeys in the hope that it will breed. And he goes to the land of the birds where he's going to be tried for the crime of being a human being, of course therefore being beastly to birds most of the time. It's absolutely full of things to draw.*

I then wanted to do something rather different, to do a very realistic book, a Spanish book ... called Lazarillo de Tormes[2] *which is about a boy who is the servant to a tramp. It's quite a short book and I still think it might be interesting to do, but they came back and said, 'If we're going to do a Spanish book, we have to do the big Spanish book.' So I did do* Don Quixote. *I read it all ... it's a very interesting problem to treat it in two colours and to ... find those right significant moments. And of course in* Don Quixote *some of those moments choose themselves; you have to have tilting at windmills and one or two things like that. But ... there are other moments, which you can find for yourself, paced through the book. Of course a seventeenth-century book is, in a sense, easier to illustrate because there isn't the thing that gets difficult later on: a lot of contemporary writing, or twentieth-century writing, involves a kind of personal monologue, or a lot of inward thoughts ...*

The last point is interesting because, as a reader, Blake is perhaps less of a fan of this kind of introspective literature anyway. But, he adds, he did read *Ulysses* twice, and 'it was better the second time'.

The Folio Society has been a fruitful publishing partner for Blake, and its Production Director Joe Whitlock Blundell sees Blake's easy familiarity with literature as a considerable advantage to him: he describes the process of commissioning a new work:

We always have an exchange of letters or emails about what the next book is going to be, and it's clear that Quentin's appreciation of literature is quite exceptional; illustrators are generally very knowledgeable about literature and very sensitive to it – they're good at doing close reading of texts – but Quentin has very strong literary knowledge as well as being able to do the literal reading, and his knowledge of French literature for example is really excellent.

Whitlock Blundell also enjoys the collaborative working relationship, and always finds Blake's views of possible texts illuminating, if very occasionally not to his own taste:

I thought we might do the first few books of Don Juan *but he said all the pictorial stuff was there in the text … but then he came up with one which was a very odd book indeed, a novel by the eighteenth-century author Robert Paltock called* The Life and Adventures of Peter Wilkins, a Cornish Man. *It was a sort of* Gulliver's Travels, Robinson Crusoe *kind of book – it had flying in it and lots of nudity – it's very long, and not a good work of literature – even with his name on, it would have been hard to sell … I don't think any of my suggestions have actually been taken up, but some things I suggest do spark something in him and it's a dialogue.*

But Blake's latest Folio Society venture is to illustrate Apuleius' *Golden Ass*, a kind of late-antique fairy-tale. This choice was welcomed by Whitlock Blundell, as was the fact that Blake took such a time to find the right translation: 'We always have great discussions about the translations – I think he read three different ones for *Golden Ass* altogether before he found the right one, and that would be unusual; normally we would present an illustrator with a text and say, "This is what we're doing."

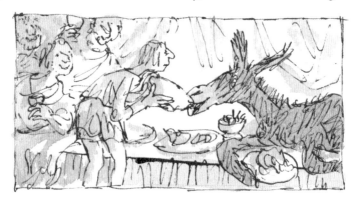

A close reading and understanding of text is also involved in the question of all the (at the time) living authors whose work Blake has illustrated. As he often says: 'My main collaboration is not with the author, but the text.' The extensive list (over a hundred) of furnishers-of-texts includes many of the best writers for children of the last 50 years: Joan Aiken, J. P. Martin (author of the cult *Uncle* books), Nils-

Olof Franzen (who wrote the equally cultish *Agaton Sax* books), James Reeves, Clement Freud, Dick King-Smith, Dr Seuss, John Yeoman, Michael Rosen, Michael Morpurgo, Russell Hoban, Sylvia Plath, more recently David Walliams and of course most famously Roald Dahl, not to mention authors of the more distant past such as John Masefield and Hilaire Belloc.

The Dahl collaborations have been widely written about by Blake himself and recently by Donald Sturrock in his Dahl biography *Storyteller* (2010), and they are referred to in other places in this book. But there are two others from the long list of authors who should be singled out here because their texts were influential in Blake's own early development as both an author and illustrator during the 1970s.

Russell Hoban, the expatriate American author of nearly twenty novels plus many more works for children, also started his career as a freelance illustrator, working for advertising agencies and magazine companies. His edgy novels, which were all written after he moved to London in 1969, have elements of science fiction and magic realism and they have always had a cult following. The works for young children operate in very different spheres, although some do have dark corners: there is the gentle *Frances* series about a little girl (based on one of his own daughters) who appears in the books as a cute but wilful badger, the strange and powerful *Mouse and his Child*, and several books, illustrated by Quentin Blake, where the humour is more caricatural and often grittier, including the fantastical *The Rain Door* (1980), *Monster* (1979) – a slightly alarming take on the power of drawing – and, perhaps best loved, the two *Najork* books: *How Tom Beat Captain Najork and His Hired Sportsmen* (1974) and *A Near Thing for Captain Najork* (1975).

Blake thinks the first Najork book is the better one, perhaps for being the first, and he loves it not only because of what he calls the 'strong visual clues' that Hoban gave him – famously the description of Tom's maiden aunt, Miss Fidget Wonkham Strong, who 'wore an iron hat and took no nonsense from anyone', but also at a more conceptual level: he savours Hoban's description of Tom, a boy who loved 'fooling around'. Fooling around gave Blake many visual opportunities but, in the story, it also happens to be a metaphor for Blake's personal theory of education, which is central to almost everything he does. 'Fooling around' here means experimentation: how can you best cling on to this wooden bridge so that you can fish out the things you've (deliberately) dropped into the river? What's inside this barrel? – find out by getting into it yourself. What can you make with two cigar bands and a paper-clip? It's about the power of self-directed learning, the kind you feel Blake knows about because he's done it himself. It's the opposite of learning 'pages 64 to 75 of the Nautical Almanac' as the aunt makes Tom do (and which, of course, he can also manage). Blake also says about this first collaboration that when his editor, Tom Maschler, gave him the text to read, 'it immediately felt like a book I was meant to illustrate ... In picture-books, Russ had the organization of language that told you he was a poet.' But, in a rare example of having to 'audition' for an author, Blake had to wait for Hoban to choose his set of roughs over those of other possible illustrators before being allowed to start on this desirable project.

Hoban was very keen to do a follow-up to the first *Najork*, not least because, as he said to Blake, 'now I know what the characters look like'. Dahl, by way of contrast, often had quite a strong visual sense of the people he created, and described them, although he did not always know how they would work as illustrations: famously he and Blake together rethought what the BFG would look like, and Dahl even sent Blake a sandal of the kind he imagined the BFG would wear.

Blake also illustrated the very last book of any kind that Hoban wrote, in the year he died and when he was already very ill and could barely see. *Rosie's Magic Horse* is a slightly curious story, perhaps not Hoban's surest and most imaginative text, but Blake's response to the request to illustrate it is entirely typical. The two met at the publishers and, according to Jake Wilson, a mutual friend: 'You can see that Blake really wanted to do it and I remember he said that he . . . let everything else go . . . and put all his effort into those pictures'.

Education is also the link between Blake and John Yeoman, who wrote the first book for Blake to illustrate, *A Drink of Water and Other Stories* (1960), and the two have since collaborated on some 30 works – at one period they were producing a book a year. Yeoman, who later became Head of English at the Lycée Français in London, is an old friend of Blake's. In fact they went to the same grammar school, although not in the same year, and they both went on to read English at Downing College, Cambridge. Blake acknowledges that in their early children's book collaborations, he learned from Yeoman: 'He is very good at writing in pictures.' And Yeoman describes how their first published book came about:

Quentin wanted a book to illustrate and he just asked me to write one.
I quite liked the idea of writing; that is, I couldn't have written a novel at that time, so if I were going to write, it would have to be something short, and for children, because I was beginning teaching. I was doing teaching practice in a primary school . . . and using some folk tales which were almost certainly Russian, so a couple of the tales at least from A Drink of Water *are Russian . . . I wrote the stories, it was as simple as that. I had no view of the book, although I'd chosen stories which lent themselves to illustration.*

Yeoman was probably being modest here because he goes on to describe a book which was truly a joint effort: 'Actually though, they were things I would like to draw . . . I was drawing all the time, scribbling . . . some of the books I drew before I handed them to him. For *The House that Jack Built*, he's got my roughs that he traced!' And Blake says that *Snuff* (1973) was very much Yeoman's text although not acknowledged.

But it was a give-and-take partnership too, Yeoman also admits:

With The Wild Washerwomen *. . . the first draft I gave him was sprawling and it had a sort of subplot . . . which he took his scissors to, and the result was much improved . . . it was probably that I had the Washerwomen idea and then I thought of other things which could happen, which made it want more narrative, which it didn't . . .*

This book was published in 1979 and Yeoman's words suggest that, by then, Blake already had a sense of what made a good children's book text, although he had only written a very few himself at the time (*Patrick Jack and Nancy Angelo Snuff* and the three *Lester* books). Blake does however say that, after *Snuff*, he had run out of ideas of 'how to do story'; what helped him to find a different modus operandi was illustrating a Dr Seuss book, *Great Day for Up*. Dr Seuss was the pen name of Theodor Seuss Geisel and *Great Day for Up* was the only text he wrote as Dr Seuss that he handed over to another illustrator. He did in fact get as far as doing as the roughs, and he did keep an eye on what Blake was doing, even though he only asked him to alter the position of a giraffe's neck. Blake thinks that the reason Seuss allowed someone else to do this job may have been that he 'chickened out of what he wrote for himself' – the last spread reads:

Up! Up! Up! Great day for UP!
Wake every person, pig and pup, till EVERYONE on earth is up!

The prospect of drawing everyone on earth may have been daunting but Blake found a way – his little figures in perpetual motion seem to double their number on the page . . . Whatever the reason, the resulting book has the unfettered joy of young children about it, with its upbeat rhyming scheme and Blake's illustrations, which echo this spirit so exactly.

Up, whales!
Up, snails!
Up rooster!
Hen!
Up!
Girls and women!
Boys and men!

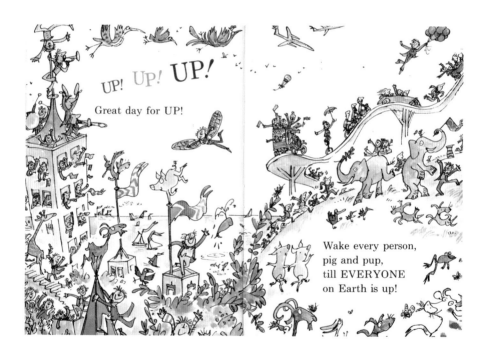

Writing

Blake says that illustrating this book gave him 'permission' to make something similar. He understood that a book for very young children could work just as well (better even) without much narrative, but with simple inventive rhyme and illustrations, which introduced one new idea to a spread. *Mister Magnolia* (1980, and for which Blake won the Kate Greenaway Prize in 1981) was the first outcome of this.

Interestingly, this minimal text (some 160 words) actually started life as a counting book, but became even simpler and more effective when this element became implicit and the narrative took precedence. It is a perfect example of how Blake's ideas, both visual and written, are always so expertly and beautifully reduced to their essentials. In this spread, the almost neutral words 'He gives rides to his friends when he goes for a scoot' give rise to a magical autumn scene, with the giant scooter rounding a bend at great speed (the little boy tightly clasping Magnolia's leg) – and the surprise and delight that the reader feels is echoed and affirmed by the astonished expressions on the rabbits', cows' and dog's faces, and by the old man agreeably jolted from his rest on the bank.

It is important that the texts that Blake writes for himself do not come about through knowledge of how other children's texts work (rather as his drawing style was not influenced by that of other children's illustrators). Like Dr Seuss/Geisel, he never had children himself (Geisel famously said: 'you have 'em; I'll entertain them.'). He didn't really know what it was like for an adult to sit with a picture-book and a four-year-old who delights in words, especially the odd and unfamiliar word, who simultaneously and with wondrous focus scours the images for the strange, the funny, the delightful as well as the safe and reassuring. He doesn't remember reading many children's books as a child, and didn't as an adult, until he began to illustrate them. Instead, certainly by the time he was writing *The Story of the Dancing Frog*, or *The Green Ship* or *The Five of Us*, he is more likely to have learned the anatomy of good storytelling from reading Shakespeare, Simenon, Dickens and Cyrano as from Bemelmans, Milne or Lewis Carroll. Although it is difficult to isolate words from images when they are conceived so closely together, it is possible to appreciate the text of *The Green Ship*, even without its poetic illustrations.

The story is simple – the narrator's recollection of a childhood summer holiday with his sister: one day in a neighbouring garden they discover an assembly of trees, which appear curiously like a green ship. Its owner Mrs Tredegar (whose husband, we gather later, had been a captain who was lost at sea) takes the children on an extraordinary make-believe sea-voyage. We join them at the height of a dramatic storm:

The swaying of the lantern and the rain rushing against the windows made it seem as though we were truly at sea. And the storm seemed to go on forever.

At some point we must have fallen asleep, because when we awoke we were on the floor of the wheelhouse and the early morning sunlight was shining on us.

Mrs Tredegar was still at the wheel.

'She came through,' she said. 'She came through.'

Then she turned and looked at us and said: 'Well, done, crew. The captain would have been proud of you.'

And then Mrs Tredegar walked out across the grass and with a long trail of ivy tied up the battered ship as if she had come into port at last.

We still go back and see Mrs Tredegar every year. The Bosun says he's getting too stiff to climb up and trim the masts and the funnels, and that Mrs Tredegar doesn't seem to mind.

And so gradually, year by year, the trees are getting back their old shape; they are becoming ordinary trees and soon there will no longer be any way at all of knowing that they were once the Green Ship.

This is a model piece of writing in itself: the relief contained in the repetition of 'she came through', the minimal use of adjectives, so that those which are there such as 'battered' and 'stiff' glisten in the text. The length and pace of this flowing sentence: 'And then Mrs Tredegar walked out across the grass and with a long trail of ivy tied up the battered ship as if she had come into port at last', which moves from the short factual statement, 'And then Mrs Tredegar walked out across the grass' to the second half: 'with a long trail of ivy tied up the battered ship as if she had come into port at last', a phrase that is heavy with expressive allusion and emotional depth – we are not quite sure if it is the ship that is being described, or Mrs Tredegar herself, for whom the imaginary storm-battered journey seems to have provided some kind of cathartic closure to the mourning of her lost husband.

Quite apart from matters of style, the sources for Blake's own texts (as mentioned elsewhere) are immensely wide and naturally include the literary. A friend reminded Blake that the phrase 'Good morning my fine-feathered friends' from the inimitable *Cockatoos* (1992) actually came from a Thurber cartoon. Blake has no conscious memory of this purloining but it's another example of how deeply words which mean something to him become embedded.

Blake the spinner of narrative in his children's books is also an elegant writer for adults. He has written books about his career[3], as well as the introductions to his own exhibition catalogues. He has also written introductions to books by other authors (for example, *School Blues* by Daniel Pennac) and many press and journal articles. He

is an artful and regular letter-writer, as many friends and colleagues can testify; letters which in the past might have been sent as faxes, for immediacy, something which Blake likes. Such letters, in handwriting as expressive as his drawings, are documents to savour: you know how much every word on that heavy cream paper has been considered; unlike his drawings, which Blake says he doesn't consciously compose (but, he says, 'his hand and eye do'), each letter really is a composition; and you know that it will be the best kind of letter you could ever hope to receive – words addressed to you, in the situation at hand – and that you will be surprised by an illuminating word or phrase, or even by a drawing, which says the things that the words can't quite.

Writing about Blake

Finally, there is another kind of literary outcome of Blake's art. In a neat reversal of the way in which good writing can summon great illustration from him, his own drawings have inspired other authors to powerful prose, something that the 'low-status'[4] art of illustration has rarely managed to do. One of Blake's big life-intentions has been to encourage critics and other writers, as well as museum and gallery curators, to take illustration more seriously: to foster public discourse about it, to find a critical language for it; to acknowledge its place in the history of art, and to show how this most available of art forms can play a vital role in everyone's visual and emotional education. The following extracts contain both a respect for Blake's technique and a strong impulse to capture in words the way the drawings work as illustrations to text. In a piece for the *Financial Times* written to coincide with the opening of the House of Illustration in 2014, the historian Simon Schama describes Blake's drawings made for the Folio Society edition of *Candide* (2012):

Many of the illustrations he has drawn for Voltaire's Candide *fully match the philosopher's determination to turn hearty chuckle into mirthless cackle. Dr Pangloss, Candide's tutor, who despite a procession of slaughters and rapes will not be shaken from his optimistic dogma that this is 'the best of all possible worlds', gesticulates inanely in Blake's drawing over the mangled bodies and debris of the Lisbon earthquake, while ignoring his protégé pinned beneath the masonry. A stain of bloody light blooms on the horizon. Another image, a little masterpiece of contemporary art, equally faithful to Voltaire's mordant verdict on the human comedy, summons Blake's inner Goya, depicting a victim of the Inquisition's auto-da-fé swinging from a rope while a trio of canting friars roll their eyes to heaven . . .*

No saint could produce the universe of visual mischief that is his repertoire. But he doesn't have it in him to deliver the sting of cruelty. When, at the end of Candide, *Pangloss, looking like a decrepit snail, is still droning on about the best possible world and Candide responds, 'That may very well be but it is time to cultivate our garden,' the artist has the younger man looking down at the seedling cradled in his hands, while forbearance is traced on his sweet face with a single, perfectly economical stroke of Quentin Blake's enchanted pen.*[5]

The bloody hilarity of *Candide* was rather far away in Blake's 2012 exhibition of recent work at the Marlborough Gallery in London. Here, instead, were shown sets of

etchings and lithographs of what the author and biographer Jenny Uglow described in her introduction to the catalogue as 'characters in search of a story', and which Blake calls 'like illustration pulled inside out'. In many of these in other ways quite disparate sets the underlying themes of making art, comedy and compassion were vividly described by Uglow:

We can take up the 'suggestion of story', but we can't miss the struggle to make art. Blake's first independent book, Patrick, *showed how art – in that case music – could turn dull monochrome lives into vibrant colour. In the current show, this idea recurs in the pairs of shimmering youth and grizzled age, where the pen and ink scumbles the watercolour like wrinkles on a face. We know that these golden lads all must, 'like chimney sweepers come to dust', but for the moment they glow lazily, as resigned models or listeners (where old and young read side by side, you know they are reading different books). By contrast it is the old who are the artists. The women draw intently, the old man plays the violin so fast that his hair stands on end. The consolation of art does not fade.*

Comedy and compassion return here, and in the playful etchings of insects. Following the old tradition of the bee-hive or ant-colony as models of society, Blake invents sociable creatures, their antennae twitching for gossip. Dressed to the nines, they go shopping, brandish parasols and find their many arms useful for multi-tasking. Some care for nervous youngsters and some have seen better days, like the old insect-lady walking home in the sunset with her heavy bag. We share the joke. We laugh at this not entirely alien world. Like the lonely people, the big healthy girls, and the floating heads, the insects share the elliptical, magical quality of Quentin Blake's art – as we endow them with stories we leap from the real into a strange, transformative realm.

The birds which appear in *The Life of Birds* shown opposite share some of the qualities of those good-humoured insects, but there is another kind of depth here; in form and expression, they are perhaps the closest that Blake ever gets to his hero Honoré Daumier's lithographs for *Le Charivari*: the artist's sidelong glance at a domestic situation, a street-seller, a conversation, a type. Many are humorous (*L'en-Cas* on the left, Blake says, is based a man he once saw eating like this in a café), but others have a frankly elegiac or dark quality.

In the English edition, where the pictures are untitled, the late Peter Campbell, journalist and artist, wrote:

Drawing can do something . . . remarkable, something neither painting nor photography is good at: it can show how funny, sad, silly, and odd the world is. The drawn line is saturated with the character of the draughtsman – it is like handwriting but with several extra dimensions of variability. The artist's delight and despair become legible. We learn things we knew without knowing, saw without seeing.

In Blake's case character and movement are, as it were, his prey – the thing he catches. There is pleasure in the pull and turn of his lines when they are regarded as abstract marks, but they come into their full power when the abstract handwriting begins to register as

*part of a living creature – a glancing eye; a jumping leg; a tentatively waving arm; an
expression. A person appears on the page. Or is it a bird?*

*Like other masters of comic art he can discomfort us pleasurably and amuse us
painfully.* [6]

The French edition is introduced by the well-known French novelist Daniel
Pennac, who 'reads in' to these images to find meaning, and when he does he glimpses
the big universals of Blake's art. I put the original first before my translation because
the French is so good:

*Les oiseaux de Quentin Blake parlant pour chaqu'un de nous, il ne faut pas frustrer le
lecteur de sa propre interprétation. Le 'lecteur' ... Oui, décidément, ces dessins se lisent.
Le trait de Blake est une écriture. Une écriture qui saisit le temps. Quelques traits de plume
... l'encre, la couleur et l'eau se dissolvent dans la fibre du papier ... ce sont les traces
éffrangées que nous laissons dans la mémoire de Quentin Blake, tout autant que nous
sommes, et que sa rêverie recompose. Nos jeux, nos apprentissages, nos appétits, nos tracas,
notre insouciance, nos vanités, notre énergie, nos lassitudes, nos premiers moments et nos
derniers mètres, nos bruyants petits bonheurs et nos regrets muets, tout y est, vraiment,
jusqu'à notre poésie, car l'homme sait être un oiseau poétique quand il pédale sur la grève
où rêvasse dans le brouillard des marais ... Oui à regarder de près, Quentin Blake dessine
moins des individus que ce qui fait de nous des individus.*[7]

(Since Quentin Blake's birds speak for every one of us, I will not frustrate the reader from
making his own interpretations of them. I say 'reader' ... because these drawings are clearly
to be read. Blake's lines are handwriting. A handwriting that seizes hold of time ... A few
pen-strokes, some ink, and paint dissolve into the fibre of the paper ... we leave frayed
traces in Quentin Blake's memory, just as we are, and in his musings he recreates them.
Our games, our lessons, our appetites, fears and insouciance, our vanities, our energy, our
weariness, our first moments and our last steps, our noisy little pleasures, our silent regrets,
everything is there, truly, even our poetry, because a man can be a poetic bird pedalling
along the shore or dreaming in the marshy mists ... Yes, when you look closely, it is not so
much individuals that Quentin Blake draws, but what makes us all individuals ...)

The queue of French writers and illustrators who want to pay tribute is long and includes François Place, prize-winning children's author and illustrator, who recently stood in for Blake at the Montreuil Children's Book Fair, and wrote to him afterwards, in a rhetorical outburst of admiration:

I think you prefer unpredictable and capricious whirlwinds to the rather abrupt laws of gravity enacted by Isaac Newton. If an apple falls on your head you'd prefer to crunch it with your teeth or with the end of your pencil. Under your pen each small bit of fence, each little balcony, or the humblest of suburban gardens becomes a paradise overrun with wild greenery . . . your characters are borne along on a gentle folly; they are always touching, always moving, and even the baddies who parade their evil characters so joyously, belong to the good side of life. I hope I've been able to convey the admiration I have for the freedom of your line, for the mischief and sharpness in your well-meaning eye. There are few who have such force and elegance.

Whenever I feel a prisoner of my well-behaved line, of my rather too plodding concern for detail, I open a Quentin Blake, in the way that one might open a window to air a room and to take in a great gulp of air. And I keep the books safely in my library, for my grandchildren, if any come along.

(Je crois que tu prefers les tourbillons de vent imprévisibles et capricieux aux lois de la gravitation un peu trop abruptes édictées par Isaac Newton. Si une pomme te tombe sur la tête tu préféreras la croquer à pleines dents ou du bout du crayon. La moindre palisade, le plus petit balcon, le plus humble jardin de banlieue deviennent sous ta plume, des paradis envahis d'herbes folles . . . Une folie douce emporte la plupart de tes personnages, toujours touchants, toujours émouvants, et meme les méchants, qui étalent leur sale caractère avec jubilation, sont du bon coté de la vie . . . j'espère que j'ai pu faire passer l'admiration que j'ai pour la liberté de ton trait, pour la malice et l'acuité de ton observation bienveillante. Il y en a peu de cette force et de cette elegance.

Quand je me sens prisonnier de mon trait si sage, de mon souci de detail un peu trop besogneux, j'ouvre un Quentin Blake, comme on ouvre la fenetre pour aérer la pièce et prendre un grand bol d'air. Et je les garde précieusement dans la bibliothèque pour mes petits enfants, si' m'en vient.)

Joann Sfar, the multitalented creator who compared the prospect of meeting Blake to that of meeting Father Christmas, peppers his extraordinary visual diary, *Caravan*,[8] with references to Blake's art and descriptions of their meetings:

The text here roughly translates as:

Quentin Blake has the graceful gestures of Charlie Chaplin. Once I had to be photographed and the journalist complained that I wasn't smiling or looking in the right direction. I told him that there was nothing to look at over there. So Quentin Blake put himself in the nothing to look at place and he began to dance so that I would

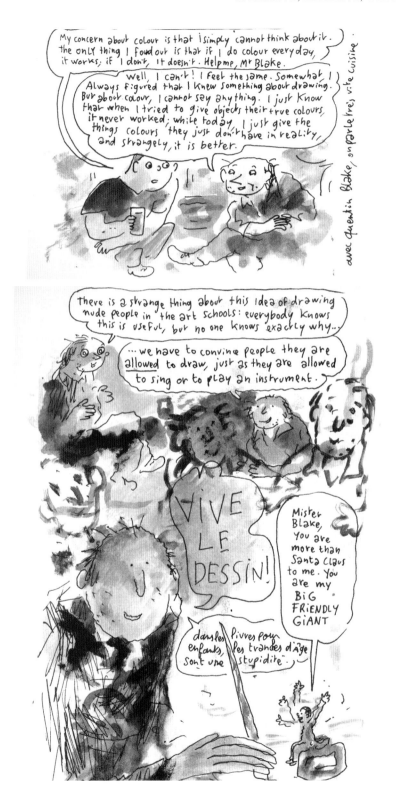

look where they were telling me to look and so that I would smile. I'm not joking: he danced with the grace of Charlie Chaplin.

Draughtsman = actor

Draughtsman = dancer

Draughtsman = better than mime

And here is the photo of this remarkable event.[9] Actually it's not remarkable – it's a completely characteristic Blakean pose, which he takes up, always unexpectedly, often on the other side of the road, for the delight of his good friends and sometimes to the surprise of other pedestrians.

Finally, two pieces by Russell Hoban. The first is the whole of the (short) introduction to an extraordinary publication Blake brought out in 1999, published in a small edition of 200 by the Camberwell Press. *Woman with a Book: Twenty Drawings by Quentin Blake* is not easy to pick up or handle. Measuring a substantial 47 × 66 cm, the fleeting watercolour drawings are printed on beautiful Rivoli white paper, and the text summons the kind of inventive, right-brain response that Hoban is justly famed for.

Wrapped attention, also unwrapped

Orpheus with his lute made trees
And the mountain-tops that freeze,
Bow themselves when he did sing …
(Shakespeare, *King Henry VIII*, III.i.3)

Quentin Blake, another sort of Orpheus, does it with a line; wandering here and there with it coiled loosely over his shoulder, he flings it with nonchalant accuracy at what catches his eye. Whatever and whoever has been captured by that line enters the multitudinous gallery of high-spirited girls, boys, men, women, animals, houses and

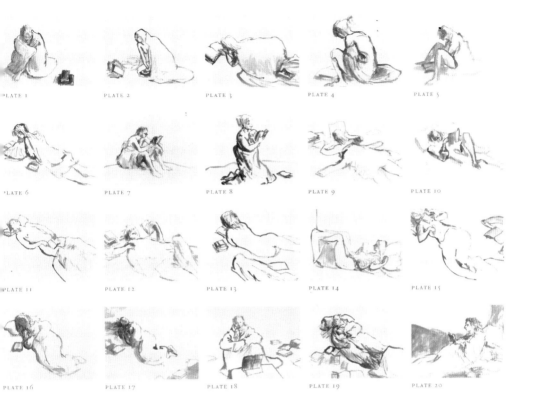

PLATE 1 PLATE 2 PLATE 3 PLATE 4 PLATE 5
PLATE 6 PLATE 7 PLATE 8 PLATE 9 PLATE 10
PLATE 11 PLATE 12 PLATE 13 PLATE 14 PLATE 15
PLATE 16 PLATE 17 PLATE 18 PLATE 19 PLATE 20

trees that walk, run, jump, dance, prowl, gallop, stand and grow with the *joie de vivre* given them by this Orpheus-mad-about-drawing.

What makes his images so memorable is a matter of mind: how often, waiting at the corner of a railway station, have we sighted the face of an expected friend or lover, only to find that we were mistaken; anticipating the arrival of the one awaited, we see the familiar face and figure because the mind is full of the idea of that person. Artists who, like Quentin Blake, draw from memory and imagination have always made use of this phenomenon: Breughel, Tiepolo, Goya, Daumier, Toulouse-Lautrec, Grosz, and many others, have in common an eye for the gesture that stays in the eye, the shape of the action that tells the story, the visual hyperbole that imprints itself on the memory. The gesture contains the idea of the one who gestures; the leap becomes the leaper; the dance the dancer; the reading the reader.

How were the drawings in this book done? There's not a whole lot to it: all you need is some good cold-pressed watercolour paper, a few tubes of watercolour for your greys, two or three brushes, some water and a little magic. The magic consists in using your brushes in such a way that the white paper under your lines and washes assumes substance, takes on roundness and form; then the paper reasserts itself and the substance is gone, only to come and go again, flickering continually: magic.

All of the women in these drawings are involved in books: they're about to read,

they're reading, or they've been reading; and bear in mind that there were no models – these females have all come out of Quentin Blake's head. 'What about this?' I asked him. 'What is it with these wrapped and less-wrapped women and their books?'

'Well,' he said,

you'll remember that I had an exhibition of paintings and drawings, nothing to do with illustration work, in 1993. They were done with a very broad technique and non-naturalistic colour, but one could still see that they were nudes. As a tactic to get myself going again after that show, I decided that, for a change, the nudes should be wrapped up. I think I had some undefined notion that their being more or less wrapped corresponded somehow to areas of privacy or introspection – but that may have just been a fantasy. At any rate the drawings of the wrappings – shirts, dressing gowns, blankets and so on – seemed to call for a more descriptive technique, which took me a step or two backwards towards illustration.

At the same time I discovered that the women were reading . . .

I interrupt him here to say that this remark, questionably candid though it may sound, is significant: when Quentin draws a leaper, a dancer or a reader, he discovers that person leaping, dancing or reading. First he sees the action, then he finds whoever is in it. But why – I mean really – reading? He can draw anything at all out of his head, so why reading? And why more wrapped than unwrapped?

I know, from other drawings of his that I've seen, that Quentin Blake is respectful of the mystery of the female. Even in his jolliest illustrations he does not take liberties with his girls and women but keeps to the decencies of his own comic conventions and inventions. His non-comic women, his nudes, are approached with wonder – Eleusis is never very far from those nudes. I think that Quentin didn't feel altogether free to draw his bookish women all uncovered – he seems here to be asking their permission to imagine them in their privacy.

But, as he was saying:

I discovered that the women were reading, that their attention was elsewhere, that they were no longer conscious of being turned into art-objects. (In life classes, years ago, I always thought that the rest-period was more interesting than the pose. They were also becoming more like individuals, reacting differently to their reading, or perhaps the way they read is indicative of some other situation they're in.

Each of these women undeniably has a life of her own apart from what Quentin has observed, but for me that other life has been absorbed by the reading, and the drawings have arranged themselves in a narrative sequence. Quentin says he had nothing like that in mind and cannot now remember the order in which he did the drawings, but anyone looking at them is bound to find one suggesting itself.

Is it possible to think of reading as a sexual act? Reading requires the surrender of the reader to the book; the idea of a naked woman reading a book therefore has

certain reverberations for those for whom this sort of thing reverberates. Under their blankets, dressing gowns, etc, these women are naked. Wrapping leads to unwrapping. There's a lot to think about here.

In Plate 1 the woman is completely wrapped, her body entirely hidden; only her head, the mind part of it, is exposed as she thinks about the books that lie before her. She's looking at them both contemplatively and critically. Will she or won't she be receptive to one of them?

In Plate 2 she's made a choice and, in a show of willingness to meet the book more than halfway, opens herself to the written word. This, however, is not a commitment. Will she proceed to the next stage?

Yes! In Plate 3 we see the classic tented-bum position in which the reader, on knees and elbows before the book, has draped herself in such a way as to contain the literary emanations for maximum absorption.

In Plate 4 the woman, partly turning her back to us, looks down at the book that lies open on the floor between her naked legs. The physical gesture is earthy, almost a birth-giving position frontal to the book.

In Plate 5 the woman's legs are fully exposed and the book has moved in close to receive her concentrated attention. The chiaroscuro makes one compact unit of woman and book, as solid and self-contained as a Tanagra figure; the intimacy is physical, intellectual and aesthetic.

In Plate 6, the intellectual aspect is uppermost as the woman, prone to acquiescence, yet she maintains some objectivity as she reads.

In Plate 7 she's completely at ease and feeling increasingly book-friendly.

In Plate 8 she has quite settled into her reading but reminds herself that she's naked under the blanket.

In Plate 9 the reader is again prone but only partly covered by the shirt that she's flung over herself. She has definitely committed herself to a relationship with the book.

In Plate 10 the woman lies on her back, one leg raised and crossed over the other in a good-friends-in-bed position.

In Plate 11 the book would seem to reach parts not reached by it before.

In Plate 12 our reader is more or less in the position in which Danae received Jupiter as a shower of gold. Definitely an 18 certificate for this one.

Plate 13 finds our reader altogether unwrapped and raptly re-reading.

Plate 14 shows us, I think, how it was for her: cold feet perhaps but warm elsewhere.

In Plate 15 we see the reader remembering what has gone before.

In Plate 16 she's covered again, perhaps asleep, perhaps dreaming.

In Plate 17, our dreamer, cuddled in the warmth of memory and duvet, dreams on.

In Plate 18 she has moved out of the dream and into a wintry reality that brings with it a new objectivity.

In Plate 19 more wrapping-up is needed as well as more sleep. Good reading is known to have that effect.

Plate 20 brings us up to date and who can be surprised? The book is still with her, so it was clearly not a one-night read. Will she give birth to a book of her own?

So concludes my journey through this collection of drawings. If my descriptions are

questioned I can only reply, in the words of the patient who astonished his psychiatrist by his reading of the Rorschach inkblots, 'Hey Doc – they're your pictures!'
(Russell Hoban)

Hoban was able to see and articulate things that many people who only think of Blake as a cartoonist or a cheerful children's book illustrator can't or don't see. And in this last small but entirely original literary tribute he shows that he understands the skill as well – Hoban wrote this dedication on the title page of Blake's copy of *Riddley Walker* (1980). This book is a science-fiction novel, set in a post-apocalyptic dystopia. The young narrator, Riddley, speaks a language which, when written down, can seem like a phonetic transliteration of the Kentish dialect. At first, this language appears like text we might find in the social spaces of the internet: impulsive, misspelt commentary about this or that, which some readers might be inclined to dismiss as illiterate rambling. But of course here it is the creation of a sophisticated writer, and full of invention, wit and depth, exactly the qualities that Hoban brings to this dedication, where he applies to Blake a wonderful double meaning for 'draw' and where the last sentence is one of the most poetic and acute observations ever made about him.

Drawing is Blake's first language but words are always there on the edges, behind, in front, on the margins, close by – as all 'readers' of his textless book *Clown* know, the drawings alone can say more than words but it is with words that we want to respond to them.

Riddley Walker

Russell Hoban

DRAW IS A INTERSTING WORD. THERE
IS DRAW MEANING FETCH OR PUL AND
THERE IS DRAW MEANING DRAW A PIC-
TER. THERE IS THIS BLOAK QWENTING
BLAKE WHICH HE IS A TOP DRAWER
BOATH WAYS HE CUD DRAW YOU ANY
THING YOU CUD THINK OF AND LOTS YOU
CUDNT. PUL THEM LIKE RIGHT OUT OF
THE AIR AND ON TO THE PAPER.

RW 27.11.80

JONATHAN CAPE
THIRTY BEDFORD SQUARE LONDON

PLUS BEST WISHES
FROM ME SAME DATE
RUSS

PROMENADE
DE QUENTIN BLAKE
AU PAYS DE LA POÉSIE
FRANÇAISE

GALLIMARD JEUNESSE

4 Calling on France

His name

To Quentin Blake's family and old friends, he is Q. Otherwise he is Quentin and really only Roald Dahl called him anything else: 'Here's Quent,' he would say (something Blake can mimic hilariously). But, when in France, which he is very often, Blake also readily answers to the French pronunciation of his name, where the soft, rich vowels at the back of the throat seem somehow closer to his personality than the bright e and i of Quentin in English – in any case, the name Quentin is heard much more often in France than in the UK.

Blake does not know why he was given this outlandish first name – it doesn't feature in any top 100 lists of British boys' names for the 1930s. Indeed, so unusual was it that, as Blake remembers, on his first day at primary school in Sidcup, his mother felt obliged to suggest to the teacher that if the name Quentin was 'too difficult' for staff and fellow pupils, 'he could be called Paul instead' – fortunately this did not prove to be necessary.

But there is a possible reason for the choice: Blake's parents spent the first 10 years of their married life in northern France and Belgium, where his father had gone to work as a clerk in what was then known as the Imperial War Graves Commission. The couple evidently became fond of their new home, sending their eldest son Kenneth to French schools, learning to speak a kind of French themselves (Blake describes his

Book cover for *Promenade de Quentin Blake au Pays de la Poésie Française*

father's as 'with a stiff English pronunciation' and 'mainly in infinitives'). According to Blake, they made such good friends within the French community that when, 30 years later, the family made a pilgrimage to the places they had lived in, they were recognized with appreciation by the family of the *patronne* of a local bar, who immediately pulled out a celebratory bottle of champagne from under the counter.

Blake himself was not in fact born until after the family returned to the UK in 1932, but he agrees that it is not unlikely that the choice of a French name for their second son, who was probably conceived in France, could have been a kind of tribute to the country that had welcomed them. In any case, the family's connection with and love for France seems somehow to have imprinted itself on Blake, and he is a truly francophone Francophile. Perhaps even without knowing it, he may have been keen to participate in the chapter of the family story that he missed out on by being born in England. In any case, from early on he seems to have had an engagement with French language and culture and, as we have seen, he often speaks of French films, artists and literature as having been instrumental in the budding and blooming of his own artistry.

And, on the other side, there are now also countless French readers, publishers, artists and institutions who have become committed Blakeophiles. This chapter is about the strong French corner of Blake's identity, and looks at how he and his work are seen in the country with which he feels so connected.

Cultural encounters

At school Blake learned French, the modern foreign language that everyone did, at the time. As it happened, the headmaster Dr McGregor Williams was the author of *La Formule*, the French textbook used by the school, so the language may have had an extra cachet. In any case, Blake has two stand-out memories of how he benefited from school French: the first is of hearing Charles Trenet's iconic song *La Mer*, which was played during a 'French Culture Day'. First recorded by Trenet in 1946, the song was a recent hit, and would have seemed something modern in the classroom. Trenet briefly trained and practised as an artist and perhaps Blake's imagination was touched by poetic images of the lyrics: sea dancing along the bays of southern France, past reedy ponds and white birds. Even more important though to Blake though was as we have seen the 1945 film directed by Marcel Carné, *Les Enfants du Paradis*. This film introduced the teenage Blake to the notion of 'the mime element, which is an important part of illustration . . . of telling the story by acting it'.

Telling the story by acting it is exactly what another of Blake's early and enduring heroes, Daumier, did. Also while still at school, Blake made another London visit. Since they are specifically mentioned, these trips to the capital – only 15 miles from home – seem to have had great significance for Blake. They meant escaping from Sidcup to the lively place where art, theatre and film were to be found, and perhaps the taking home of something precious from the big city had a symbolic value. In this case, Blake brought back a volume of Daumier lithographs, which he has kept: a large beautifully produced hardback volume of 1946,[1] with the artist's characterful HD signature printed large on the faded beige cloth cover.

Inside, Blake was enthralled by a selection of black-and-white lithographs, which originally appeared in the nineteenth-century French weekly illustrated newspaper *Le Charivari*, published in Paris between 1832 and 1937. In the book, these images, containing both political satire and social comment, are reproduced at actual size, and are full of the wit and, even more importantly, the sense of everyday drama that were later to characterize Blake's own work so strongly. It was also the most expensive book he had ever bought, costing two guineas, and he remembers his mother asking him (in a concerned but sympathetic way, Blake emphasizes) whether he really wanted to spend all that money on a book. This memory also nicely illustrates the point about what home does and doesn't contribute to a young person's development – Blake, the best-known book illustrator of his times, remembers very few, if any books at home. His mother's incomprehension at the sum of money spent and his own certainty about the book's value to him both suggest how confident Blake already was to follow the path that seemed to be opening up before him.

In 1952, a couple of years after leaving school, Blake was able to visit France for the first time. He went to Bordeaux with a school friend to visit another who

was at the university there. Here too the memories are of book buying: a volume of eighteenth-century French drawings which he found in a bookshop in the Place Gambetta, and another of French posters of the Belle Époque by artists such as Steinlen and the innovative poster-designer Cappiello. All three of these books of French art are still in Blake's possession, and he says that he realizes now how much the works he found in them were to mean to him later. Taken together, the art in these three volumes points towards some key aspects of Blake's work, the ones which make his production so unmistakable and so powerful. In addition to the humour and drama of Daumier's lithography, there is the fluid and elegant drawing of the French eighteenth-century masters such as Watteau and Fragonard, and lastly, in the book of posters, comes a strong sense of both design and colour: how to use a page for greatest effect and, maybe most important of all, in works such as a poster by the illustrator Cappiello advertising an aperitif, the fact that these kind of images are really both about art and about ordinary life at the same time.

One other French artist should be mentioned in the context of French heroes, but, unlike the others, this was a man who Blake met and got to know a little: the artist and illustrator André François (1915–2005). François had been born into a Hungarian family but moved to Paris at the age of 19 where he stayed for the rest of his life. He studied at the Atelier Cassandre, where he learned a great deal about design from its eponymous founder. Cassandre developed among other things an innovative poster style, which paid dues to the art movements of its moment – cubism, surrealism and futurism – but which was also individual and striking (his 1930s adverts for companies such as Dubonnet and various transatlantic shipping companies are particularly recognizable). François himself went on to become a painter, sculptor, set designer, and graphic designer as well as a book illustrator. Today and in the UK he is especially remembered for the cartoons and magazine/newspaper covers that he produced for *Punch* (then under the maverick but enlightened editorship of Malcolm Muggeridge), *The New Yorker* and *Le Nouvel Observateur*, and for many book covers, illustrations and his own authored children's books (his best-known one is *Crocodile Tears*).

These were drawn in his painterly style, at first glance a naïve one, but with many highly sophisticated elements. Blake especially admired the 'rough and improvisational quality of the urgent draughtsmanship' and acknowledges that he found in François a 'sense of liberation in that lack of British sobriety'.[2] The work is indeed always characterized by a sophisticated sense of play, fantasy and the surreal, which takes him into another realm, which is all his own. As Blake says, 'He could draw a rhinoceros in socks or a man getting out of bed and stretching out his wife's fur coat as a rug, all without ceasing to create a work of art.'[3] What Blake learned from him was lessabout style, more something about free-ranging imagination and a lot about the illustrator's profession. While Blake was still in his early twenties and doing occasional work for *Punch* magazine, he came across François' name and his work in *Lilliput*, a small-format British monthly magazine of humour, short stories, photographs and the arts, published during the 1930s, 40s and 50s, and to which Blake himself once contributed.

Blake was already impressed by an incident he had heard about from an advertising agency, in which François had been asked by the agency on behalf of a client to make some changes to a picture of a cockerel. As the story goes, the client expectantly opened the package containing the revised drawing only to find a picture of an elephant. According to Blake: 'François didn't want to change anything, he just wanted to go on creating something.' The idea of being 'allowed' to do what *you* want was an enabling one for Blake: as well as understanding that experimentation is one way of finding out who you are as an artist, he learned about self-confidence. This also included the idea that you could draw with anything: Blake says that there was a story circulating that François would trawl the post offices of Paris, stealing the worst pens he could find, in order to get a scratchier line. We have already seen in the chapter on drawing what scratchiness means to Blake.

With some courage, Blake sought out François' address outside Paris and asked for an interview, which to his surprise, he was granted. Blake remembers marvelling at Francois' ungrand lifestyle: he picked Blake up from the station himself and drove him to his home. Here Blake found a striking example of an artist's living space (very different to his own where his art is mainly safely tucked up in plan-chests):

In his sitting room there was a wonderful trompe l'oeil drawing of shelves, with things on the shelves, which he'd done ... which were very effectively trompe l'oeil, but actually didn't deceive you ... they were three dimensional, but you still knew they were drawing. And the other thing I found rather touching [was that] he hadn't finished it. It was something that he was doing when he had time to do it.

While at François' home Blake also witnessed one end of a phone call from the Pirelli company, which had commissioned a piece from François but was dissatisfied with the result. Again, Blake was delighted to hear the great man say: 'No, no, that's all right, I don't want to do it again, just send me the rejection fee.' Blake concedes that Francois' by-now highly respected status allowed him to confront clients in this way, but, he says, it was 'strengthening' to a young artist to see this happening in front of him and it was a piece of valuable advice he was later able to pass on to his own students at the Royal College of Art. Something else that Blake experienced with François, and which he has always practised himself, was generosity and support to the younger colleague: Blake was somewhat astounded, and honoured, when François appeared, also bringing along his distinguished publisher Robert Delpire, at the private view of Blake's Paris exhibition in 1999 at the L'Art à La Page gallery on the Left Bank.

François was already drawing for *Punch* in the year that Blake's first cartoon was published there (1948). This magazine also had a sort of genetic connection to France since on its first edition in 1841 the masthead proclaimed it as 'the London *Charivari*'. This direct credit to its Parisian satirical predecessor came from *Punch*'s founders, the wood engraver Ebenezer Landells and the writer Henry Mayhew, who used the French magazine as a model. It may have been a happy combination of this history

and the fact that *Punch*'s then-editor Muggeridge had been brought in to revitalize the publication that provided Blake with another engagement with France. He produced a double-page spread of cartoons of French Impressionist and Post-Impressionist artists, *A propos des Maîtres* (1957), captioned entirely in French; something that would, to the previous editorial regime, have seemed outrageously and foreignly intellectual.

Muggeridge had dispensed with the 'pastoral sketches, illustrated poems and quaint anecdotes about marriage and women', sacking chief cartoonist E. H. Shepard of *Winnie the Pooh* fame, and giving the publication a modern feel. In particular he experimented with the cover, which had had an unchanged format since the early days. These French artist drawings of Blake's are looser and more fluent than some of his others of the period; he thinks this may be thanks to the extra space they were given: 'the little ones were so cramped'. But perhaps drawing 'in another language' (a theme which is taken up later) also in some way liberated him from the tradition of

British *Punch*; the theme of drawing art and artists may also have been a freeing one.

The French is very correct and the art-historical references sophisticated – in the first picture the scrawny model is drawn in a Renoir pose and is advised that she will eat better '*chez M. Renoir*' (who would of course have preferred a more rounded female form). In the second, a couple is in bed, but the woman senses a small black-bearded man painting her – here Blake refers both to a (not particularly well-known) painting by the notoriously short Toulouse-Lautrec, and to a Thurber cartoon. (Blake acknowledges that the writer, John Yeoman, who is a strong linguist, also helped with the jokes.)

Unserious as these cartoons undoubtedly are, the understanding of both art and French in such early works is yet more evidence of how imprinted with French Blake was, already in his early twenties. By then he had been exposed to, or had discovered for himself, artists who were to mark his own practice. In an extraordinary synthesis, his personality, imagination and education met their ideas, techniques and approaches, and the result, as we will see later, is particularly well recognized in France.

French editions

It was not surprising therefore that Blake's French radar would be extremely sensitive to the good things about France and the French. We cut to a weekend 20 years later, in the mid-1970s. By this time Blake is an established illustrator and is teaching at the Royal College of Art, but his success has by no means affected his down-to-earth sense of play: he is on his knees on the floor of The Children's Book Centre in Kensington, doing something he revels in, though nowadays perhaps no longer on the floor: a large roll of paper is stretched out in front of him and he is drawing, to the joy of his rapt audience of children and parents. Among them that day was the French woman Christine Model, who was later to marry the manager of the bookshop, Robin Baker. Model was immediately captivated by the scene: by the man, by his work and by the response to it. When, a few years later in 1979, she joined the French publishing company Gallimard Jeunesse (the children's book branch of Gallimard), one of her self-confessed intentions was to 'reveal Quentin Blake to France as a genius illustrator'.

The story of Blake's reception in France is a paradox which reflects both Christine Baker's and Blake's differing views of French culture, especially literary culture: to Baker it is a monolithic nationalist structure, with a large glass penthouse where the classic giants, the *philosophes*, Proust and Gide, Sartre, live. She sees children's literature, and in particular the illustrators who are often also its authors, languishing in the basement of this edifice, largely invisible and unvalued. Baker describes a children's book publishing scene in 1970s France which was quite unlike that of the UK or even the USA in the same period. In this country a new wave of author-illustrators such as Brian Wildsmith, John Burningham, Janet and Allan Ahlberg and Pat Hutchins, in addition to the emerging Quentin Blake, had all exploited the opportunities offered by new high-quality colour printing techniques to produce a

highly innovative and individual array of works. In France, says Baker, there was very little of interest or quality on the shelves of libraries or children's bookshops; the diet was either the book versions of Disney films, Saint-Exupéry's enduring *Le Petit Prince* or seasonal heritage classics such as Caputo's evergreen *Roule Galette*, illustrated by Pierre Belvès, and first published in 1950. This is a story about a '*galette des rois*', that most traditional of French cakes which appears in bakeries after Christmas, to be eaten on the Feast of the Epiphany, 6th January. According to Baker, the book's success is more due to its unique place in seasonal celebrations than it is to the quality of text and image. Where, asks Baker, was our *Very Hungry Caterpillar* or *Mr Magnolia*?

To Blake, on the other hand, France was the home of his hero artists and writers, and to be connected to them in some way by being published by Gallimard, France's most literary publishing house and home to that almost mystical imprint, Pleiade, would be an accolade. So when Baker bought the French rights for the Dahl and Blake picture-book *The Enormous Crocodile* and some of the earlier books which he had produced with the author Russell Hoban, Blake was more than prepared to do the self-help marketing that publishers expect their authors to commit to: promotional appearances in libraries, bookshops, book fairs such as Montreuil and even in schools. For Baker and the new Gallimard Jeunesse section, led by its individualist and autodidact founder Pierre Marchand, there was now an opportunity to present French audiences with high-quality, sophisticated and well-designed children's books. Gallimard (the house which has been described as having, 'the best backlist in the world') could now extend its policy of discovering and publishing the best new voices in literature for adults, to provide the same for children.

From these beginnings grew a relationship with Gallimard which has bloomed brightly and persistently for over thirty years: virtually all Blake's books for the UK market are also published in France; there are even a couple which have appeared exclusively there: one of these is *Promenade de Quentin Blake au pays la Poésie Française*. This anthology of French poetry for young people includes relatively few of the classics normally crammed into the heads of young citizens, and a refreshing number of little-known verses such as 'Sardines à l'huile' by Georges Fourest, a mid-nineteenth-century poet of the burlesque.

Choices such as this one offered Blake rich opportunities to encourage young readers to engage with a form that is still sometimes considered difficult, and his choice of the works and their order of appearance are made with a special care for this: it is no coincidence that the book opens with two daft poems about sardines, then moves gradually into the elegiac with the Renaissance poet Du Bellay's famous sonnet 'Heureux qui comme Ulysse' and a poem about the old station of Cahors; at this point it can safely plunge into two tough works about war, the plaintive 'Gordes, que ferons nous' by De Magny and de Musset's 'Chanson de Barberine', before finally lifting the mood again with the Brassens' 'La Canne de Jeanne' and a surreal and jolly poem about a pelican by Robert Desnos.

Gordes, que ferons-nous ? Aurons-nous point la paix !
Aurons-nous point la paix quelquefois sur la terre ?
Sur la terre aurons-nous si longuement la guerre,
La guerre qui au peuple est un si pesant faix ?

Je ne vois que soudards, que chevaux et harnois,
Je n'entends que parler de conquêtes et de terres,
Je n'entends que clairons, que tumulte et tonnerre
Et rien que rage et sang je n'entends et ne vois.

Les princes aujourd'hui se jouent de nos vies,
Et quand elles nous sont après les biens ravies
Ils n'ont pouvoir ni soin de nous les retourner.

Malheureux sommes-nous de vivre en un tel âge,
Qui nous laissons ainsi de maux environner,
La coupe vient d'autrui, mais nôtre est le dommage.

OLIVIER DE MAGNY

Gallimard's confidence in their British author-illustrator is to be seen in the fact that they published *Dix Grenouilles* (Ten Frogs) in France before it appeared in the UK; they also risked publishing a work which did not sit comfortably in any of the highly compartmentalized sections of bookshops or libraries (usually the cause of a book's early demise in sales terms): *Vive Nos Vieux Jours* (2007) is a unique combination of art, humour and therapy to be enjoyed by people of all ages; a commentary-free suite of images from the series (known as the *Kershaw Pictures*) which Blake made for an NHS ward of the same name. This ward was a residential diagnostic unit for older adults, who were often confused and unhappy. But in these joyful pictures, grey-haired people cavort companionably in treetops, reading, making art, playing the trumpet; doing the things they once did and, in the right circumstances, might still be doing. It was only in the following year that the work was 'translated' for the UK as *You're Only Young Twice* and published by Andersen Press.

Despite Christine Baker's sense that children's literature and its creators are generally undervalued in France, it does seem that Blake enjoys a particular kind of celebrity there. This may be thanks first to the broad spread of his work – which starts with books for children such as the Dahl novels (which enjoyed huge success in France in the 1980s and 90s), and includes his own *Armeline Fourchedrue* (Mrs Armitage), *Le Bateau Vert* (The Green Ship) and *Clown* (no translation needed) as well as books for children and everyone else such as *Nous les Oiseaux* or *Vive Nos Vieux Jours* – and second to the fact that this range is visible both to the general public and to professionals, in the physical spaces of bookshops. Because of current strict anti-discounting laws in France, the internet book trade is smaller than in the UK, and bookshops still do exist as places to visit and spend time in, often in great numbers

(for example, Tours, a French town of 140,000, currently (2014) lists 27 while St Alban's in the UK, with a similar population and demographics, has 5). Public libraries also still play a major cultural role in France, being relatively well funded and often easily accessed through their central locations. As a result there are many more professionals such as booksellers and librarians with expert knowledge of their stocks, who are able to guide book buyers and borrowers. Between about 1980 and 2005 Blake made dozens of popular appearances in the places where librarians, booksellers and also teachers meet – book fairs, bookshops, exhibitions in libraries, and schools – and so his recognition is extremely high. For Blake and his publishers the ultimate tribute occurred in 2013 when *Promenade de Quentin Blake au pays la Poésie Française* was included in the Ministry of National Education's influential list of recommended books for primary-age children.

Schools

Blake's engagement with schools in France has been something that means a great deal to him. During the 1980s and 90s Blake criss-crossed France on such missions. He would turn up in Marseilles, Metz, Orléans, Bourg-en-Bresse or Limoges, and make his way across the grey-surfaced playground with its regulation plane or chestnut tree to the primary school entrance. Inside he would talk about his books to the children and teachers, perhaps also draw for them. Blake found this experience to be a particularly organic way of discovering France and the French, for here he was calling in on adults and children in their normal working environment. Sometimes he would be put up in the homes of teachers or families and he remembers the charm of a teenage girl returning from a holiday in the US, having learned to say 'awesome' in the most perfect American accent. To such things could be added the pleasurable feeling that, even though the people he was visiting were all unknown to him, they, on the other hand, knew a lot about him and appreciated his work, so there was already a kind of established and warm rapport. So efficiently did his reputation precede him that when he recently visited a school in Aytré, in the Charente-Maritime, wearing a pair of beige shoes instead of his habitual white ones, a disappointed teacher exclaimed: '*Mais Monsieur Blake, où sont les chaussures blanches?*' (But Mr Blake, where are the white shoes?)

Language

The Gallimard adventure was in the end to have an even more profound impact on Blake's life and work. Blake began to realize that his spoken French was, in his opinion at least, still too schoolboy for the communications he needed to have with the Gallimard editorial and production teams as well as in more outward-facing situations such the Montreuil Book Fair. He decided to take conversation lessons, which he took seriously, and which therefore had results. He also then embarked on a journey through French literature: by today (2014) he has perhaps read even more widely in French than in English, somehow being more interested in contemporary French literature than its English counterpart. Christine Baker once said: 'Quentin

has read more books in French than many French people.' He listens to French radio and watches as much French TV as he does British, and he is prepared to use his now excellent French to address audiences of hundreds in lecture theatres, or thousands on the radio or television, on the many occasions he has been asked to do so. Listening to him speaking French today, the language is delivered, as it is in English (though with the speech a shade slower), with the same deliberation without excessive underlining; it is flowing like his drawings, and as colloquial as they are, and the little hesitation devices (the er's and ah's) have a proper French timbre. Thanks to his extensive reading, his speech is also eloquent and literary, and he often delights and amazes his French interlocutors when he quietly murmurs into the conversation a word such as '*désinvolture*' (a word that translates uncomfortably into English as 'casualness').

It's possible to speculate here about what his French-speaking may mean for Blake. The Czech proverb 'Learn a new language and get a new soul' says something about a kind of freedom from the perceived self that mastery of a second language can bring, and which has been described by many psychologists. The non-native speaker can use a second language to express aspects of their personality, which may be more satisfyingly and differently articulated using words or expressions in the second language.

Blake chose to learn French again as an adult: he knew it would help him in his work and so the learning of it was full of moments of pleasure and achievement. In the sense that when a person speaks another language he takes on 'someone else's words' and makes them his own, it is not so different from acting. Maybe the francophone Blake is another version of the actor manqué, who joins seamlessly with Blake, the boy who acted at school and in the army, and Blake the mimic, who pretended to be a frog and made his RCA students helpless with laughter in a Paris restaurant.

It is not just the French language that Blake has loved and read and practised all these years. We have seen that his family connections with the country were full of meaning, and how attractive its art and culture were to him from an early age. It is also the territory that beckons to him, its towns and villages, and its people, the way they shop, eat, drink and celebrate. As with many of his generation, for Blake France was the first bit of 'abroad' after England and even in a period when the British were discovering Italy, Spain and Yugoslavia, he tended to go back there for holidays, taking a car with friends and renting houses or staying in modest hotels. All of which culminated in a wish to buy a property there, which, thanks to the financial success of his collaborations with Dahl, he was able to do in 1990. He does admit though that he was almost put off the purchase by the then daunting prospect of the protracted uncertainties involved in buying a property abroad.

Chez lui

Blake's first French visit had been to Bordeaux, and since then he has been particularly drawn to the south-west region. Holidays in and around La Rochelle had introduced him to the Charente-Maritime, and its flat coastal landscape was attractive to him: it's a place of wide skies, egrets, herons and storks; views where concrete

water towers, Romanesque churches and agricultural buildings seem to punctuate the green expanses with equal monumental nobility; an undramatic environment, dotted with signs of oyster cultivation: the oystermen's modest wooden cabins with their red-tiled roofs and cheerfully painted woodwork, and an endless mosaic of *claires*, those rectangular ponds, formerly salt-pans, where oysters from the Marennes region are refined for the final stage of their complex life-journey to the French dinner table. Blake decided to buy a property there and spent time looking for the right house but, as usual, the search itself was not a wasted experience: one rejected house became the setting, and inspiration, for his book *Cockatoos*, the story of a not-so-bright professor with a collection of pet cockatoos who outwit him by finding ingenious hiding places all around the home. Blake finally settled on a *maison bourgeoise* in a village on the Arvert peninsula north of Royan, where he has spent several months every year. This house and its location seem to contain and represent some of the things about France Blake is closest to. The village is comfortable but unremarkable, with few notable or historic buildings. But it has a thriving primary school, two churches, a minimarket and a bar – it feels open for business in a way that many shuttered French villages do not. A singular path leads down to the river, along which, in the season, the oystermen open their cabin doors and set out little round tables with rusty chairs, where shell-fish can be taken, with a glass of local white wine.

The house itself, stone, with pale blue shutters, still bears the traces of its previous owners: a stretch of wallpaper with tiny orange and blue flowers, the rambling attic where owls once found a nesting place, the pine-clad laundry room – intended or not, it's as if, by leaving them unreplaced, Blake takes on some of their Frenchness by osmosis. A blue-checked kitchen where Blake cooks, in simple, French style, leads to

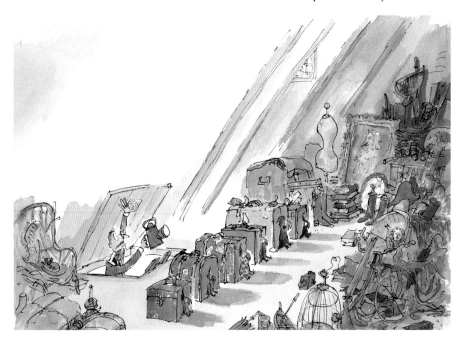

the calm, dark-wood-panelled dining room. Here the remains of breakfast may form an unintentionally beautiful still life, lit by the sun pouring in through the French doors.

Outside on three sides of the house rambles an English-looking garden with lawns, fruit trees, roses and flower beds; only a clump of robust palm trees suggests the southern latitude of this place.

This is an area where the French holiday – small towns by the water, where the Bay of Biscay meets the Seudre estuary, fringed by campsites in the pine woods, and little villas called '*Brise du Soir*', '*Nos Ancêtres*' and even one which, according to Blake, he saw once but has never managed to find again, the unforgettably named '*Hasty Weekend*'. Blake will choose a bar for his visiting friends, perhaps by the sea, but, just as likely, it will be one in an ordinary corner of the town, with nothing particular to recommend itself to the uninitiated. This will be a place to drink a coffee or a *demi-panaché*, or eat an ice-cream, at a street-facing table of course. Because the view of French town life going about its business, is as attractive to Blake as any perfect beach perspective, perhaps more so. Sitting with him in such a place I have sometimes caught a glimpse of him, apparently looking purposefully at (but never sketching) the small details that may later find their way into his drawings and give them their character: no traces of heavy realism here, but a light-touched authenticity which is all the more convincing: the design of a wicker basket, the angle of the shopper's head closely inspecting a fish in a market stall.

The café pause might be followed by a walk along the wild white sandy Atlantic beach, whatever the season, but probably not a dip in the sea, even in hot summer. Then, later on, a dinner might be had in one of the many plain-speaking establishments of the area. Blake enjoys these meals, the food of course, especially

traditional dishes that his mother or grandmother would have produced if they had been French, *rognons de veau* in a mustardy sauce, or a guinea fowl with mashed potato. But he seems to enjoy every aspect of the restaurant experience, from the waiter's deft bottle-opening manoeuvre, to the preposterous Wild West painting on the wall, to the napkins, tortured into absurd folds for the sake of bourgeois elegance, to the fact that someone actually spent time on this activity.

Paris

When not in the Charente-Maritime, Blake also has reasons to be in Paris. Just sniffing the air would be one, but more often his work takes him there. He might be curating an exhibition, as he did in 2005 when the Musée du Petit Palais Museum reopened its doors after a major refurbishment and invited him to select works from their reserve, animated by his own drawings on the walls. Or perhaps he will be working on a hospital project: a scheme for the Hôpital Armand-Trousseau, a children's hospital in the unfashionable 12ème district, was a demanding example in 2008, involving Blake (then 75 years old) in trips across Paris, often by Métro and on foot, followed by lengthy meetings with staff and patients, all in French of course.

Blake has also recently shown his own work in the Paris Galerie Martine Gossieaux in the Rue de l'Université. This gallery has for 20 years specialized in the graphic arts, in particular the work of Sempé, and Blake's recent exhibition there was of a series of works called *Nos Compagnons* (2014). These images felt particularly at home on the Left Bank – sophisticated, sexy, witty and intellectual.

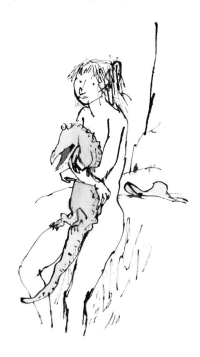

And the Left Bank is also where Blake himself feels at home, reassuringly close to the Gallimard Jeunesse mother-ship, also in the Rue de l'Université, and to his favoured small hotels and restaurants: Les Marronniers, Le Petit Zinc, and, in the past, the now sadly departed and poetically named Temps Perdu.

Like the Charente-Maritime, the Left Bank seems also to resonate well with Blake's personality, although addressing a different aspect of it. Not for Blake the painter's Paris of Montmartre – he is more likely to be nosing out Daumier lithographs in a print dealer's in the Rue de l'Université. Although he certainly does visit exhibitions – the Musée du Luxembourg and, for sentimental reasons, the Musée du Petit Palais are both favourites – his preference these days is to spend time in the bookshops of Saint-Germain, establishments with names such as L'Écume des Pages, an atmospheric small shop with very tall shelves, which stays open until midnight most evenings, where he might pick up anything from the rare Simenon novel he has managed not to have read, to something by the art historian Daniel Arasse; he might equally be found in the similarly poetically and nautically named La Hune (The Crow's Nest), with its refined stock of literature, arts and humanities books. In between visits to these two, also geographically between them, a *porto blanc* might be taken at one or other of those icons of Left-Bank culture, the Café de Flore or Les Deux Magots.

Connections with literary Paris are also often excuses for Blake to be there. Dinner, perhaps, with his friend the prize-winning author Daniel Pennac, in his book-lined dining room at his home in the bustling northern suburb of Belleville. The two men have a great deal in common although they are opposite as personalities: Pennac the larger-than-life extrovert, and the more reticent Blake, who Pennac has beautifully described: '*Il y a chez lui une gravité et un quant à soi à mon avis infranchissable.*' (There is a seriousness about him, and a self-possession that is, in my opinion, unbreachable.) And these differences may in part account for the mutual admiration, which clearly exists. They are both teachers who left schoolteaching to 'do' education differently, Pennac (after 20 years in the classroom), through his writing and public speaking, and Blake, through his books and, increasingly, works beyond the page, both share a humane approach to life, which is supremely contained and expressed in their work.

Pennac has terrifying experiences of the worst excesses of the French education system, which used fear and rote learning to cram the ossified canon into the heads of reluctant learners, dunces ('*cancres*') as Pennac identified himself. As a result he became a French teacher working in a tough secondary school, knowing what it would be like to be the class failure. He devised ways of encouraging that student to want to read books, the key to all learning, in Pennac's opinion. His first tactic was to read to students for an hour at the end of the day, and ask no questions after the session ('A book is not an exam, it is a gift', he says in *Comme un Roman*, his first book about education and for which Blake illustrated the cover for the English translation called *The Rights of the Reader*). After a few of these readings, he found that the most cynical of the class illiterates would come up to him at the end of class, asking, 'Who was this Roald Dahl then? And did he write anything else?' and this student would be saved.

Blake did not suffer from this kind of education; on the contrary, he seems to have been a model pupil who had no difficulties in accessing literature, even though there were no books at home. But he has true empathy with those characters who don't make the grade or who are rejected, as his works such as *Clown* demonstrate. And he shares Pennac's belief in the essential role played by high-quality 'real' books (as opposed to publishers' reading schemes): compelling stories and illustrations which will motivate children to learn to read in the first place and then to become lifelong readers. Both Blake and Pennac have written introductions to each other's work and both praise a spirit that each recognizes in the other, and which somehow transcends the work itself.

Pennac writes, in his introduction to *Nous les Oiseaux* (The Life of Birds):

Les dessins que Quentin Blake nous propose dans ce livre ne sont pas des illustrations. Ils ne sont pas nés d'une lecture, ni d'une observation, mais d'une vision. Chacun est une oeuvre à part entière. On pourrait écrire une nouvelle, voire un roman, sur la plupart d'entre eux…

(The drawings Quentin Blake presents us with in this book are not illustrations. They are not born from reading, nor from observation, but from a vision. Each one is a work on its own. One could write a novella, or even a novel about most of them . . .)

Likewise, Blake writes on Pennac in his foreword to *School Blues*: 'There aren't many books on education, I imagine, that affect one's feelings as Pennac's do . . . What he brings to the situation of the no-hoper is the prospect of hope.'

More recently Blake also visited Paris to carry out a duty that very few Britons are ever asked to do. In the UK when the state honours one of its citizens, the Queen or other members of the Royal Family pin the ribbon and medal on to the proud recipient's chest, but in France honorands are (delightfully) able to nominate the person they would most like to decorate them. Joann Sfar was appointed Chevalier de l'Ordre des Arts et des Lettres in 2011 and his obvious choice for the 'decorator' was Blake, whose work he had so long admired: in *Caravan* he draws/ writes about the prospect of his first meeting with Blake. The occasion was an interview about the Roald Dahl books commissioned by the cultural magazine *Les Inrockuptibles*.

This visit is, Sfar says:

as if Father Christmas in person was granting me an audience. Some drawings you have looked at since childhood help you to learn about reality, how to make the world less frightening. Ever since I was small . . . I've learned to see things through Quentin Blake's . . . eyes. [His] drawings have this wonderful ethical power: they help me to put up with my fellow human-beings, love them even sometimes. Oh eternal God, deliver us from priests but protect the people who draw.

The pinning-on of Sfar's decoration was a thoroughly French act. It took place in one of the bare but historic seventeenth-century salons of the Gallimard offices in the Rue Gaston-Gallimard. Packed with Sfar's excited friends, mainly under 40, from the *bande-dessinée* (comic-book) world, the room was also alive with audible and visible enthusiasm for Blake, who carried out the ceremony in faultless French. 'Ahs' of delight followed from the audience when he presented Sfar with a large drawing of him as a knight on horseback – yet another example of Blake's ability to conjure and combine many ideas (knight, seventeenth century, portrait, identity, inspiration) to produce something perfectly suited to the recipient and to the moment.

Blake's own contribution to the promotion of French culture, both in France and in the UK, has of course also been recognized: he has moved through the ranks of the Ordre des Arts et des Lettres, having been nominated both Chevalier and Officier, with ceremonies at the French Institute and Residence in London, where he was decorated by his publisher, friend and greatest French supporter, Christine Baker, and by the French Ambassador. He then joined the prestigious Légion d'Honneur as Chevalier, an honour presented to him at the French Ambassador's residence by the visiting current French minister of Culture and Communication, Aurélie Filippetti.

'Chavalier jouant au banjo...
(9⁰ᵐᵉ siècle)

French recognition

Paris was also the scene of the achievement in France that Blake is probably proudest of: the exhibition mentioned earlier, which he guest-curated for the reopening of the Musée du Petit Palais. This extraordinary building faces its bigger and more monumental brother, the Grand Palais, in that grand area of the city, mainly formal gardens, which borders the Seine on the Right Bank and stretches from the Louvre at the eastern end, takes in the Tuileries Gardens, and fringes the Elysée Palace on its west side. Designed by Charles Girault for the Universal Exhibition of 1900, but in a state of genteel decay 100 years later, the Petit Palais was restored to its former glory in 2005. The plan was to find an opening exhibition which would remind a broad audience about the museum's collections, which had languished in the stores for the five years of the closure. A connection to people working for the Musées de la Ville de Paris, a group to which the Petit Palais belongs, led to a lunch attended by, among others, Gilles Chazal, at the time Director of the Petit Palais. His conversation with Blake at this lunch convinced him that Blake would be an interesting choice of curator

for his opening exhibition. Not only did he know about the art represented in the collections (mainly nineteenth-century French), but he could make drawings on the walls, much as he had done at the National Gallery for the exhibition *Tell Me a Picture,* and invite a new kind of audience into the building. As a result, he offered Blake carte blanche to guest-curate an exhibition – something common today, but much more unusual in France in 2005, where professional expertise is so trammelled. Blake was invited to trawl the extensive reserve collections and I was asked to act as a consultant on the project, having already co-curated *Tell Me a Picture* with him in 1999–2000.

Blake would make a selection of works from the stores and then 'illustrate' the exhibition with a series of his own drawings, enlarged and printed on acetate, which would occupy some of the spaces of the 15-metre-high walls, and act as 'exhibition guides'. As Christopher Frayling, at the time Rector of the RCA, described it: 'a huge Quentin-style gateway to an exhibition of nineteenth-century paintings'.

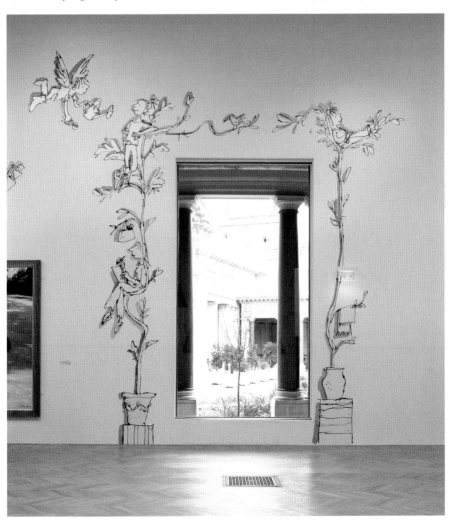

The collections included paintings, prints and drawings by many of Blake's favourite artists including Daumier, Steinlen, Jacques-Émile Blanche and Forain. After several lengthy research sessions in the museum's store on the Boulevard Peripherique, Blake identified 'women' as a unifying theme for the exhibition. The works he eventually chose to illustrate it were a very characteristic selection: apart from a wispy *fin-de-siècle* vision of Ophelia drowning by the hardly known Paul Albert Steck (died 1924) and one or two more fanciful pictures, the images were all of everyday life. A Vuillard lithograph of a woman washing dishes in a kitchen here, there two laundresses engaged in some minor confrontation in a Steinlen print, a girl next to her bicycle representing feminine freedom in 1903, by Comerre, a mother and her two restless little daughters in a Degas pastel. Degas was one of a few famous names, but the pictures were mainly many little, speaking scenes, which were echoed by those taking place between Blake's small winged figures who hovered around the framed works, leading visitors towards the artists, travellers, laundresses, goddesses, mothers and lovers, and acting as visual commentators. Aude Mouchonnet, the young gallery curator assigned to assist on the project internally, came up with the clever title for it: *Quentin Blake et les Demoiselles des Bords de Seine*. This suggested both Blake's familiarity with French art (the second part of the title being the name of a painting by Courbet, a version of which is in the Petit Palais collection), the location of the museum and perhaps also his own particular enjoyment of the company of French women.

Ironically it was two French women who also made the experience of working on *Demoiselles* less straightforward than it might have been: the two senior internal curators who advised on the exhibition at first showed some barely concealed Gallic scepticism at the idea of a British illustrator with no formal training in art-history being let loose in their picture stores. However it was noticeable that by the time the exhibition opened, they had begun to smile more; over the course of many meetings Blake was always quietly respectful towards them (as he is to everyone), but his confidence in his own artistic aims for the exhibition remained resolutely intact. This appeared to have a softening effect and in the end they were quite helpful.

The exhibition turned the towering white expanses of the new exhibition galleries into graceful, dancing spaces. These included cleverly signalled views into the beautiful and surprising interior garden, with its palms and grasses, and mosaic-bottomed pools. Blake, said the *Figaro* online review, has 'created a rhythm between these works and his own drawings . . . displaying both his wit, his delicacy and all the poetry of his universe.' (*Il a rythmé la présentation de celles-ci de dessins de sa main sur les cimaises du Petit Palais, révélant à la fois son humour, sa délicatesse et toute la poésie de son univers.*) And it is worth quoting the director Gilles Chazal's catalogue introduction to show how completely he understood the philosophy behind this exhibition:

A work of art lives only through the gaze cast on it by its viewers. And gazes come in many varieties; when they are negligent, the work slumbers on, when erudite it remains caught in the net of its original context. When the gaze is that of an aesthete, the work sings with all its components, materials, forms and colours. When it is poetic, it opens up the work's

unbounded potential, for sensibility, comic or tragic reality or for dreams . . . for all of humanity, in fact!

Quentin Blake's gaze is in the last category. Because the Petit Palais admires his works, and loves the man, and has trust in his talent, it has given him carte blanche. Carte blanche to choose from the reserves works that will delight him. Carte blanche to let him leave his own traces on the exhibition walls, which are so resonant of the place's history, to make drawings that will charm the visitors.

So the walls of the galleries have begun to float like clouds, and the ladies on the banks of the Seine to speak, discuss, cry and laugh, and sing . . . The works of art have really come alive!

Blake has also been honoured by too many French literary invitations to list comprehensively here: poignantly, because I happen to write this the day after the murder of among others four *Charlie Hebdo* cartoonists, he was given a spread in that publication. Catherine Meurisse, a fellow cartoonist who missed being murdered by arriving late at the office on that fateful day, also interviewed him at his French home and out of it created the touching centre-spread on page 143.

In 2012 he was asked to illustrate *Le Figaro Littéraire*, an occasional and respected supplement to the main paper, which comes out for the '*rentrée littéraire*'. The word '*rentrée*' (return) usually means the general return after the (long!) French summer holidays. Associated with '*littéraire*', however, it refers to the early autumn period when most books are published, when publishers engage in heavy promotion of their authors in the hope of their winning one of the many literary prizes that are awarded in the season. Blake's illustrations were accompanied by an article about him, which conveys France's appreciation of him in succinct, if rhetorical, lines: '*Le dessinateur anglais nous fait l'honneur d'illustrer ce numéro du* Figaro littéraire *consacré non à la rentrée des enfants, qu'il gâte tant, mais à celle des livres, qu'il vénère.*' (We are honoured to have [Blake] to illustrate this edition of *Figaro Littéraire* for us, which is dedicated to the *rentrée* not of children, who he so indulges, but of books, which he worships.)

It is a mark of Blake's grounded character though, that, honoured as he felt to be asked to be involved in *Figaro Littéraire*, he was almost as pleased to be awarded the 'Prix Littéraire Quentin Blake', not in Paris this time, but by the primary school children of the town of Thouars in the Department of Deux-Sèvres. This was a prize that he couldn't help winning, because each child had to vote for their favourite of Blake's books, which were classed in different categories, and he says he was touched by the amount of preparation and research on the part of both children and teachers that went into this project.

So Blake has been very widely recognized in France, from enthusiastic young schoolchildren to the intellectual heights of the TV Talk Show *Apostrophes*. This programme, which ran from 1975 until 1990, was hosted by Bernard Pivot, a tough ex-*Figaro* journalist, and became one of the most watched and influential cultural programmes of its age, even being criticized by the writer Régis Debray for ruling as

Fantastique maît[re]

"Ici, l'huître naît !" nous annonce un panneau à l'entrée du bourg...

Sa perle rare est lovée dans l'atelier d'une belle maison charentaise : l'illustrateur britannique QUENTIN BLAKE élit domicile une partie de l'année dans ce village de Charente-Maritime.

Les dessins de Quentin Blake, quand ils vous cueillent dans l'enfance, ne vous lâchent plus. Acolyte de Roald Dahl, John Yeoman ou Michael Rosen, Blake, lui-même parfois auteur, a illustré plus de 300 livres, essentiellement pour la jeunesse. En 60 ans.

Son trait, espiègle, n'est jamais caricatural ; il est léger, intense, gai, et Q. Blake s'étonne qu'il évoque si souvent la joie qui se dégage de ses dessins. Lui ne prévoit rien :

"C'est la main qui dirige, plus que la tête !"

Enfant, j'ai le souvenir d'avoir senti que les dessins de Quentin Blake, si singuliers, si peu mièvres, ouvraient une fenêtre sur un monde plus "adulte". Ses images, débordant d'humour, ne prenaient au sérieux.

"Quand je suis arrivé ici, il y a vingt ans, j'ai trouvé quelques meubles en brocante pour ne déranner. Rien n'a changé depuis."

L'artiste dans son plus simple appareil : tréteaux, table lumineuse, plumes, encres, papiers.

LE CHAT NE SACHANT PAS CHASSER

...en 1932 dans le Kent, Quentin Blake étudie la littérature et les arts, puis enseigne au Royal College of Art de Londres de 1965 à 1985. Nommé Children's Laureate en 1999, il remplit sa mission de promotion de l'art et de la littérature jeunesse au Royaume-Uni avec enthousiasme.

Cette année, la Reine l'a anobli. Ce qui ne sonne pas autant la retraite pour Blake, qui dessine tous les jours, inlassablement.

...tout, des livres : les siens, ceux des autres. Beaucoup de Roald Dahl, bien sûr. Quentin Blake aime parler littérature.

"Je suis sûr d'avoir fait le bon choix : la littérature, les mots sont si importants pour moi."

"J'ai lu, en français, Balzac, Flaubert, j'ai même essayé de lire les frères Goncourt... pas facile ! J'aime Alphonse Allais."

Allais, auteur facétieux, cousin à sa manière de Quentin. Quant aux Anglais :

"J'aime Dickens, sa puissance, sa satire généreuse."

Au début des années 50, j'avais vingt ans et des doutes : vers quelle voie me diriger ? Entrer à l'École des Beaux-Arts, peut-être vais-je cesser de ..., ou lire moins. Si j'étudie lettres, je sais que je continuerai à dessiner.

...étudiera l'anglais à Cambridge.

C'est chez un bouquiniste, il y a longtemps, que Blake découvre "Les États et Empires du Soleil et de la Lune", de Cyrano de Bergerac. Fasciné par la folie poétique de l'auteur, il l'illustre. Suivront Gulliver, Aristophane, Hugo, Voltaire. Gallimard vient de publier "Candide", mais pas "Notre-Dame de Paris" (sorti...

"Cyrano, c'est peut-être un peu compliqué pour les enfants, mais Victor Hugo..."

Le livre illustré, dans la tradition de Gustave Doré, n'aurait pas la cote ? Et pourtant :

"Il me semble que le dessin a cette force persuader le lecteur d'entrer dans de grandes œuvres."

21 août 2013 / CHARLIE HEBDO N° 1105

uentin Blake

...ubert n'aimait pas trop ...illustrateurs : il les jugeait ...apables de se mettre au ...veau de la littérature.

...st sûr qu'il faut agir ...e discrétion, avec un ...t de la suggestion qui ...t stimuler le lecteur ...ns "Candide", par ...emple on peut tout ...ustrer. Mais l'objectif ...l'illustrateur n'est pas ...même que celui de ...uteur. Il y a comme une ...toire avec les mots et une ...tre avec les images.

...Angers, une sage-femme m'a dit :

...omment avez-vous ...ça ?

...e signifiait ce "ça" ? le rapport ...e la mère et l'enfant ? Autre ...se ? C'est cela qui est fascinant, ...ns le dessin : on a envie de trouver ...elque chose, on ne sait pas trop ...n quoi, mais on le voit apparaître ...dessinant lorsqu'on est chanceux."

...ake aime l'interaction, et c'est ...à là même qui produit le ...nique dans ces illustrations

...moi, l'humour ne consiste ...s simplement à imaginer des ...Je me souviens d'un prof ...Chelsea qui m'avait dit : "You know ...w to make the good people look ...sting? tu sais comment rendre ...personnages positifs intéressants. ...'est pas difficile de dessiner des ...échants pittoresques ; ça c'est ...s de dessiner les bons.

...ropos ...ndré ...nçois ...5 2005), ...tre, ...sta et ...artiste ...cial :

"il a été très important pour moi. Il osait emprunter des "trucs" de la peinture pour en faire de l'illustration. Je me disais, ébahi : c'est autorisé de faire ça ??" Ci-dessous, un crocodile de François, un de Blake.

Le mot chance revient souvent dans la bouche de Q. Blake, pour qui le dessin, les collaborations avec les auteurs ou la joie transmise au lecteur sont des "cadeaux".

"La plupart du temps, je ne sais pas ce que je veux faire. Je suis très reconnaissant aux textes des auteurs, qui m'emmènent dans des lieux, des directions où je ne serais pas allé spontanément ; des personnages que je n'aurais pas prévu de rencontrer. Je suis comme un comédien dont le répertoire doit se renouveler."

"C'est comme un accident, que l'on désire." L'accident est favorisé par les outils utilisés par Q. Blake : plume et roseaux, taillés à la main.

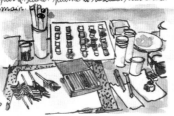

"J'ai toujours été attaché à cette dimension du dessin : savoir rendre la beauté et la laideur en même temps, l'éloge et la satire. Ne pas se contenter de la cruauté."

"Les Deux gredins" de Roald Dahl :

Sur Ronald Searle (1920-2011), autre "maître" :

"Il y a une question que je n'ai jamais osé lui demander, c'est : avec quoi vous dessinez ?"

Cette question, on peut oser la poser cent fois à Q. Blake.

"J'aime dessiner debout, cela me permet d'incarner plus facilement mes personnages, de faire leurs gestes."

"Le théâtre est très important pour moi. Je vois des similarités entre le dessinateur et le metteur en scène. J'aime la réunion de comédiens sur une seule scène, ou de personnages dans un seul dessin. J'aime voir et dessiner l'interaction, les regards croisés..."

Q. Blake est un illustrateur gâté, qui gâte en retour, à tous les stades de l'existence : il dessine pour les enfants, les adultes, les vieux, et même les nourrissons. À Angers, on n'accouche plus dans la douleur depuis que les murs de la maternité sont recouverts de ses couleurs :

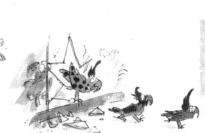

Le dessin serait un art vivant, tour à tour théâtre et danse : Q. Blake sait faire d'une grenouille un danseur virtuose ("Danse, danse", Folio Gallimard) :

Q. Blake ne se désintéresse pas pour autant des dessinateurs purement caricaturistes. Il est lecteur de "Charlie" et connaît bien "le Rire" ou "l'Assiette au beurre", revues d'une époque qu'il apprécie pour ses talents : Toulouse-Lautrec, Vallotton, Steinlen... Le dessin politique l'a-t-il tenté ?

"Non... Je suis trop lâche ! Et trop poli... Il y a sans doute un autre moi qui aurait pu faire cela..."

Il aime les dessinateurs, parce qu'avec eux, "nous pouvons parler de choses qui nous passionnent", dit-il, l'œil malicieux. Sur la route du retour, un rond-point éblouissant :

L'important, c'est le geste !

'a virtual dictatorship over publishing markets'. Blake did understand how important and rare it was for an illustrator, a children's illustrator as he then was, to appear before Pivot, the high priest of literature. Pivot had in fact told Gallimard that he would never do a programme about children's literature and Blake was invited on an '*entente cordiale*' thematic with other Franco-British personalities. Since his French was not yet the smooth running machine it is now, Blake practised his answers to possible questions with Christine Baker, most assiduously, she says. In the event, though, she remembers that, in true French fashion, Pivot was utterly distracted by one of his other guests, the actress Jane Birkin, and Blake and the rest of the guests barely got a look-in. Blake also recalls that in the pre-programme Green Room chat, Pivot, unfamiliar with children's book authors as he was, leafed through *Cockatoos* and said in a surprised voice: 'It's quite good, isn't it?'

Gallimard themselves have paid homage to Blake in significant ways, which are testimonies to the respect in which he is held both internally at the company and more widely by its readers. One was in the Gallimard centenary in 2011, which the publishers celebrated in various ways throughout the year. A lavish 400-page publication, *Gallimard 1911–2011: un siècle d'edition*, contained a page (only one – children's literature is still not rated in France in the way Baker would like) about the Gallimard Jeunesse imprint, with its slogan '*de la lecture à la littérature*' (from reading to literature), and Blake was the person invited to write it, which he did. Secondly, at the fortieth anniversary of Gallimard Jeunesse, the publisher Antoine Gallimard made a speech in which only two or three of their authors were mentioned, one of them being Blake. Lastly (and this is perhaps harder for a British readership to appreciate), his drawings for Voltaire's satirical novella *Candide*, which first appeared in the Folio Society edition (in a translation by Tobias Smollett) in 2011, reappeared in the Gallimard Folio Classique imprint in the following year. Folio Classique paperbacks are the French equivalent of Penguin Classics, a collection of the most prestigious titles of world literature, but somehow even more revered in France than Penguin is in the UK. 'Can you imagine?' says Baker. 'There's nothing more traditional and literary than this imprint. And *Candide*, a sacred French text, illustrated by a children's illustrator? It was illustrated in colour; we had to change the paper especially for him, and nobody made a fuss.'

Gallimard's embracing of Blake is not just about his value to them in terms of sales or marketing; it is an acknowledgement that in the 30 years they have worked with him they have seen something about the man (which many others in France now do) that is at once reflected in his art but is also bigger than his art. They and countless other French organizations and people see how his wholehearted engagement with French art and literature has given him something to say to even the most culturally insular Frenchman. In this British man they recognize a kind of learned humanity which comes through a lifetime of observing, reading about, and finally drawing his fellow human beings, which in some ways finds its match in great French artists such as Daumier. To repeat Pennac's words: '*Quentin Blake dessine moins des individus que ce*

qui fait de nous des individus.' (What Quentin Blake draws is not so much individuals as *what makes* us individuals.) .

'La Dédicace', from *Le Figaro*, Literary Supplement, 2012.

5 Flying (and swimming)

Quand son crayon se laisse aller naturellement sur une feuille de papier … c'est un oiseau qu'il dessinerait naturellement, ou quelque chose qui plane ou qui, s'envole, ou qui céde a une énergie de l'évasion, quelque chose qui s'en va, quoi. (When his pencil lets itself go on a sheet of paper, it'll be a bird that he will draw, or something hovering or flying away, something yielding to the energy of flight, something taking off, in other words.)
Daniel Pennac, *Les Ateliers de la nuit*, radio programme for France Culture

Birds – symbols of Quentin Blake

In Quentin Blake's studio, the artist's tools, paper, books, furniture, drawings and mementoes, even the walls, conspire to create a wonderfully coherent portrait of the man and his work. But when visiting it for the first time in the 1990s, I remember catching sight of a magazine-cover that didn't quite belong to the picture of Blake I was gradually putting together in my head: *Psitta Scene*, with its unsophisticated photographic cover of a green and red parrot, seemed out of place in this artistic-literary powerhouse. But I was wrong. Blake has a great fondness for parrots: 'They are very intelligent creatures,' he says, and members of the *psittacidae* family do keep alighting in Blake's work, either as principal characters such as in *Cockatoos*, or as

From Blake's series of drawings for Angers Maternity Hospital, Angers, France (2011)

the archetypal Blake detail: thoroughly incidental, but somehow lifting the page and making it sing, and the reader smile.

But parrots and their relations are not the only birds for Blake; many distinct varieties appear where the text calls for them, as do other more generic versions. Birds, Blake would say, have this positive about them: in common with flowers and mushrooms, you call them by their proper names, and they are like us, they walk on two legs. This last fact has also prompted him, late in his career, to create a separate Blakean genre: birds which/who (?) behave like people.

Blake's fondness for them may in part go back to childhood – he still has a book he bought when he was about 12 by Eric Hosking, an innovative bird-photographer at the time. Perhaps these dramatic and unfamiliar black-and-white images stayed in Blake's mind, helping to spark a lifelong attraction for both birds and the act of flying. Of course, the manner in which his cockatoos make their inky, scratchy journeys across the page has nothing to do with Hosking's barn owls, with their sharp, fanned-out wings, in the bird books; but both image-makers clearly find the bird a subject of delight and wonder. For Blake the illustrator they also have their particular uses on the printed page, as we shall see.

This chapter follows the birds and other airborne things in Blake's work, both for adults and in his better-known output for children. It also explores a metaphorical theme of people 'off-the-ground' in general, either in the air or in the water. It asks whether the constant recurrence of this type of imagery may be linked as much to its symbolic value as to Blake's fondness for wildlife, genuine as that is. So it looks at flying as a kind of underlying sign for something which I will call imagination, which characterizes all of Blake's drawing (and, in some ways, all of his lived life).

Childhood bird-watching and reading about birds led to a good knowledge of bird species and their habits and, early on, Blake had in his head a ready-made bird repertoire, which he used as subjects from the earliest times. Members of the Rahtz family remember that their father Roland, who also taught at Chislehurst and Sidcup Grammar School, had once whitewashed his garage wall and was happy for Blake to use it as a large white 'canvas'. Blake proceeded to paint a large cockerel, using house painting brushes and black paint. 'It was six foot high at least, a great big splashy picture', remembers Madeleine Rahtz. This memory is interesting for two reasons;

first, it is one of the few childhood recollections that the sisters have of Blake (Blake is about 10 years older), and so it suggests how impressive the event was. Second, it's a very early example of Blake working on a large scale. His reputation as an illustrator of world-famous children's books sometimes trumps that of Blake the creator of images 'beyond the page': although these are mainly drawings scaled up for printed reproduction, they are planned to be big, and a few, such as those which covered a building wrap in King's Cross, were very large indeed.

The Rahtz sisters also recall another occasion with Ajax, their pet jackdaw. This bird had been rescued as an abandoned fledgling by a teacher colleague of their father's, who had then brought it home to Hurst Road, where it lived for a while in admirable freedom in an open-fronted cage. The sisters remember that Blake was once at their house, doing a drawing of Ajax, when it suddenly swooped down and settled on the end of what was either a silver pen, according to one, or perhaps a pencil with a silvered rubber-holder at the end – they can't decide who was right. Whichever, they thought that the bird must have been after a shiny object, of the kind that jackdaws are said to hoard in their nests. This picture of untamed nature, and the more docile Blake at work, was clearly also a significant memory. Today Blake uses pencils much less than brushes, waxy crayons and, principally, pens of various sorts. These include a clutch of birds' feathers, and it is typical of Blake that he once drew a picture of a lively vulture using a vulture's quill.

So whether in early professional works such as the freewheeling magazine covers Blake drew for the *Spectator* or *Punch*, or in the first picture-books he illustrated, mainly texts by his author friend John Yeoman, the presence of birds is striking. 'I can't seem to keep birds out of my books,' he says in a *Guardian* interview in 2007. And, 'because birds can fly, [you can] make them appear anywhere on the page'.[1]

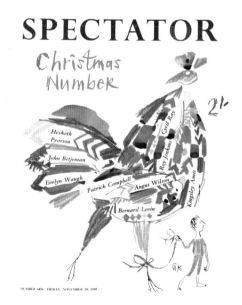

Is it a man or is it a bird?

It is not therefore hard to see why, in 1971, already a successful children's book illustrator for 10 years, Blake would have found the prospect of Joan Aiken's *Arabel* books appetizing. These stories first appeared in the BBC's *Jackanory* programme, read by Bernard Cribbins, in his wonderfully memorable, low-key way. To those unfamiliar with the series, four-year-old Arabel's taxi-driver father brings home an injured raven, which Arabel names Mortimer. The raven turns out to be a crazy character whose favourite food is staircases and who has a single word of human language, 'Nevermore'.

Perhaps Blake was tickled by memories of the Rahtz jackdaw, or by the literary association ('Nevermore' is the word spoken by Edgar Allen Poe's raven in his 1845 narrative poem of the same name), or by the fact of the bird's breed being correctly identified by a policeman, who knows his ravens from his rooks. Whatever the reasons, the drawings of Mortimer manage to be, in their sketchy way, fully raven-like in anatomical detail and behaviour, while also possessing the human emotions necessary for the reader's empathy. Birds can't smile, but in this illustration (*Arabel*, p. 79) the placing of the pupil in the eye and the angle of the beak are enough to persuade us that they sometimes do. Blake went on to illustrate all 18 of the *Arabel* and *Mortimer* series and the collaboration with Aiken was an extensive one.

Mortimer, as Blake says, is really a person, and there is no doubt that the same thing can be said of the birds that appear in both *Featherbrains* (1993) and *The Heron and the Crane* (1999), both texts by John Yeoman.

In *Featherbrains* the theme of the friendly jackdaw returns when Jack guides two accidentally released battery-hens to a confusing new life out of doors. These hens are puny, hopeless characters, and because of this, the way that Blake makes these benighted birds soar joyfully towards their new freedom is both ridiculous and moving at the same time – a perfect example, incidentally, of Blake's ability to represent the emotional complexity of a situation, even in a book intended for very young children. In *The Heron and the Crane*, a Russian folk-tale, the bird disguise is very thin indeed. Herons and cranes do look human anyway because of their long legs, but the story is really about a couple trying to work out their very contorted relationship; again, Blake's loose brush drawings improbably combine the exquisite

poetry of Chinese-style brush-painting with the slapstick of the birds' hopeless comings and goings across the marsh.

Metaphor is also at work in Blake's latest picture-book with a bird hero. In *Loveykins* (2002) Angela Bowling, a single woman of uncertain age, rescues and adopts an unusual baby bird, blown from its nest in a storm.

The bird, which she calls Augustus, is treated like the baby Angela never had, until he starts to grow alarmingly and destructively and eventually flies away, as he must, though he does occasionally drop in on his foster-mother with a present of 'a dead mouse . . . or a few beetles'. 'She never eats them', runs the last line. This is a book with the kind of strong simple narrative that small children need and enjoy. But, as in *Zagazoo*, and with the airiest of touches, it tells adults a story *they* need, in this case the one about children flying the nest. And as in the best kind of picture-books, it does this with an eloquent and lyrical pairing of text and image. This joyous image makes me wonder whether flying the nest is something that Blake might have wanted to do earlier than he actually did.

So in these books, the birds look like birds and fly and perch and walk like birds, but they sometimes find themselves in human circumstances. This sequence cannot end though without a mention of two other books, both aimed at adult audiences, where birds are mainly on the ground and behave in fully human ways.

The first of these is *The Birds* (in which yet another jackdaw appears, though with a walk (fly?)-on part only). This is a work with double significance in the Blake oeuvre: it was his first 'through-illustrated' book for adults and, as such, is the precursor of the line of wonderful productions for Folio editions. But it is also relevant for being the text of a play.

Blake happened to have read and enjoyed *The Birds*, a comedy by Aristophanes first performed in 414 BC, which imagined an ideal state in the sky, CloudCuckooland. Blake's copy of the play was a 1958 Faber edition, described as an 'English version' by Dudley Fitts, its American translator. In 1971 Blake, by then teaching illustration at the Royal College of Art, was asked by Richard Guyatt, Head of the Department of Graphic Design, to choose a text to illustrate for the Lion and Unicorn Press. This press had been founded by Guyatt at the RCA in 1953 and it published a few volumes each year, in limited editions, which reflected the highest standards of book production in typographic design, illustration and binding. In this way the Press could discover and foster new talent and ideas in each of these fields, among both the staff and the student body, and the volumes were in fact often collaborations between a student and a member of staff. The titles were pleasingly eclectic and included illustrated texts such as Vallans' sixteenth-century poem, *A Tale of Two Swannes*, and text-only books such as a sixteenth-century handwriting manual and *Five Speeches* by Kenneth Clark; some of the volumes were collections of images such as a set of wood engravings by Eric Ravilious; others were texts illustrated by artists who are household names today, such as David Hockney, David Gentleman and Hugh Casson.

Blake's choice of *The Birds* had good design and artistic reasons behind it. He recalls that up until then the Lion and Unicorn volumes were rather formal things, with heavy and elaborate bindings; they seemed unmodern, and unsuited to Blake's own loose and playful drawing style. *The Birds*, however, in Fitts' contemporary but poetic version, seemed to him an ideal vehicle for his work. In contrast to the previously published volumes, Blake planned a large-format paperback, with back and front covers free of all text, but decorated with inky feathers floating haphazardly in the air.

The play's characters, which are largely either birds or men-birds, are unencumbered by settings or background; they skitter or fly in and out of the text, which is set in a sans serif font, and the whole book has a feeling of lightness, which echoes that of the text. Compared to the previous output of the Press it must have seemed a very fresh and up-to-date production.

The importance of Blake having illustrated a play at this stage cannot be overemphasized. Illustrating *The Birds*, Blake now remembers, gave him an early opportunity to explore the idea of birds as people. They are not individual

portraits but Blake worked out a way of manipulating the bird's anatomy to create human poses, which remind us of nothing more than actors on the stage. Take this messenger bringing good news to the birds, for example.

She (the angle of the knee somehow suggests female) prances in with outstretched arms (wings) and announcing beak. Her tail feathers curl up absurdly optimistically and the whole effect is one of pure pantomime. So here, with this Ancient Greek comedy, in part attractive to Blake for its bird theme, Blake was embarking on two new activities, which he continues to revisit today. He was turning birds into people and, crucially, he was turning those characters into actors in a play: in his words, 'acting without scenery'. These figures occupy the page in much the same way that actors do a stage, and Blake is their director, in the way that he constructs each page layout, using drawing, line, composition and space to tell the story around the text in the most communicative and effective way.

In the second work, *The Life of Birds* (2005), the birds wear clothes, go to schools and offices and the hairdresser, they paddle pensively by the shore, smoke and drink, behave like teenagers, businessmen or circus performers, but/and they are birds: they use their wings as hands and they don't wear shoes.

What Blake does so cleverly in this series of drawings without a text is to combine the bird anatomy that his pen knows so well with the situations and behaviour he has observed in his fellow humans, to create moments and characters that we recognize. For a moment we believe them as birds and then we realize they're really us.

Blake has clear sympathy for his fine-feathered friends: they appear in almost every one of his 300 books, and they are almost always benign: optimistic in *Mr*

Magnolia, where owls perch on Mr Magnolia's bed, learning to hoot; intelligent and wily in *Cockatoos*, where they manage to outwit Professor Dupont at every opportunity; cheerfully mad as in Blake's prints for the Museo Luzzati; or solicitous and caring in *The Life of Birds*.

But the fact that there are so many other winged or flying things on Blake's pages suggests that the idea itself of being airborne is an appealing one. Angels seem to be especially useful to him as they are both winged and as benevolent as the person he is himself; they keep appearing, especially in the most recent part of his career.

Angelic creatures

Quentin Blake et les Demoiselles des Bords de Seine was, as described in the last chapter, another opportunity for Blake's drawings to become airborne. The challenge of putting on an exhibition of largely small-scale pictures, as these were, in the Petit Palais was that the walls are 15 metres high. Blake's solution was to create a cast of small angels (the museum called them 'angelots', but, as Blake says, that word means 'cherubs' in English and what he had drawn were really 'modern children with wings'). These images were drawn and then enlarged and printed on transparent acetate and attached to the walls, occupying the heights of the rooms, and guiding

visitors around the exhibition. These characters were not only useful space-filling and visitor-guiding devices; they are also there because Blake always takes note of the context he is working in: winged beings were already all around the Petit Palais, neo-classical gilded or stone figures to which Blake's airy creatures provided a clever light counterpoint. As with all Blake's drawings, these characters are active – the flying movement is especially free, with wings and four limbs all articulating away. Blake felt that the figures in motion were also the perfect foil to the stillness and smaller size of most of the framed images below; they would transport visitors from one section to the next and then encourage them to stop and contemplate; something which did seem to happen. These exuberantly free figures somehow embodied the sense of exhibition, the idea that the framed pictures below them were, as with Pennac's description of books, 'gifts not exams'. In Blake's view, works of art in galleries are there to be enjoyed for what they are – the finding out about the facts behind them can always be done later and elsewhere.

Angels must have been in Blake's mind in 2005, because in the same year he produced the children's book *Angel Pavement* we met in the chapter on drawing. If the name sounds familiar, it's because Blake borrowed it from a novel by J. B. Priestley, published, as it happens, in 1932, the year of Blake's birth. As we saw, the book is about the uses of drawing, and Loopy and Corky, the two benevolent angels of drawing, fly with wings drawn in a multicoloured pencil. Though delicate, these wings are well able to carry them on a flying-drawing journey around the city. Blake seems to use this journey, so full of freedom and delight, as a kind of metaphor for drawing: both the physical act, and the pleasure it provides for the viewer. As the last line puts it: 'But then, when you start drawing you can never be sure what is going to happen next, can you?'

Other striking angels appeared in the following year in *On Angel Wings*, written by Michael Morpurgo. This is a retelling of the Christmas story from the perspective of a shepherd-boy who gets left behind to mind the flock while his companions visit the newborn Jesus in the stable. He is rescued by the Angel Gabriel and this image of the angel in full flight, with the shepherd-boy on his back, is a marvellous instance of Blake's ability to convey multiple layers of meaning through simple colour and line. The angel's power and strength are suggested by the deep vermilion of his wings, by his great, outstretched arms, and by the watercolour vapour-trail behind him; his gentleness, by the boy's arm tightly clasped around the angelic neck, and by the underlying warm yellow wash. At the same time the look of surprised wonder on both faces hints at the image we, the readers, don't yet see, of the baby in the manger.

If we were in any doubt about the importance of angels, or angelic creatures, to Blake, we only have to look at the cover of his latest book about his own work, *Beyond the Page*: here, the unmistakable figure of Blake, at the bottom of the page and coloured in a modest grey wash, gazes in open-armed astonishment at his own creations: glowing yellow and orange, and at the characteristically large scale of the images Blake has been designing in the period covered by that book, a (female) adult angel looks back at the little boy-angel flying alongside her, followed on the back cover by another male/female pair with a winged dog bringing up the rear. Flying flowers complete the image. This picture seems to me to do two things in a pleasing parallel of answer and question: the answer is Blake's certain and warm view of humanity (and animals), and the question he is asking himself is where in earth or heaven his inspiration for drawing it like this has come from.

Lastly, to come back to earth, we can't leave angels without a mention of a book Blake produced much earlier on, in 1969. *A Band of Angels* is a sequence of humorous drawings without texts. The angels are men, women and children, on the ground as much as off it. And like his anthropomorphic birds, these have decidedly human behaviours.

But Blake also uses the white spaces of the page to allow the angels to play their own brand of badminton or develop a successful pancake-tossing method.

The book was eventually published by Gordon Fraser (after being been turned down by another publisher, who thought there were too many naked women in it). It did not sell well – Blake remembers that 'it was almost immediately remaindered', but he bought 100 copies himself, and it can still be found on second-hand booksellers' websites. It's a slight thing – 32 pages of A5 – but turning its pages is like being given privileged access to somebody's imagination at play.

Weightless

Blake's love for flying things may have started with birds, but over the years his white pages have become the air through which people, animals and vehicles are also propelled.

A Sailing Boat in the Sky is the English translation of a book first published in France, as the outcome of the collaborative education project involving 1,800 francophone children (described in the chapter on France), where Blake created the story and illustrations from ideas supplied by both himself and the children: he began with three drawings of a sailing boat which could sail, drive and fly. The children ignored the sailing and the driving and focused their story fully on the flying version, and it is not hard to see why. The image of the boat in full sail ploughing through the sky, piloted by its child crew, was the ideal vehicle for the children's own imaginative flights.

Of course the notion of children in the air is an elemental one: freed from gravity and from the constraints of the adult-controlled world, it offers children the sense of autonomy they often lack. The theme appears persistently throughout the history of children's literature: J. M. Barrie's *Peter Pan*, Mr and Mrs Smith's *The Long Slide* (1977) and Oliver Jeffers' *How to Catch a Star* (2004) to name a very few. Russell Hoban, with whom Blake collaborated many times, wrote three texts involving magical flight which Blake was delighted to illustrate, *Ace Dragon Ltd* (1980), The *Rain Door* (1986) and *Rosie's Magic Horse* (2012). Each of these books involves a creature flying through the sky with its human rider, and the latter two offered Blake the opportunity to make extraordinary coloured skies, the landscapes of flight, which set the emotional scene so readily, as in this page.

These two flying horses are more magical for not needing wings, as Pegasus does. In *Ace Dragon Ltd*, Ace flies with John on his back, and performs feats of sky-writing. This section gave Blake three double-page spreads, each with less text; young readers become freed from words so that they can effortlessly enjoy the dragon-powered flight; the last one has no text at all, save for the name 'John' scrawled in watercolour over the sky, to the boy's utter delight.

People in Blake's world can also become airborne for other reasons. Great speed can lift them, such as in his many images of Mrs Armitage, a fearless woman, constantly seeking to improve the performance of the various vehicles she finds herself in charge of. The better the performance, the more the speed lifts her and her bicycle/car/surfboard into the air, and the more thrilling the story becomes for the child reader. Or there are the moments when people are literally thrown into the air:

the best known being in Roald Dahl's *Matilda* when the appalling Miss Trunchbull launches an unfortunate sweet-eating child out of the classroom windows. Here the flying perhaps comes closest to cartooning and this takes us back to Blake's earliest works in print, those cartoons for *Punch*. There are many other similar moments: the delightful one when Zagazoo's new parents chuck their newborn son across the room to each other, or the two heartbreaking ones in *Clown*.

For children who will already have identified with the little cast-off creature, seeing him being tossed in the air is to feel with him a sense of the rejection that they (and we) can all recognize – and so the flying that started out as a comedy gag has, by the time of *Clown*, become something altogether more profound.

This links us to the way in which Blake takes his human or animal characters off the ground for metaphorical purposes. The cover for the Bologna Children's Book Fair (2003), for example, where in a sunset-yellow sky, children read books in the air, as if lofted by their own imaginations. In *Patrick*, an enduring favourite, the beauty of Patrick's violin-playing encourages fish to 'jump out and fly about in the air', for sheer joy, it must be assumed.

In Blake's series of pictures commissioned for the Kershaw Ward in the South Kensington and Chelsea Mental Health Centre, there is also metaphor in the way the older people represented have found their way into trees. In this in-patient diagnostic unit the patients were mainly older adults with one or other type of dementia. Blake's brief was to provide works for the communal spaces in the unit, including the dining room, corridors and day room. The mood is light, 'whimsical' as Blake puts it, in inverted commas; the characters are engaged in various pleasurable activities familiar to the patients themselves, either because they still perform them, or because they once did. The conceit of having these benign souls

eat, drink, sleep, read or play music (as in this image) in trees works on several levels: humorous in its improbability, it also (and more vitally) transports patients from a difficult present to a place which connects them with the people they were, and in some respects often still are.

The set proved such a great success with staff and patients that the commissioners decided to ask Blake for more, and he went on to make another series of images for the patient bedrooms – he had only been asked for 20 but, as almost always with Blake, once he set about drawing, he found it hard to quell the torrent of ideas, and he went on to produce 60. This allowed patients to pick an image of their own choice, choices often being in limited supply in NHS mental health facilities. The range included images of birds, cats and individual figures reading, painting or eating; but there were a few, such as this one, that wandered into a different territory, even surprising Blake. Here a solid-looking older woman (not a habituée of the Blake female canon) in a grey belted raincoat stands holding a thin golden thread, which is attached to something hovering in the air beside her, and to whom she addresses a quizzical smile. The drawing of this something is light touched and blurred by grey and gold colour washes, which invite us to look more closely. When we do, we can make out another woman, who perhaps flies down to meet the grey lady, and smiles back at her. What are we to make of this figure? Is she a friendly ghost, a kind of angel, or even an 'alter' or former ego? Blake himself does not have an answer to this question. And so, again, we are invited to participate, to bring our own understanding and interpretation into the picture.

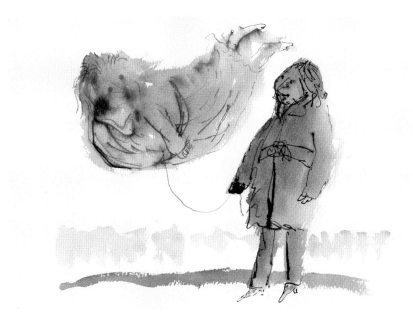

Many more hospital projects have followed this one and are described elsewhere in this book, but there are two related ones that should be included here, although the related element is water rather than air.

For the Gordon Hospital in Victoria, again for adults with learning disabilities, Blake made some drawings of individual or pairs of figures. These people are fully dressed, but apparently swimming underwater, since they are accompanied by fish, other indeterminate aquatic creatures and sometimes by dogs or shopping bags, other things from the safe world of home. Blake has said of this series, which he calls *Life Under Water*, that he came to realize that the figures were 'everyday people finding themselves in an unusual situation, but unfazed'[2] – again it is interesting that he was not conscious of what the result would be when he set out on this project. In common with the angels, birds and other flying things, these swimmers are free. They make their own way through the water and, although unsuitably clad for the situation, and surrounded by strange animals, these swimmers appear to be in control, calm and with a sense of purpose. This seems to be some kind of metaphor for an ideal hospital stay: the patient knows why she is there; it may be strange, frightening, uncomfortable, but the people who work there accompany you.

Blake's images of mothers and babies which give such character to the walls of the maternity hospital in Angers (south-west France) are also apparently under water – also in a space of liberty, that unparalleled physical freedom experienced by many mothers in the moments after giving birth. In Blake's words:

The mothers and babies are drawn with a reed-pen, in Indian ink, and coloured with watercolour, mostly a non-naturalistic watery colour, blue or green. After a certain amount of experimentation I realized the thing not to do is to paint the water. Moved about

only on the bodies, watercolour is able to suggest the human forms and the movement of the water at the same time. That there is no other presence of water takes the picture further into a parallel reality – there's more of a sense of a celebration in the mothers' and babies' liberty of movement. They might almost be flying.

Then there is another kind of flying in some work that Blake produced for Cambridge University. As sometimes happens with people who don't have families themselves, Blake has a well-developed sense of loyalty to the people and institutions who have supported him professionally and in his private life. Cambridge was important for him in many ways, but he is not umbilically attached to it, in the sense of needing to return to college dinners, or keeping up with contemporaries. He had a reason, though, to be in contact with Downing College when he was given an Honorary Fellowship, became president of the alumni association one year, and produced, as we have seen, drawings to be used on college merchandise. So, when Blake was approached by the organizing committee of the Cambridge 800th anniversary celebrations, to produce a sequence of pictures of famous Cambridge alumni, he accepted readily, feeling naturally reconnected to his alma mater. The drawings he produced for this scheme became what he calls 'an informal panorama' which included Milton pondering *Paradise Lost*, with the biblical cherub wielding a sword and dismissing a Masaccioesque Adam and Eve, Darwin comfortably installed on the back of a giant Galapagos tortoise, Byron and even (slightly against Blake's better judgement) Henry de Winton and John Charles Thring, inventors of the rules of football. The last image in the series was different though.

Here Blake interpreted the strapline of the 800th anniversary 'Transforming Tomorrow': the image shows a group of gowned and book-toting students and dons, some on foot and others cycling. Starbursts of pink, orange and green explode over their heads, and they look up with amazement at those in front of them who joyfully leave the ground, and cycle or fly off into a golden dawn. There is a multitude of them, and they have flown high and far, like a flock of pre-roost starlings disappearing off the edge of the page. In its context of course it is meant to suggest the rich benefits of a

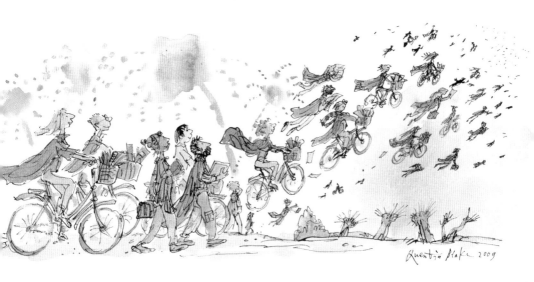

Cambridge education, the starbursts standing perhaps for intellectual inspiration and the student take-off as the successful career-launch.

But this image also seems to have a much more universal appeal. Carl Jung: 'good old Carl' Blake teases me, and other interpreters of dreams have seen the bicycle as representing independence and balance; for most it is the first vehicle we learn to ride. Those impossible bicycles in the sky can also speak of the way good education works for every learner, in any situation: a chance to defy expectations of parents or teachers, to take off and soar in your own direction.

This is a very limited selection of the things in the air that Blake has drawn from the very beginning. With a few exceptions, the white page is his air, perhaps his oxygen too, and air is for flying through, either literally or metaphorically. Angels, birds and things that shouldn't be able to fly, all of these can be found making their way, joyfully free of gravity, through the Blakean air – he has even drawn himself as a hovering artist (rotor-blade assisted).

One can speculate a little on Blake's strong preference for the airborne condition. As a human being, Blake might be described as grounded. Friends, acquaintances and colleagues, both those who know him very well and those who have met him once or twice, when asked to characterize his default state, choose, almost in unison, words such as considered, cautious, calm, unassuming, slow-moving (though, they added, exceptionally quick-thinking) – and this doesn't sound like a conspiracy; the words seemed to come fresh from the reliable source that personal experience can be. Blake

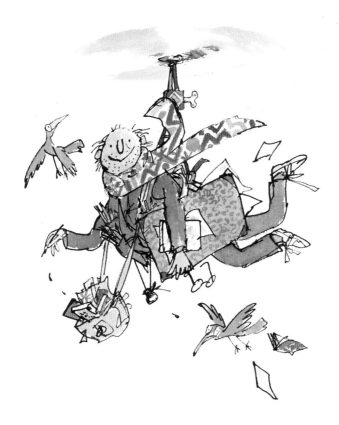

does not fly off the handle or into a rage. He does not fly off the ground if he can help it, avoiding air travel wherever possible, although he has forced himself to cross the Atlantic a few times. He has never willingly practised the kind of sports where speed or obstacles force the athlete to take off. Cycling and some (not so gentle) table tennis have been as active as he has wanted to get – he did learn to swim, 'but it's only wallowing' and he has never really relished it, even though he is in many ways a man of the sea. So why does he seem to return so often to 'off the ground'?

Might these recurring angels, birds, flying people and objects represent Blake's own world-view? As suggested above, Blake says that when he is not illustrating a text where the images need to work closely with words, he is mostly unaware of the origins of the drawings that flow or splutter from his pen. The drawing of these things, the visible thinking as it could be described, is unconscious, but it is an insistent return to the theme.

Three thoughts occur here: one is the idea about the creative person using his art vicariously to live a life he doesn't/can't /won't do in reality. It is the vehicle which has taken the man away to places and situations he hadn't been to before, but which he can represent imaginatively on the page.

The second is closely linked to this one: the idea of flying as a metaphor for the imagination more generally. Here imagination could be seen as the way in which the

creating person comes upon content, freed from the gravity of prescription of any kind: what one of the other famous Blakes (William) called 'threefold vision', which arises from what he called Beulah, the place of poetic inspiration and dreams. This mirrors the way that birds might be free to take any compass direction and choose how low or high to fly. It might be useful at this point to hear Blake's own take on imagination, which is actually all about the way that it is misunderstood, even by his faithful and appreciative public:

A chance acquaintance observed to me recently: 'There is a little hairy dog that appears in your drawings sometimes . . . Do you have a dog?' The answer is no; but it serves as a brief tidy example of how some people seem to think imagination works. Another version which I encounter from time to time is the same though in reverse: how can you work in children's books if you haven't had children? That, I am afraid, shows small notion of what might be going on in the creation of a book for children, a novel, a play, a performance. I was pleased to discover from something he had written for a newspaper feature that Barry Humphries had had a similar experience. In his case it was the mistaken assumption that the incentive for him to become Dame Edna was that he was a transvestite already. A bit, he observed, as if you wanted to play Hamlet because you were Danish.

There is a problem for some people to imagine imagination – that it could actually exist without practical explanation. Is it perhaps reassuring to feel you are keeping in order something unsettlingly alive and various?

An observation from Hilary Mantel might be appropriate here. It is from a recent discussion between Mantel, the actress Harriet Walter, and the playwright Timberlake Wertenbaker, about imagination and theatre. Mantel's reaction is rather to those who think of the exercise of imagination as lightweight, fanciful. 'It's not like that: to imagine properly, you have to imagine strenuously – it has to come from the depth . . . Imagination, properly understood, is a physical process.' It is something that a little dog can offer you very little help with.

So here is evidence of how wide open Blake's imaginative mind is to possibility, to the 'unsettlingly alive and various'; and this is true as much with commissions as with self-initiated projects. His early training as an illustrator for *Punch*, the *Spectator* and *Radio Times*, where ideas had to be summoned, sometimes from nowhere and always on time, must certainly have helped. As he says, 'It was a bit like being an actor in a repertory company, playing a different part every week, and each week in a different style.' The span of the work he has undertaken since the age of 70 is huge: it ranges from large-scale exhibitions to building-wraps and schemes for hospitals. For charities he has decorated deckchairs and designed scores of logos and marques; away from commissions he has come back to lithography, has invented new book-forms (*Woman with a Book*, for example) and has produced a torrent of new works which occupy a fresh and indefinable artistic territory, something between illustration and 'fine art' (a term which to Blake's mind begs many questions). They are all on paper and they share a sense of narrative, but they are drawn with different tools, and their

subjects are varied and various, including anthropomorphic insects, large women, heads emerging from the ground, and lumbering vehicular creatures. It is this kind of openness to inspiration that seems to have a parallel with flight, that multidimensional form of travel. And perhaps it is because he is operating in this sphere that he is able to 'give to airy nothing a local habitation and a name', as Theseus puts it so exactly in Shakespeare's *A Midsummer Night's Dream*.

The third symbolic idea about flight is one that focuses on the process of drawing itself: we have seen how Blake can treat his paper as a page of air, through which his hordes of flying things make their way; and so the passage of the pen across it is another kind of flight. It is free, bound only by the paper's edges. Watching Blake at work, either on the many public occasions where he performs, or at work in the studio, it is clear that three-quarters of a century of daily drawing have given him this freedom. There are habitual traits such as the dots for eyes, the retroussé nose, the feet, flattened though also always in motion; but then there will be a sudden change of direction, a new burst of lines, an unexpected colour flush, which will surprise even him in the act of drawing. And this is true flying. In the words of another poet, the Victorian Robert Browning, in *Paracelsus*:

> *Truth is within ourselves;*
> *It takes no rise from outward things*
> To know, *rather, consists in opening out a way whence the imprisoned splendour may escape.*

Part 2

Why the art of Quentin Blake can make you feel better

Quentin Blake

11.am Monday May 31st
World Parrot Day
 The World Parrot Trust
has its home in Paradise Park
in Cornwall, but its reach
is international, and members
have come — some with their
parrots — from all over.
What am I doing here, boarding an open-
top bus with the rest of them? For years
I have been drawing parrots in books, &
the WPT have asked if They can use
an illustration from my book Cockatoos
on their teeshirts. And will I help
deliver to Downing street a petition
calling for an effective ban on the
import of wild parrots? There are
about 300 species of parrot, and a
third of them are endangered,

including the
amazing Lear's Macaw.

11.15 We set off for a tour of Park Lane,
Oxford St, Piccadilly, Westminster —
with lots of waving — even from a
policeman with a submachine gun.

12.30 Arrival in Trafalgar Square.
A greenwing macaw supervises me as I
draw, & we all talk to journalists
and television cameras.

1.30 We process to Downing street.
Six of us are allowed in, including
Michael Reynolds, chairman of the Trust,
and a brave man dressed in a Superparrot
suit who has been addressing London
from the bus — and our parrot, Gizmo,
a blue and yellow macaw, sits happily on
my shoulders as I knock the knocker
at No 10, & gives a few shouts of
triumph as we leave.

4 pm Home;
put jacket in
washing machine;
write up diary.

6 Giving

C'est fou comme Quentin a le pouvoir de rendre heureux [It's crazy how Quentin has the power to make people happy].
Catherine Meurisse

It's a scene Quentin Blake might himself have relished drawing, and of course I later discovered that he had in fact done so: in a photograph in the *Daily Telegraph* he is seen framed by the black door of Number 10 Downing Street[1], Blake stands face to camera, shoulders uncharacteristically braced, a concentrated, brave smile in his eyes. Also eyeing us directly, Gizmo, a blue-and-yellow macaw, is stiffly perched on Blake's shoulders ('That jacket had to go to the cleaner's', he remembers); man and bird both apparently determined to endure the mutual discomfort in the interest of the cause they are both there to support: in his right hand Blake holds a fat volume – a petition 'to ban imports of wild birds'.

Blake's presence at this event, World Parrot Day 2004, a Trafalgar Square demonstration followed by a march which he and Gizmo led to Downing Street, is one example among very many of his disposition to support. Great artists have a reputation for self-absorption (often justified) but Blake has an unusual ability to look out of the studio and see further than the next commission. Over many decades and without any fuss, he has been giving his talent and his time, not to mention works and money, to charities whose needs he sees and wants do something about.

These are charities which are mainly unrelated to the arts, and with which he has

Blake's diary of World Parrot Day 2004 for *The Spectator*

no obvious connection, but he and the charities both appreciate that a tailor-made drawing is worth as much or more than a financial contribution.

The seriousness with which he approaches these gifts is striking: he might produce something relatively small-scale, such as these images for Christmas cards sold in aid of Survival International (the charity which helps tribal peoples defend their lives), and pay the job the same respect as he would to a much more glamorous project. Blake's dislike of global travel has prevented him from ever visiting, say, the Canadian Arctic or Amazonia, so he has never seen or got to know the peoples there. But, as with every other experience he has never had, he knows how make it up. He will have done the necessary research – he will always be able to make a mobile phone or pair of trainers, or Inuit-wear for that matter, look up-to-the-minute, but, every time, it is the authenticity of the situations and their contingent emotions that really make us believe in them. Here it's the way that the smallest Inuit child tugs eagerly at the hand of the older one, which in a few pen-strokes describes her (and so our) delight at the vision of the Northern Lights displayed above her.

In the Survival International Annual Report of 2010 he wrote of the charity:

For me, Survival is important for two reasons: one is that I think it's right that we should give help and support to people who are threatened by the rapacious industrial society we

have created; and the other that, more generally, it gives an important signal about how we all ought to be looking after the world. Its message is the most fundamental of any charity I'm connected with.

'Rapacious' is a strong word for Blake, but it shows that his humanitarian concerns are deep. He expresses these concerns intelligently through his art, delighting rather than shocking the viewer into giving.

With an equally intelligent sense of how to maximize the value of his donations to such charities, Blake usually diverts payments for works commissioned by his friends to such charities: both Survival and Flora and Fauna have benefited from these funds.

Blake would never have made the trip to Livingstone, Zambia or Puerto Lopez in Ecuador to teach children to read. But that didn't stop him devoting time to creating a series of drawings, this time greatly enlarged drawings, for the Book Bus charity. Founded by Tom Maschler, Blake's distinguished former publisher at Random House, this charity aims to improve child literacy rates, initially in Africa, but now also in Asia and South America, by providing children with books and by motivating them to read.

The five Book Buses (actually a converted Safari vehicle and a white van, plus three conventional buses) now tour these continents, each bringing thousands of books, along with staff and volunteers, to the places where their help is needed. Blake was Maschler's first and only choice to be the artist to animate the first buses: 'He is one of the most remarkable children's artists, artists of any kind, in England; I've watched him develop and develop,' says Maschler, 'and he said yes immediately.' Blake, modest as ever, says: 'When I was asked to do this I was taken aback and excited – generally he [Maschler] asks me what my next book is going to be. It's the first time I've been asked to illustrate a bus.'

As an illustrator Blake is of course always highly aware of his brief – he had to deal first with the logistics of making drawings for an unfamiliar and irregular space: 'We sent him a profile of the bus,' says David Gordon, Project Director for Book Bus, 'and the drawings just flow, under the doors even, telling a story from front to back.'

The drawings for such a project will never be something merely generic. Here he designed each set to reflect the destination country. And with his teacher's instinct, by doing this he would also be encouraging and reassuring young bus-users that the activity in the bus would be for *them*, and that it would be enjoyable: children cling to the necks of the jaunty llamas who range over the South American bus; when the Book Bus pulls into a Zambian village, it is 'welcomed like an ice-cream van, or Father Christmas', as David Gordon puts it, and children are greeted by an elephant who obligingly holds up a book with its trunk, so that the engrossed child on its back can read in comfort.

Education, children and animals are also a theme of the Farms for City Children charity, which Blake has supported for many years. FFCC was founded by author Michael Morpurgo with his wife Clare, with the aim of bringing city-bound children into close contact with the rural environment through week-long stays on one of the charity's three farms. Blake is now a vice-president. As he says:

I knew Michael already: we met years ago at Montaubon, where we were both going out to give talks in a variety of French schools and met up back at the hotel in the evening to compare notes on our experiences in the front line. We kept in touch and were brought together again over the Children's Laureate scheme, of which he was the initiator, with Ted Hughes, and I was the first incumbent. I have also illustrated two of his anthologies of verse, and his story On Angel Wings. *It was in fact drawings that Michael came to me for FFCC. I illustrated the covers of two books –* Muck and Magic *and* More Muck and Magic *– to promote and raise funds for FFCC. I also illustrated the inside pages of the second book, and provided illustrated endpapers for the hardback edition of the book. It was this last set of drawings that have turned out to be the most useful and versatile: the little girl with the ducks and geese became the charity's logo, and some of the others have appeared on merchandise (such as the hothands – oven gloves – I use in my kitchen) and, more recently, on a range of clothes for children from which a percentage of the price goes to FFCC.*

I suppose I ought to confess that, as I have never been to see any of the threatened tribes that Survival International is concerned with, I have never been to any of the FFCC farms. I am not motivated by a desire to join in . . .

This last sentence is certainly true, but, given the scale of Blake's generosity to these and other organizations, its apologetic tone seems entirely unnecessary – his skill is, to bring a situation to life even though he has not experienced it himself.

Children with serious illness benefit indirectly from Blake's 'gifts' to Roald Dahl's Marvellous Children's Charity. Blake's hugely successful collaboration with Dahl started with *The Enormous Crocodile* in 1978 and carried on throughout the 1980s with household-name titles such as *Matilda*, *The BFG* and *The Witches*. By 1978 Blake had already illustrated over a hundred (published) children's books, plus many other adult titles, but in terms of sales, the Dahl partnership was a turning point for him. With worldwide sales of millions, he became 'never financially uncomfortable' and his generosity to Marvellous, to the Roald Dahl Museum and Story Centre in Great Missenden, as well as to the Dahl website, is an acknowledgement of this, and has been considerable. He has created new images such as the red crocodile logo or the Dahl nurse picture for Marvellous. For the museum he drew the map and licensed existing images to be used without charge: 'There's no question that Quentin Blake made the museum,' says Liccy Dahl, Dahl's widow. 'Everything, including the palette of colours, children love it . . . it was very generous of him.'

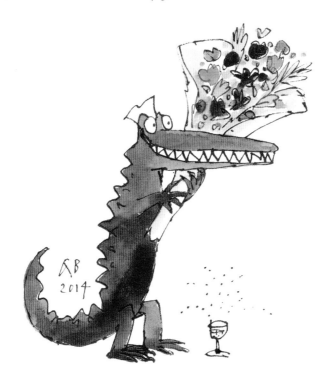

Children's access to the arts is also a cause that Blake understands is important and in the case of the charity now known as the Prince's Foundation for Children and the Arts, he did feel able to 'join in': the charity offers children who never visit galleries, theatres and concert-halls opportunities to do so, through partnerships between schools and arts organizations. Over several years Blake was very involved – drawing logos, appearing at fundraising events, lecturing, and even devising and introducing a teacher's book: *In the Land of Illustration*. To each of these he dedicated the same time and creative imagination as he would do to any paid commission.

Finally in this list of charitable involvements there comes the French Institute,

although it is not a charity itself. Inside this elegant art deco building in South Kensington are to be found some of Blake's favourite things: people speaking French, a French bistro, cinema, and, best of all, a good French library. And so he said yes when he was approached to take part in the first South Ken Kids Festival in 1998. There are now many children's literary festivals attached to their adult versions, in places such as Bath, Cheltenham and Hay. In Manchester, Cardiff and Cirencester, for example, independent festivals of children's literature have been created in the last few years; but in the 1990s a combination of France's embedded literary culture, a dynamic head of the literature department and a committed children's librarian helped to create such an event for London. Blake's involvement has been twofold: first he creates logos and drawings such as the one for this year's banner and the one that he made for the first festival: 'I did a drawing of a boy and a girl looking at books and each one was pointing at the other's book and I think I thought that one was French and one was English and that . . . we're looking at each other's languages and we're doing it through books.' This theme is a persistent one with Blake since so many of his books are translated into French, or, as we have seen, even originate in the language.

Blake also contributes to the festival by being the British partner in the Anglo-French 'drawing duels': these performances are the visual equivalent of the party game where a story is created by each player contributing a single word at a time; here each of the two artists challenges the other to continue his drawing. Blake's French partners in drawing-sparring have included the distinguished illustrators François Place and Joann Sfar, Bruno Heitz and Philippe Dumas. These events are notable for many things – the silent intensity with which each draws, and the defiant though always gentlemanly flourish as one calls on the other to continue. After which Blake is inevitably himself challenged to sign yet more books for the expectant fans.

Even now, in his eighty-third year, Blake agreed to support the fundraising auction for the refurbishment of the Institute's children's library described earlier: Blake does not relish late-running gala dinners but on this occasion, as we saw, he made a speech, donated two works and then did a live drawing which was also added to the lots. This kind of support makes a vital difference to a cultural organization and Blake readily agreed to take part, because he feels fundamentally aligned with the cause of reading for enjoyment – something which libraries can so uniquely encourage.

This is a long list . . . when you look at it, certain themes do emerge – education, literacy, survival – and there is also a sense that Blake's choice of charities to support

echoes the subjects of his own work. All his output, the book illustrations, the paintings, the projects he calls *As Large as Life*; the series for hospitals, gallery walls, banners, building-wraps and murals; even the more private pieces such as telephone and fax drawings, they are always alive, first with humans and then with animals, birds especially. (Landscapes, places in general, do appear and richly so – the fierce urban sunsets in *Clown* or the great storm in *Green Ship* – but they are almost always at the service of the narrative and the actors who play it out for us.) There is a compassion for life on earth in the drawings that seems boundless, because it keeps on finding new outlets in every new project Blake undertakes. These drawings have a special power to encourage other people's imaginative empathy with the cause in question, and so to donate.

Campaign for Drawing and HOI

However much these broadly humanitarian charities have gained from Blake's generous and fruitful input, his contributions to the Campaign for Drawing and the House of Illustration have been at an altogether different level. These are both in fact also charities, but he puts them in a different category: they are institutions close to his heart, relating as they do to drawing, the thing he does every day, and his involvement with them over the last 15 years has been immense.

The Campaign for Drawing is an independent charity, set up in 2000 through an initiative of the Guild of St George, which wanted to celebrate the artist John Ruskin's centenary. Ruskin had founded the Guild in 1871 to 'assist the liberal education of artisans' and the Campaign for Drawing's purpose isolated a simple principle from this: it would promote Ruskin's belief that drawing is a key to understanding and knowledge.

The idea for the Campaign came from Julian Spalding, a sort of polymath of the visual arts, who was Master of the Guild at the time, and who freely admits that he was 'more and more fed up with modern art and conceptual art' and that 'something had to be done about drawing'. Having known Blake for many years, he says he knew he 'wanted him on the Campaign's board as a patron saint' because of his 'huge appeal, and because he draws like an angel'.

Spalding is convinced that Blake's contribution to the early success of the Campaign was crucial. He enthuses that, together with Sue Grayson Ford, the Campaign's first and continuing director, Blake 'really made the Campaign and really made it work. He did all the drawings, he did the main designs, all the banners, and he gave out the awards . . . he was there . . . and he was of course a tremendous draw (himself) . . . his loyalty and his commitment to it was just unquestioning, even though he was so busy.'

The year 2000 was indeed a very big one for Blake. It was the year of the Children's Laureate when he was busy promoting children's book illustration; he was centrally involved in *Un bateau dans le ciel*, and it was also the year in which he had curated the groundbreaking exhibition *Tell Me a Picture* at the National Gallery. As Spalding comments:

I got the impression that he wanted to become more of a public figure, to contribute on a wider scale, [to have] a wider horizon. I think he felt this campaign absolutely dovetailed [with what was happening] … and it really introduced him to the museum world … in his very quiet way he got very excited about it … he was the drawing king and he made it work.

Under Sue Grayson Ford's dynamic and tireless leadership, the Campaign, alongside other initiatives such as the Prince's School for Drawing, and the Jerwood Prize, have certainly shaken drawing from its sleepy or comatose condition in some of the art schools and placed it firmly in the public realm, where Ruskin would have been happy to see it: through its Power Drawing education programme, it has given skills and ideas to primary teachers who have to teach the subject with little or no training. And the Big Draw month, an annual nationwide feast of drawing activities for all, often led by museums and galleries, has offered hundreds of thousands of people of all ages and backgrounds the opportunity to draw, perhaps for the first time, or for the first time in many years, and, crucially, to draw in the company of others. As Spalding put it: 'Quentin made a comment, which summed it up: "You've discovered that drawing is a communal activity, we'd always thought of it as a private activity."'

It is certainly true that, from the start, the Big Draw's main focus has been on people drawing in numbers, and watching each other draw, together. I was there at the launch of the very first one, part of which took place in the normally oppressive tunnel that links South Kensington tube station to the museums of Exhibition Road. The scene was striking: hundreds of people caught up in the act of drawing: on what seemed like a mile of white paper lining the walls, children scrawled childish scenes next to serious artists making sophisticated sketches of each other, all apparently unaware of the (equally absorbed) watching crowds. At the same launch, Blake also remembers a session in the V&A Museum where he watched a child drawing an exhibit, so immersed in the activity that she failed to notice the cameraman filming her.

These informal public drawing activities are often punctuated by performances in lecture theatres; audiences watch artists such as Blake drawing on stage and a visualizer allows everyone to see the drawing hand. Spalding recalls:

It was at the launch at the British Museum, he just drew this woman standing there pointing, and he was talking away. There was a pause, and he said, 'What is she pointing at?' And then there was total silence in the theatre and this little crumpled figure appeared [on the screen], and it was absolutely right, his little crumpled figure who had done something naughty; there was something in her expression … the audience was mesmerised, about where it had come from … at that moment you could see him actually creating … it was a sort of mime, it was like Picasso drawing, and he was just with it … everyone in the audience will never forget that performance.

And since those days Blake has taken part in most of the launch days, including at the V&A, Somerset House and the National Gallery, and even one year in Paris when

181

he could be seen on hands and knees (again) on the glossy parquet of the British Embassy drawing alongside children on long rolls of white paper.

What Blake has done for this campaign is many-layered and full of consequence: it is a model of how a 'celebrity' (he wouldn't like the word) can use talent to give more than money – he has given the Campaign an identity through his designs; he has given it prominence and authenticity through his patronage; and he has given to the wide public, for whom the charity exists, through his illuminating appearances. Embroidering Julian Spalding's description a little, as compelling as these sessions are, they are much more than a bit of artistic conjuring. In front of their eyes Blake shows people how lines become forms, how they communicate recognizable feelings and situations. The sight of Blake's drawing hand is also a kind of call to the drawing hand in everyone watching, an invitation to take part in the activity whose purpose Ruskin said was to 'set down clearly and usefully records of such things as cannot be described in words, either to assist your own memory of them or to convey distinct ideas of them to other people'.[2] (Blake, however, would answer Ruskin by saying that if he, Blake, were to preach the gospel of drawing, it would be as much about getting people to *invent*, to imagine, as it is to remember or convey things you have seen.)

The matter-of-fact, unsensational way in which Blake works in public reinforces the sense that drawing is an art that can be understood and undertaken by everyone.

Lastly there is the House of Illustration.

In conversation, Blake is often uncertain about the sources of his ideas but in this case he is very clear that the notion of HOI came *not* from him but from his friends, former student and illustrator Emma Chichester Clark and the writer Joanna Carey. They had suggested that a home would eventually be needed for Blake's vast archive of all the illustrations for his three hundred or so books. With modesty but with the cause of illustration always close to his heart, Blake immediately realized that such a place could also provide a home for illustration and illustrators in a more general way. His vision was for a place where the art of illustration of the past and present could be seen by many audiences, a place where contemporary illustrators would meet and where the discourse around illustration could take place. On 2 July 2014, almost eleven years after the idea was born, a gallery that was eventually called the House of Illustration did open its doors at 2 Granary Square in King's Cross, with an exhibition of work by Blake called *Inside Stories*.

As with all self-starting projects of this scale, the process of working out the nature and identity of the proposed organization, raising the money, finding a building, hiring staff and opening the doors to the public was bound to be a slow one: possible buildings came and went (sites in Lambeth, Southwark, Fulham and Ealing), names for the centre appeared and then had to be discarded: for example, The Quentin Blake Gallery was rejected because some potential funders, including the Arts Council, might feel that it had the ring of a vanity project. (It's an interesting cultural difference that this was not a perceived problem either in the US, where the Eric Carle Museum of Picture Book Art was founded in 2002 and regularly shows his work, just as in Strasbourg, France, Tomi Ungerer's work can be seen in the Musée

Tomi Ungerer – both of these are living illustrators in 2015).

Excitement and energy rose and fell in equal measure over the years. A low point came when the financial crisis of 2007–8 arrested the recently launched fundraising campaign. This led ultimately to the decision to lease rather than buy a property, which was a disappointment and in some ways a dilution of the original vision. As a founding Board member of HOI I am not an impartial witness to the course of the project. But I did see clearly how Blake managed to keep positive and pragmatic in face of the constantly changing realities of the situation, even in those times when he may have had private doubts about the need for some of the steps the Board felt had to be taken. For example, I remember him wondering about the need to appoint professional staff at an early stage, and whether a 'branding and identity' workshop was really what we had to do . . . But he always listened to the arguments carefully and there was never a time when we felt that he had lost enthusiasm. He has ensured its sustainability by (conditionally) pledging his illustration archive, and many rights to it, to the organization; he has given it huge amounts of precious time (many more Board and other meetings than he would have liked, plus numerous appearances at fundraising events), and very considerable financial support. He has diverted profits from various of his ventures to support HOI, for example designing Christmas cards for David Walliams and the late Lord Gavron which brought £24,000 to the charity. It would be hard to quantify the amount he has contributed and continues to do to this project, which does not have his name on it.

7 Including/cheering

In 2009 Blake was invited to make an unusual series of drawings for an exhibition called *In the Picture*, at the Foundling Museum in London. This was organized by SCOPE, the disability charity, and its aim was to challenge prejudice against disability with positive images of children with various disabilities. Blake's brief was to draw children with mobility aids but who were also behaving like characters in a story. In the past, diversity wasn't always at the top of Blake's mind: in 1970 he illustrated a book called *Doctors and Nurses* for a Longmans series called Breakthrough to Literacy. 'The doctors were all boys and the nurses girls – teachers had to put them in the cupboard in the end. I just didn't know.' And in 1996 while working at the National Gallery's Education Department, I commissioned him to illustrate *Children's Way In*, a gallery trail for young visitors. Blake drew a little gang of children to help the visitor discover selected paintings in the collection. I remember my then-head of department criticizing him (to me) for not including a black child in the group, and his ever-so-slightly dismissive reaction when I reported that back to him. He will answer a brief perfectly and beyond expectations, but he protects his artistic boundaries, strongly, if quietly. The point about this story, though, is that I think he had absorbed the

From 'The Five Strange Brothers' in *Quentin Blake's Magical Tales* **by John Yeoman**

message: 'I'm very well trained now,' he says. And there is plenty of evidence for this, including the fact that he illustrated David Walliams' hit *The Boy in the Dress,* (2012), which was a prize winner in the city of Toulouse's Première édition du Prix littéraire Jeunesse pour l'égalité Filles Garçons (First Children's Literature Prize for Gender Equality).

The contribution to SCOPE had a kind of unintended consequence: a book, which shows that Blake had completely internalized the diversity concept, but, as ever, in an entirely original way; the next book, along with many others, is of course a good story, but it is also an expression of his supportive and empathetic nature.

In 2013, five years after the SCOPE exhibition, Blake decided to create a story eventually titled *The Five of Us.* The book had a protracted gestation: first Tom Maschler, Blake's editor, failed to show enthusiasm for it, possibly because it seemed to have an agenda, something Maschler might have disapproved of. Next, Blake had originally decided on the title *The Picnic* but then had to rethink the name when he learned that Jonathan Cape was about to bring out a book of the same name by the illustrator John Burningham. The book, with its new title, was finally taken on by Roger Thorp, then at Tate Publishing, with whom Blake now has a strong publishing relationship.

Blake's adventure stars a group of unrelated children of assorted ethnicities. Each child also has a disability of one sort or another: there is visually impaired Ollie, Angie who is deaf, Mario in a wheelchair, Simona, who those familiar with the disability might recognize as having Down's syndrome, and a little boy called Eric – is he autistic, we might wonder, or perhaps an elective mute? Was Maschler right to detect an unwelcome political correctness here? But Blake's genius is that he first describes the children *in the text* in terms of their positive abilities; their disabilities are absent: 'Angie could see a sparrow sitting on top of a statue five miles away. She was amazing. Ollie could hear it sneeze. He was amazing.' And he introduces them on the first page in little half-length portraits. So the reader starts with an entirely positive image of these children. It's only in the next spread, when we attend to the illustrations, that we, adults at least, might notice the density of Ollie's glasses, that Mario is in a wheelchair, and that Eric never looks very happy. (One four-year-old known to me was so involved in the narrative that he noticed none of these, though.) The story is of course redemptive: the five children together use their different abilities to save Big Eddie, their able-bodied carer, when he collapses. Eric has the key role here and he finds a powerful voice, which he uses to summon help from the top of a cliff.

The sources for this book are full of diversity themselves – they exemplify Blake's extraordinary ability to squirrel away experiences for later use, from real life, from literature, film or from other visual forms, which he later retrieves for exactly the right purpose: the idea of the five children with special abilities comes from *Quentin Blake's Magical Tales,* a book written by John Yeoman, Blake's long-term collaborator. Yeoman had found a Chinese folk-tale, which he called *The Five Strange Brothers,* about five brothers with extraordinary skills – for example, the youngest could live without breathing and another had extendable legs enabling him to walk through rivers.

And then Eric walked to the edge
of the river and said, 'Erm ... erm ... '

Eric hollering from the cliff top, came, Blake remembers, from a moment in a film in which a group of people are stranded in the Alps after a plane crash; one of the group, an Italian opera-singer (played, Blake recalls, by the sinister Francis L. Sullivan), manages to make some contact with the world outside by using his huge tenor voice from the top of the remote peak. And the idea of disability being represented in stories came with the 2006 SCOPE project itself where, in addition to the pictures Blake had made for the exhibition, he worked with a group of disabled children to re-draw some images from his books so that disability was included.

These are the ground elements. But Blake always goes further. Talking about *The Five of Us* in a web interview for Booktrust he says: 'The idea was already there when I once again saw a reference to introducing children with disabilities into children's books; however this time I thought: "The hell with it, why can't they just be the heroes?"'

To those children with these and other disabilities, books like these really do make a difference.

In *The Five of Us* each child does act heroically, but they achieve something because they act together. If there is a message in this book it is that one; the disability issue is incidental. And as Blake said at the publication launch of the book in 2014: 'All I hope is that when we have a reprint of this book in five or ten years it won't be necessary to mention disability.' There was a little coda to this speech, which it is worth mentioning here only because it suggests that, as much as Blake is able to give through his work, he

also knows how to receive, which always makes the giver feel better:

One curiosity of this book: it's the only book that I've seen that is dedicated to two fictional characters, Loopy and Corky, who appear in another book of mine called Angel Pavement. But in fact these characters are based on real-life people: one is Emma Chichester Clark . . . and the other is the artist Linda Kitson . . . they've been wonderful encouragers and supporters and I wouldn't be where I am without them.

There are three other books (at least) from the Blake canon that have similar possibilities of therapeutic effects for readers.

The Story of the Dancing Frog (1984) is an extraordinary book, and its genesis provides another illuminating little glimpse into Blake's creative process. Giving a talk to a group of teachers one day, he found himself speaking about the need for imagination to be retained in the drawing process. 'You can,' he told them, 'draw a realistic frog' (and here he drew one) 'or you could draw one dancing!' This image, he says, stayed in his mind and 'crossed over' with other simmering ideas. Like all the best works for children, it is to be appreciated at many levels: ostensibly aimed at primary-age children, its underlying themes include death, widowhood, suicide, ageing, single parenthood, feminism and disappointed love. It is a serious piece of parallel storytelling, which manages to hold the narrating mother's story alongside that of Aunt Gertrude's, who as a new widow finds a new life for herself as an impresario for an extraordinary dancing frog. At the same time, the drawings are full of Blake's wit and magic; its covert (to children at least) cultural references range from Maurice Chevalier and Mistinguett to Isadora Duncan. One of the things Blake does with such brilliance here is to interleave the coloured illustrations to the dancing frog story with five sepia-tinted drawings: here the mother tells the story to her child Jo (neither the name nor the drawings makes it clear whether Jo is a boy or a girl – making the story more inclusive).

These drawings are some of most sensitive and communicative in all of Blake's work, certainly in his book illustrations, and these images provide a reassuring framework to contain the tough themes. The first one is a skilful piece of scene-setting: Blake gives us all of the following information in a few pen-strokes: the two figures are probably related, they certainly have a warm, trusting relationship; family seems important to them (the shelf in between the two figures is full of photographs); the briefcase by the chair suggests that the mother goes out to work (later Blake quietly hints in the text that the father is no longer around); and the child is a reader who has put her book down to hear a story from her mother: all children love stories but the best kind is the one that someone you love tells you – and all this comes before we have read a word of text. The penultimate one takes account of the time involved in storytelling – cups of cocoa have been made and drunk, biscuits eaten; there is a kind of rapt closeness between the two which anyone who has shared a story with a child will immediately recognize. The last picture is, together with the last few lines of text, a marvellous piece of post-story reflection:

'No one could really catch a frog and put it on the stage?'
'You can do all kinds of things if you need to enough.'
'Yes, I suppose so.'

Such images seem to test the limits of description or criticism: how is it possible for an artist to communicate in a drawing the concept of a child thinking about a new, important idea, a powerful life-skill?

The second life-saving book is actually about death, and it is the only one of these three that was not authored by Blake; but it is a book in which his understanding of the feelings expressed in the text make the drawings live in an exceptionally powerful way. Michael Rosen's *Michael Rosen's Sad Book* (2004) is not fiction, but a true account of the author's reactions to the unexpected death of his teenage son, Eddie. The text is brutally honest: 'What makes me most sad is when I think about my son Eddie. He died. I loved him very, very much but he died anyway,' and: 'Sometimes I don't want to talk about it. Not to anyone. No one. No one at all. I just want to think about it on my own. Because it's mine. And no one else's.'

And the illustrations all show how deeply Blake has addressed the question of how a feeling such as the last one might be expressed visually.

Blake's answers come in images such as this one, where the grey figure of Rosen stares down at the bleak shore of a muddy river, where crows pick over debris; most of the picture space is taken up by the blank, grey-yellow-coloured river wall. Everything is designed to capture the overwhelming nature of such a feeling.

The honesty of the text-with-illustrations has been widely recognized as being of therapeutic use by professionals in the field: I once saw the book shelved on the 'pastoral theology' section of a religious bookshop, and it is to be found in such places as St Joseph's Hospice in Hackney, in counselling sessions for children who have lost family-members. But it has also been named as one of the 100 Modern Children's Classics by the *Sunday Times* (2014), suggesting that its message is for everyone. The illustrations together with their text were shown in a recent

exhibition of Blake's work, *Inside Stories* (2014), at the House of Illustration. The book took up the whole of the last room of the show and at the planning stage there was some debate about whether it would be right to finish what was a largely joyful show in such a minor key, and Blake did ensure that the walls in that room were not painted in a dark colour. Some visitors feel the need to return to the more cheerful sections, though, and I saw many leaving that room in tears. In some ways, the book is as unbearable as the situation which gave rise to it; but the tears seemed somehow also to be tears of relief that, thanks to art and to literature, such feelings can actually be named.

Clown appeared in 1995. It is a textless book, which tells the story of a discarded toy clown in a gritty urban setting. The drawings are mercurial and the layout organized in an almost filmic manner, with rapid changes of pace and long 'stills' where the moment requires more reflection; but here we can look at it as a marvellous representation of empathy. Because there are no words, our emotions are engaged directly by a combination of the fast-moving narrative scenes, and the full-page images at key dramatic moments such as this one where Clown is thrown into the air, with a gloomy city backdrop behind him.

Like many children's picture-books *Clown* has a 32-page portrait-format; it starts with an image of rejection: a small toy clown is taken to the dustbin along with other unfortunate unwanted animal toys by a disapproving woman. In the first image she holds out the wretched bundle at arm's length, her pointed nose expressing sneering disgust. The second picture is a perfect example of Blake's ability to show us a situation from the perspective of the protagonist: we see something Clown would have seen and experienced: a brutal pair of pink hands in the act of throwing, followed

by the sad faces of the creatures in the bin. Clown is sharp-eyed and resourceful and soon makes his escape, thanks in part to the natty striped trainers that he finds in a pile of rubbish. These give him the kind of feet he needs in order to get on with his main concern: to rescue the other toys, still hopelessly stranded in the bin. But to do this he needs help from the human city-dwellers. The children delightedly recognize a fellow small person, but the adults see him only as a piece of rubbish and he is discarded, sometimes violently. In spite of this, Clown is not distracted from his mission: the book is punctuated with drawings of him remembering his left-behind friends. As the story progresses, Clown's urban experiences become more dangerous – a vicious dog corners him in a rubbish-strewn street and its equally thuggish owner tosses him, this time not out of, but into, the window of a miserable third-floor flat. Here he surprises a little girl trying in vain to cheer her screaming baby brother. As ever with Blake, the few details in the picture are all we need to understand the situation: the single light-bulb, peeling wallpaper and tipped-over saucepan on the floor – the potatoes and puddles of water poignantly suggesting the girl's hopeless attempts to prepare a meal.

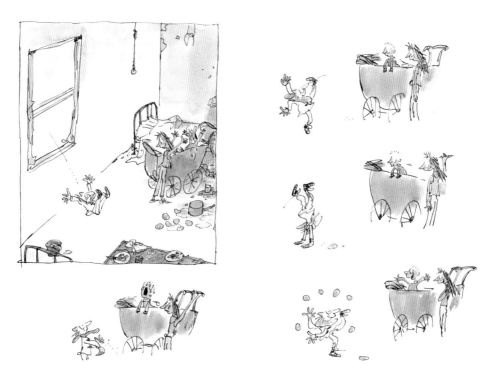

Needless to say, the benign Clown helps her with the chores, giving her time to return with him to the bin and rescue the animal friends, who are more than happy to find a new home. They all get back in time for the girl's downtrodden mother to return from work; tearfully joyous she finds a tidy flat, a scrubbed and shining baby,

and the meal (potatoes back in their pan) ready on the table, now decorated with a bunch of flowers, which Clown has naturally freecycled from another bin.

Without words, this book nevertheless has many things to say: in the subtlest way possible it speaks about rejection, homelessness in the city, the powerlessness of children and, more than anything, about a kind of compassion for people in need – a compassion which is normally most keenly felt by those who have experienced the same thing themselves, but in Blake's case this is achieved vicariously.

There is quite a bit of Quentin Blake in Clown. Blake is not particularly tall and he notices things. This helps him to know what it is like to be a person in many situations he hasn't been in himself. He doesn't quite do handstands to cheer people up but he has a wonderful equivalent gesture and he is very good at rescuing. When he is aware that a friend might need a bit of rescue he will act immediately – in practical and generous ways ranging from financial help to long-term emotional support. A small example of this is the time when Blake understood straight away the difficult situation Geneviève Roy, the otherwise highly skilled French teacher, found herself in when she arrived in London to work on the *Bateau dans le ciel* project, described elsewhere:

I went to London for Bateau dans le ciel. *I was completely lost, because I didn't speak the language, it was terrible … I was panicking and Quentin just helped me, I mean really helped me! He came to fetch me at the station, found a place for me stay [with a friend], then he took me back to the station. He looked after me as if I was his little sister, because life goes much too quickly when you don't speak the language … he saw I was panicking and he looked after me … it was crazy, he has other things to do but he does [things like that]. (Author's translation)*

Further back, Blake's colleagues and students at the RCA recall his generosity to Brian Robb, who was his predecessor as Head of the Illustration Department and had been his most important mentor in Blake's early career. Friend and distinguished potter Alison Britton says: 'He was Brian's surrogate son really, incredibly loyal.' This was demonstrated in the period when Robb became unwell but was still at work. The artist Russell Mills recalls that Blake 'carried' the situation, covering up for him when necessary. Blake is Robb's executor, and his way of giving back has been to generally try to raise interest in the work of this gentle but at his best highly witty artist and illustrator. For example, according to Joe Whitlock Blundell, then working at the publisher John Murray (later to become Blake's art-editor at the Folio Society), in the 1980s Blake tried very hard (in the end unsuccessfully) to persuade him to publish a book that Robb had written and illustrated about the RCA student visits to Venice.

Robb wasn't a relation and, as we know, Blake didn't marry or have children; his birth family was small, only one elder brother Ken (died 2006), who married Edith, and who had two daughters. But, perhaps because of this, Blake has always been supportive of his equally small extended family (his two nieces and a great-nephew), very much behind the thick screen that protects his personal life. But he speaks of them with the warmth and admiration of someone who recognizes the complications

of family life, maybe also even with relief at not having to be in the middle of these complications himself.

Blake is modest about these personal things that he does. He is much readier to share the stories he hears from people he has unwittingly helped through his art, and there are now many of those. A man once wrote to him describing how 'although only in his forties he had had to retire from work because of illness; he explained later that it was from profound depression'. He happened to visit an exhibition of Blake's work, *As Large as Life*, a show which toured to several galleries in England and Scotland. The exhibition featured prints from four of Blake's projects for hospitals and other healthcare settings. Assembled together for an exhibition, these works lost their 'healing' context; they were no longer on the walls of labour-wards or children's outpatient waiting rooms but this did not stop them from speaking to Blake's letter-writer. He described to Blake how 'blown away' he felt about such a positive view of humanity (something that Blake is occasionally accused of, he admits, cheerfully).

More than that, it had had a very positive effect; the pictures were for him, he said, better than any drugs the doctor had given him, and it was an effect that seemed to be quite real, as some months later there arrived another letter from him saying that he had moved to London and had a job working for a charity. It was another step in my consciousness of the ways drawings can actually speak to people.

In spite of this Blake doesn't really know how this effect actually comes about. Perhaps it is partly that, as he says: 'The people in some of my drawings are simply in strange situations which they are more or less coping with.' These strange situations might be the fact of being in hospital for the first time, but they might equally well describe the situation of mental illness that this man found himself in. The fact that people are 'more or less coping' suggests a kind of barely adequate minimum; and what Blake doesn't mention in that quote, but often implies in his images, is that there is almost always someone around who can help the sufferer get to that base-camp of coping. In hospital that might be a health professional or a visitor, but, in the exhibition, perhaps that person was Blake himself, speaking through the drawings. I think that, beyond this, there is something about the nature of the drawing itself, the energy of the line, a gesture, an expression, the choice of a colour, which is both consoling and encouraging to the viewer.

Bringing people together, helping them stay together

Blake has recently had several more letters in the above vein. Some of these are, he says,

from people who share an interest in my drawings, often, understandably a childhood interest, and most frequently the illustrations in the Dahl books. One was from a couple who read Matilda *to each other as they drove to Devon on their honeymoon. Another was from a woman who asked whether I would send a greeting to her wonderful Italian*

husband on a significant birthday. It was only after their relationship had been established that she mentioned her enthusiasm for the books and discovered to her surprise that he shared it – she hadn't realized that the books also existed in Italy; evidently this brought the two even closer together.

Perhaps the most interesting of letters of this kind – and the trickiest to anyone other than Blake – was from a young man who wrote asking for help:

He had messed up his relationship with his girlfriend; it was his fault; he had drunk too much and been badly behaved. But they both liked my drawings. He sent a photograph of them in happier times.

I knew nothing about him except that he was repentant; I didn't know if it was a good idea that they should get together again, or what I could do. In the event I took a sheet of paper and drew him on the left-hand side and her on the right. In the space between them I wrote: 'Any chance of getting this ironed out?' and then I scrunched the sheet of paper into a ball and stuffed it into an envelope and sent it to him.

I heard nothing back – one doesn't often expect to hear – and I assumed nothing had happened. Quite a long time afterwards though, I was at a private view of my work in London and they appeared – hand in hand and with a T-shirt for me. On the front was a photo of them together, with the drawing ironed out and framed, and the ironing board. This was two or three years ago; I hope they are still happy together.

8 Healing

Blake's hospital projects have been widely written about both in the press and by Blake himself, in his book *Beyond the Page*. For obvious reasons, few have ever seen them in their original settings. The projects arose from a chance invitation from a clinical psychologist, Dr Nick Rhodes, to make a series of works for the ward for older adults in South Kensington and Chelsea Mental Health Centre in 2006. This was the first commission in an ongoing series called the Nightingale Project, a charity working with the Central and North West London NHS Foundation Trust, whose intention is to 'brighten up the environment in mental health services through art and music'.

Rhodes had realized that the environments of the mental health institutions he worked in were not helping his patients: 'Before I left for the night,' he says about a patient he had admitted because he considered him a suicide risk, 'I went to see him in his room. I looked around and saw this bare little cell and I thought, "What have we done? We've admitted a suicidal man to this depressing place."' He decided that he would, with curator friend Stephen Barnham, set out on a mission to make these places 'more homely and welcoming'.[1]

There is a long and well-established tradition of art in hospitals, which is

From the series 'Welcome to Planet Zog' for the Alexandra Avenue Health and Social Care Centre, Harrow (2007)

described in Richard Cork's comprehensive *The Healing Presence of Art*.[2] However it is clear from that book that the intentions of those who install art in hospitals have not always been to make them more welcoming places: the obvious historical example is the sixteenth-century altarpiece painted by Mathias Grünewald for the Monastery of St Anthony at Isenheim, and which is now on display at the Unterlinden Museum in Colmar, near Strasbourg. The monastery specialized in hospital work, where it treated plague patients, as well as those suffering from ergotism, a devastating gangrenous and convulsive disease, and Grünewald paints a Christ on the cross enduring these shocking symptoms. The intention of this painting may have been a kind of empathetic one, but one that might seem perversely so to us today: to remind patients that Christ suffered and understood their suffering. It is hard to imagine any patient finding any comfort in such an image today.

Blake's work, though, is compassionate in a very different way – he has spent very little time in hospital, so his open-hearted response to the invitation from Rhodes cannot be explained as that of a 'grateful patient'. He readily admitted to identifying with the life-stage of the patients whose ward he decorated – 'I didn't want to be disrespectful but as I was their age . . .' – but there is clearly much more to this set of images than a *Golden Girls* view of old age: that 1980s American sitcom of four oldsters living up their final years in Miami in a haze of alcoholic companionship. The digital prints (scaled up from smaller drawings) that filled the public spaces such as the dining room or corridors did indeed show older people enjoying life. But this is life to the full – they dance, read to themselves and to each other, garden, eat chocolate, paint, exercise, cook, play football and drums, sculpt, dress up, feed birds, do all the things we all sometimes like to do, and they do them in a fine multi-generational company.

The pictures feel light-touched and full of good humour, typical Blake images you might say, and they would and do certainly make viewers smile, something that Rhodes believes is a 'significant achievement' in a psychiatric ward. But I think there is even more to them than that. The message seems to be both *for* and *about* the patients, most of whom had some form of dementia. It says that they are still alive and it connects them with the human activities, which, in the best settings, they might still enjoy. It reminds clinical staff, carers, family and friends that the lady hunched silently in a winged armchair in the corner is also someone who thrilled to Elvis in the 1950s and might still do so if someone could remind her, with images or with music. As dementia specialist Professor June Andrews advises people with the disease, in her guide to dementia,[3] 'If you want to stay at home for as long as possible the important thing is to keep busy. This means doing everything you usually do, whether that's bowling, gardening, going to church, visiting museums . . .' The *Kershaw Pictures*, as they are called, really seem to me a confirmation of this, and a plea for engagement with the person inside the illness or disability.

The last word about this project comes from Nick Rhodes again. It stood out from many of the Nightingale ones, he says, because along with his essential understanding of the world on the ward in which the patients were now living, Blake brought such a unique and practical grasp of how to illustrate 'a place' in terms of fitting the images to the environment. According to Rhodes, Blake has an immediate and unerring sense of how each space could be animated. He even knows how to deal with the impossible problem of the Fire Exit, or other pieces of signage, which in the NHS tend to appear on walls with minimal aesthetic consideration, highlighting the anonymous institution over anything else that might have been placed there to mitigate such an atmosphere. In the Kershaw ward a Fire Exit sign appeared prominently on a wall at the end of a long corridor, in a place Blake had identified as a good spot for an image. Blake first wondered whether the sign could even be incorporated with the image, but finally settled on a decidedly horizontal picture showing a man in a hammock which was placed well below the sign and managed to distract all attention from it.

Other hospitals have been quick to recognize the value of these schemes and since 1998, prompted by the Nightingale Project, Blake has done an average of one project a year. These range from waiting rooms in the Armand-Trousseau Children's Hospital in Paris, to mental health centres in London, to maternity wings in Cambridge, Scarborough and Angers, (France), to an Eating Disorders Unit in London. Sometimes the works are commissioned by hospitals, but Blake will also occasionally come up with an idea (as if from nowhere) which Stephen Barnham, co-director of the Nightingale Project, seizes upon gratefully. For example, Blake remembers being on holiday in France and starting to draw figures, who were swimming but fully clothed.

He showed them to Barnham who saw at once, with his valuable and rare knowledge of both art and the needs of patients, that these images could find a good home in the Gordon Hospital, a mental health unit in London. Blake now realizes that

these figures were also in what he calls a situation, which is parallel to the actual one they find themselves: alien certainly, but with reassuring elements.

He currently has more plans for London hospitals including a smaller-scale project at the Great Ormond Street Hospital for Sick Children, where Blake has made a set of images for a pleasant and comfortable room. But this is the room in which parents can be together, perhaps only for a day or two, with their critically ill and dying baby or child.

These drawings were commissioned by a couple who lost their own baby, Elliott: as Jenny and Michael Walker recalled in an *Observer* interview (3 May 2015), there was no family-room for the three to be together during Elliott's last days, and they ended up staying in a store-room at the end of the corridor. 'As Elliott was dying,' says Jenny, 'we said: "We don't want any other parents to have to go through this,"' and so they set about raising money for an 'end-of-life care room . . . to enable families and their children to have a quiet, peaceful time in their last hours together'. For the couple, the idea of an artist's work helping to create such an atmosphere was an obvious one, and Blake was a natural choice of artist: not only did Jenny love his work, but they knew that asking a well-loved illustrator to make work for the room would be a consoling bonus. The couple were delighted with the results of this commission: Jenny says: 'Blake has captured in pictures what I sometimes struggle to put in words.' And of the image illustrated here, she says: 'One [horse] is drinking; [the other] is looking round. I'm not a horsey person, but it moved me and my husband to tears when we saw it because the horses are really caring for each other.' There really is a different kind of healing at work here, because, as Jenny has understood, these images are not primarily designed for the patient, who will not recover, but for the soon-to-be-bereaved family.

Speaking about the project Blake says:

In the ten years from 2006 to 2015 I have had the opportunity to undertake an extensive sequence of projects for hospitals. The most recent two of these were, unusually, both commissions from individuals. The set of four related pictures for Dr Kathrine O'Brien is described later: the second, Elliott's Room, is still at the time of writing not yet in place, which is why Ghislaine Kenyon has asked me to write some notes about how it came about and how it is developing.

About a year ago I was approached by a young couple, Jenny and Michael Walker, whose son, born in Great Ormond Street Hospital, had sadly not survived. So that they could be with Elliott for the end of his short life the hospital had put them in a room not specifically intended for that purpose. Subsequently, aware that there would be other parents finding themselves in a similar situation, the Walkers asked if Great Ormond Street could find such a room; it would be called Elliott's Room, they would pay for its furnishing and decoration, and having seen some of my other work for hospitals, they asked me if I could produce some pictures for it.

I have been fortunate in the sequence of hospital projects I have worked on that I have encountered – more by accident than design – a gamut of different situations: young patients in England and France; adult and elderly mental health patients; those with eating disorders; mothers about to give birth. And how I was eager both to respond to this young couple's positive and generous gesture, and to find the answer to a new question. It was immediately apparent that many of my visual gambits of cheering-up, teasing, activity, optimism, would be out of place. In all these projects I have taken the opportunity to consult both patients and professionals; here, in my first exploratory drawings as with later ones, I had the invaluable resource of being able to get the reactions of two people with first-hand experience.

What was needed, it seemed to me, was images which were calm and intimate, which refer indirectly to the situation and were directed at the parents as much, or more, than at the children. The pair of horses, for instance, among the earlier drawings, had meaning for my young clients, and other animals and birds were at their suggestion. The room also has to contain medical equipment and is, within its small space, quite assertively rectangular. In an attempt to ease that, the pictures have a sort of decorative vignette fringe, or a soft watercolour edge. And then, the other element that seemed to me essential, some kind of prospect, some journey travelled or yet to be travelled, some vista to be looked back over and at the same time to be looked forward to.

The pictures will be reproduced as digital prints, but even so, taking into account the relatively small size of the room, and that we wish to encourage some sense of domesticity, I am sure they will not be large.

My own take on the horses is that the picture with its leafy framing device is like a vignette, an incidental little drawing, which gives character to a page. But in this context it is something different: the two grey horses standing in a peaceful stream may be just that; perhaps the one looking up from the water is simply distracted by the birds above; but, as Jenny picked up, they can also be read as a metaphor for the parents; in the sombre tonality of the picture, that raised head might be staring into the distance – mourning an absent child. Going into the territory of dying takes bravery. Even clinical staff with whom I have worked on arts and health projects have several times admitted to me that this is something they're 'not very good at', but Blake has managed to embrace this most extreme of situations too.

Also from such a personal contact but in a very different spirit came a commission from Dr Kathrine O'Brien, Blake's former GP, to make some work for her consulting room. Again there was no brief but she was looking for something that she could actually use in consultations. As she says, her understanding of the reason why patients visit her surgery is that

it's rarely purely physical . . . rarely purely on the surface. But the longer I sit here as a GP the more you realise it's not just the physical, it's the physical and the emotional and that the physical goes on under the surface as well. For me it's always about the exploration. So [it's about] listening and reflecting back and trying to work out what it is that's going on for each individual person, which is often about something inside, so it's about how you get below the surface, for me anyway.

With this kind of sensitivity O'Brien already knew the potential that pictures have to stimulate or guide such explorations and she already had a few in her surgery, all depicting nature in some form:

one was of a desert and that was an invitation to explore as far as I was concerned, no people, just a desert. Then there was another picture of St Michael's Mount with lots of

people walking on a pilgrimage, so I said that's people on a journey, and then there was a picture of a bird taking off on a lake; it was talking about new beginnings.

So when there was an opportunity to reconfigure her surgery she took the opportunity to see whether Blake might like to make some new work, knowing as he did the context. Ever responsive to this context, that of a family doctor's surgery, he came up with four ideas, which would reflect different life stages of the patients.

In his words:

In a sense the point of it being four pictures, [is that] the perspective goes through them, they are continuous through each other and I think the fact that each picture is only one colour is a way of telling you that this isn't just a picture that I went out and drew, and filled in the colours as they actually were, but that it has another purpose so to speak. The orangey one is the more youthful one, perhaps the green is more active, although [the woman] is going a little bit into reflection and then this is the most comfortable autumnal [brown] and these are various members of the family at different ages so you ought to be able to find somebody about your age in there somewhere I think. Then the advantage of having separate pictures is that you can move those colours, it is not just a photograph of what is happening there on that day and then it also has the advantage that one picture, the bottom right, [blue one] is much lower. You are actually going down to darkness. Technically speaking she's having a swim but you are going into a different colour-way and a different mood so that was to try and move fairly naturally from an everyday buzz of children and so on, or this young couple to . . . she is sort of diving into herself really I suppose, or something like that. Which is why I wanted them to be separate pictures so that they have a slightly different atmosphere it's the same picture but it's a different day.

As we know, swimming is not Blake's 'thing' but its symbolic value, as suggested above, has always been useful, and in the case of the surgery pictures, there was an extra reason to use it as a theme, since it was the sport that Dr O'Brien practises: 'For me it's also the journey . . . my own personal journey has involved swimming . . . You do have a knack of putting us all in the pictures, and we can all see it.' She then adds that the swimming picture is actually the one that she herself used to see, as it hung opposite the seat where the patients sat: 'so it's more of an inspiration to me, quite a support'. The notion that such works are as much for the staff who see them all the time as for the patients who only visit occasionally is a key one. Everyone in the healthcare system needs this kind of encouragement and understanding.

Two more of these projects can be explored in greater detail to see how an illustrator responds to this very different kind of brief. A text is the brief for an illustrated book, a selling idea for a billboard advert, a political situation for a cartoon; in all these cases there is a specific to be dealt with. But the brief for the hospital projects is often very broad, so broad as to be almost non-existent: when

Blake is invited to create a scheme for a hospital setting he is often given carte blanche (although he will know what and where the available spaces are) – as he says 'the brief doesn't really exist, I invent it.' This is partly because the commissioning of art is sometimes an unfamiliar experience for the clinicians or managers who take on the task.

So with a new hospital commission there are many options for an artist: he could think about showing the hospital itself, as a busy institution at work, or as a building in a location; he could focus on filling a space in a particular department with safely

pleasant images of the world outside: the kind of flowered and fruited still lives, or the watery landscapes you see improving the environment of blank corridors in many institutions; or he could focus more closely and illustrate the conditions the department is trying to cure or alleviate, in the way that artist and scientist David Goodsell has done with his glowing, minutely executed watercolours of diseased cells; he could take the staff as a subject, showing reassuring interactions between them and patients, in theatres, wards and consulting rooms.

In fact Blake's gaze is often more directed towards the patients and families. Not so much on representing the 'disease journey', as artists such as Michele Angelo Petrone did in his often-bleak, intensely coloured metaphors of physical suffering, but instead on what it might be like to be a patient in what is, for many, an alienating new environment. As a patient, your stable self is under a dual attack: not only are you sick enough to be in hospital in the first place, but you are also away from familiar people and things, the latter bringing extra anxiety if you are a child. This is where Blake starts.

When Blake worked on his project for the Vincent Square Eating Disorder Clinic it was still situated in the square of the same name, near London's Victoria Station. Now relocated in Kensington, the clinic diagnoses and treats men and women (in practice often young women) with eating disorders of various kinds. These were also big unknowns for Blake, so, before starting work, he went to talk to the service users and staff there. He found this both a distressing and a useful experience: distressing to see young people so extremely ill but useful because he learned that what they often had in common was a fastidious attitude to life in general, not just to food, and this was something he could address in his unobsessive drawing style, which in this case he put to specially relaxed and generous use with a quill pen. He was also relieved to find a robust sense of humour: meeting the service manager and one or two young women for an initial consultation he asked them if there were any 'no-go' areas as far as the content of the works was concerned. 'You can draw anything you like,' said one of the young women, 'but not too much food; I've got enough on my plate already.' Armed with this thought, but with a focus on the not too much, Blake made over forty drawings, which were to hang in the public spaces of the unit.

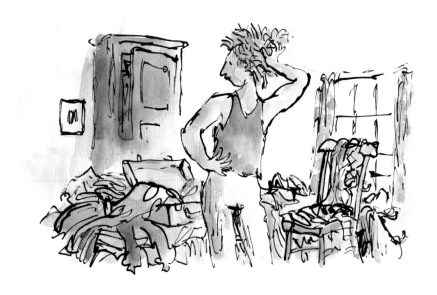

Of all Blake's hospital drawings these seem to me to have the most deliberately therapeutic intent: they start from a position of understanding: the girl in paralysed indecision in front of the clothes mountain, or desperately trying to get a clean line on her lipstick – these are things that the patients feel do really represent them. But the drawings go much further, they suggest other ways of living. In some of the images Blake makes the most basic elements of daily life seem enjoyable, even if not always perfect: you can go for a companionable walk in the rain, you can feed birds on your window-sill if you don't have a garden – (amazingly, Blake says, he later found out that there had been a patient who had actually invited the pigeons into her bedroom); you can have a great night in, slumped on an old sofa with a book and a good friend to do your hair, even if you don't have a flat stomach. And Blake managed to slip in the food message, without ever lecturing, by including animals, or cookery or gardening scenes: a dog sitting up for a biscuit, people buying fruit in a street-market, or the pleasure of pulling carrots in the vegetable plot. That the effect was indeed therapeutic is evidenced by a written response to the work by an artist who was also a former eating-disorder patient: she looks at the examples of food-sharing, both human to animal, as in this picture with cats, and human with human, as in this apple-picking session: 'The association between offering food and love, accepting food and trust, works to a very profound yet unintrusive level . . . Attending to pets also means reaching outside ourselves, nurturing them means recognizing and becoming sensitive to other's primary needs . . .' and 'It is a fine summer's day and nothing looks more inviting than enjoying together a juicy, freshly picked apple . . . as we are only spectators and our presence is not demanded or expected, we feel under no pressure to share the characters' activities, yet secretly we wish we were having such a pleasant time.'

My own work with people and pictures in hospital settings[4] has repeatedly shown me that patients relate to images in a heightened way: people so often project their own situation into a work of art, even one with no therapeutic connotations. So it is no surprise when pictures, in which the perspective of the patients has been considered and understood so imaginatively, manage to speak to them so directly. As the arts consultant Alison Cole once said to Blake of his work in such fields: 'People want you to reach out for them: you should be given a medal for services to outreach.'

The Eating Disorders Unit was, in spite of Blake's positive interventions, a place of serious illness – indeed one of the patients he met on his first visit died not very long afterwards although she did live long enough to see her much-loved dog, of which she sent Blake a photo, appear in one of the pictures, and it is now a kind of memorial. But in the new maternity unit at the Centre Hospitalier Universitaire at Angers in western France, the 'patients' would not on the whole be ill, although of course many would be feeling pain, and perhaps anxiety. The project, which I worked on as a consultant, was apparently a first in France: the first time that an artist had been involved at the early stages of the design of a hospital building, and it was a huge project in the end, with 50 works being displayed throughout the new building. Anne Riou-Chartier, the hospital's 'cultural adviser', had been looking for an artist to animate the planned new building, and found Blake through Patrice Marie, at the time working at the French Ministry of Culture. Marie had previously implemented a forward-looking government initiative called 'Culture à l'Hôpital', which required every French hospital to create a partnership with at least one local arts organization. At Angers there was already a flourishing arts environment with exhibitions and projects in children's wards. But the size of the maternity scheme was of another order.

Blake had never visited a maternity hospital before – the nearest he had got to such a place, he once implied in a quiet aside, was when accompanying a friend who was to have a termination. On our first visit to Angers we were shown around the old maternity unit (then still in use), so that Blake would have a sense of the environment he would be working with, and to meet the staff who would be working in the midst of his images.

That first meeting started well, with a four-course lunch accompanied by several good wines, in a private staff dining room (we knew we were in France). But at the business meeting round a table, which included the architects, hospital management and clinical staff, the atmosphere was much more formally French. The architects seemed reasonably sympathetic to the idea of an artist 'completing' their building but I felt that the clinical team, especially the male consultants, were yet to be convinced, or maybe their minds were just elsewhere. Blake himself confessed to momentarily feeling 'quite intimidated' when, at the second or third meeting, we were faced with a barrage of midwives, strong and opinionated women who brought all their knowledge and experience of women giving birth to his place of unknowing on the subject. But, as Blake says: 'Little by little I became immersed in the atmosphere of the hospital through my conversations with the teams.' Immersion was the right word to use here as Blake decided that water would be the setting for his figures – alluding to the amniotic fluid that surrounds the baby, to the fact that newborn babies

have a swimming instinct, as well as to the waters of the River Maine that flow past the hospital. As a result, the drawings have a gentle French rococo swirl that has reminded some viewers of Boucher or Fragonard.

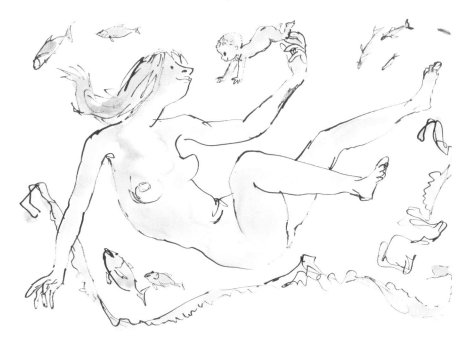

Blake's ability to collaborate with people and place was recognized by one of the more sceptical consultants who, by the end of the project, felt able to say: 'Blake didn't just bring his work with him, he was inspired by the spaces and the people who work in them.' He did respond to the place, and he did listen to the staff: when one or two of the team argued that fathers should be represented in at least some of the works, he made new drawings in which father–baby interactions were just as real and as moving as the baby–mother ones. When, at another point, for cultural reasons, reservations were expressed about a drawing in which the mother's rather spread-out legs made the pubic hair very prominent, Blake accepted that it would not feature in the final scheme. At another moment, a question arose about whether Blake would make drawings for a room which would be used for late medical terminations of pregnancy: a room where a mother would be delivering a dead baby. He readily agreed to this and when he presented several drawings, he listened carefully to the comments of the clinical teams. There was a long debate about which of the drawings he showed them would best achieve the sense of solace that he wanted to create for this particular space. This one which shows a young woman being supported by an older one (in midwife role) was, revealingly, dismissed by one male member of staff as looking like 'two lesbians'. But the midwives had a very different take. In this image they saw not only the immense difficulties faced by the mother, expressed by the thick bank of

seaweed in the foreground (also there 'to respect her modesty', as Blake later said), but also the importance of their own role as guides and helpers on this toughest of journeys. Needless to say, their view prevailed.

For the small room next door where the parents 'say goodbye' to their child ('We do consider them as parents,' said one of the midwives, 'parents of a child who hasn't lived'), Blake came up with two moving metaphors for the situation, keeping the water theme.

More serious discussion followed, ending in a decision to hang both of them; no one could decide which was more apt: the floating bouquet, which had something of a little body drifting away about it, or the single flowers, more suggestive of finality accepted.

By this time, it was clear that Blake's work and his attitude had overcome any uncertainties which may have been present at the beginning, and the team suggested to him that 50 drawings to cover every room and corridor might not be quite enough – why didn't he think of doing a few images for the glass façade too? This offer was a defining moment for Blake: a chance to mark the ship-like building, with its wave roof, with the fluid lines of his aquatic ideas. Five of these six images were head-and-shoulder vignettes of mothers with babies, and the last was a woman on her own, reflecting the fact that this unit also treated gynaecological emergencies.

Blake saw this also as an opportunity to give the passing public a sense of what was inside, because, of course, only expectant mothers and their birth-partners would actually see the scheme.

Remembering how this project developed, I think it was a model collaboration: there were no grandiose expectations on either side but a genuine mutual curiosity and a growing sense of how everyone – the artist, the client and future audiences – would benefit from these works. Their power to express a range of feelings surrounding the birth of a child was apparent to everyone, and Blake's willingness to speak French, at internal meetings but also in public to sponsors and local officials, and his quiet humour and charm, all these things made for a truly productive and warm working relationship. Within it, the purpose of the scheme, to make the users of the maternity services feel as welcome and calm as possible in the intensity of the birth experience, was always there in front of everyone. This atmosphere was also

picked up by the staff member who managed the neonatal ward where premature or very sick babies were nursed. Access to this ward was through what this lady described as a '*triste couloir*' (a sad corridor), along which newly delivered mothers would need to travel to see their babies. This manager, keen for the scheme to extend to her domain, asked Blake whether he might be able to make some images to animate this bleak space, and so perhaps also to console the mothers who were without their babies. Blake agreed without hesitating and produced these gentle metaphors, the idea here being that although the baby is separated from the mother, she knows that it will be properly and lovingly taken care of.

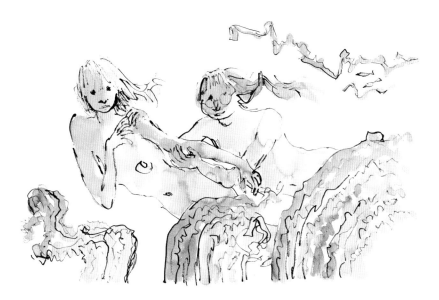

The warmth of the whole project was exemplified in a moment which Blake recalls with special pleasure, near the completion of the building, when Edmond Vapaille, whose job title is '*chef du pôle des ressources matérielles*' (he looks after the money), said seriously, 'There's one very important thing.' We held our breath. Had the money run out? Did the hospital top brass not like the drawings? But no, to this hardened administrator the really important thing was 'the exchange of look between the mothers and babies' in the drawings.

Anne Riou-Chartier, reflecting on the project, said:

It's not easy for someone from outside to go into a hospital, still less into a ward. It's like going into the home of a person who is fragile, sensitive and frail, you're always afraid you might break something. Quentin Blake understood this straight away. He pushed open the doors to the maternity unit [at the CHU Angers] with great care and attention, both for the mothers and future fathers and the babies but also for the midwives, the doctors and the nurses. His way of observing and listening allowed him to be welcomed into the kind of healthcare setting, which rarely sees artists at work ...

These works are now part of the identity of this maternity unit; they are with the staff and patients every day. The drawings were widely welcomed when they were installed, and for the clinical staff who led this project it was a beacon encounter, in an environment which can seem all too distant from art and culture. (Author's translation)

Any misapprehensions that Blake is primarily (or merely) a children's illustrator are dispelled by hospital schemes such as these. Here we see him addressing adult audiences, often in testing, grown-up situations, to which he brings imaginative empathy and hope. But, in a way, his work for children's health centres and hospitals may relate more closely to his own experiences: he has not had cancer or dementia, or a baby, but he has been a human being in the unfamiliar environment of a

hospital. For the Alexandra Avenue Children's Centre in South Harrow, Blake was commissioned by the Nightingale Project to make a large image for the reception area and several small ones for the corridors. *Welcome to Planet Zog*, as he calls the largest of the works, take as a theme the metaphor of alien life.

Blake has always enjoyed creating non-human creatures: his memorable and clever illustrations for Russell Hoban's disturbing picture-book *Monsters*, or the clodhopping purple versions for the more lovable *Monster* series. Some of his most successful live-drawing appearances, for example those at the annual Big Draw events for families, have involved him standing in front of a 3 × 2 metre stretch of paper, thick felt-tip pen poised to respond to children's increasingly fevered demands to 'give it another eye' or 'make it green and spotty'. On these occasions such yellow five-legged bug-eyed creatures give delight by coming to life on the paper, absurd and cheerful and different. But when Blake repurposed them for Alexandra Avenue, his intentions were much more specific.

Blake approached this scheme with the child's perspective in mind. What is it like to have to go into a strange building, meet unknown adults, who may sting you with a needle, poke your ear with a cold hard instrument, make you open your mouth wider than you actually can so that they can look down your throat, ask you to take your clothes off even, or use words you don't understand? The situation may be as alien to you as the creatures. So Blake, with his sure emotional logic, turns the doctors and nursing staff, and some patients too, into the aliens, the Centre into a land of striped trees and curious red mountains. Unexpectedly, these aliens turn out to be quite friendly: one makes you laugh when it spoons medicine into your mouth while holding one bottle in one hand and another balanced on its tail another can hold on to three children and an ice-cream with its four arms, *and* smile at them all at the same time with its four eyes; a third allows you to look inside *its* body by opening a pink door to reveal a fascinating mass of metal pipes and cogs.

Blake is saying to children, as he puts it, 'You will cope and it's actually interesting!'

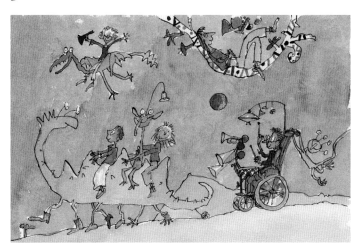

This last idea is taken up in a recent project (December 2014), hot from its successful launch at St George's NHS Hospital in Tooting. The Dragon Children's Centre is also used by young patients, but, unlike Alexandra Avenue, this is a major outpatients' centre serving more than twelve thousand children each year. In a pioneering project for this Trust, the hospital's Arts Director Lucy Ribeiro wanted to commission a scheme to animate the long low arterial corridor leading to the consulting rooms. Here are families with children with often severe or persistent conditions – a place where the anxiety level is potentially high – and Ribeiro wanted high-quality work, which would make the space a place of distraction and fun, but also empathy. Her philosophy for such commissions is that they should be grounded in the user-communities, so for this one she both consulted the staff who worked in the department and held a series of workshops, in which she canvassed families and children about the kind of atmosphere they would like to see conjured on the walls of the centre. She showed them the work of many artists and illustrators but it was Blake's work that regularly and consistently came up as a style which was appreciated and recognized by all age-groups, as one that seemed to address them personally. Blake was the man.

Apart from the dictates of the space itself, the only brief for him was 'dragons' and the fact that the users were young people of many ethnicities aged from newborns to 18-year-olds, and who mainly came with their families. The budget for the project was limited – here as in most NHS Trust arts projects, the money is raised by a separate charity and Blake did not ask for a fee, although he normally does in these situations: he says that he does not want hospitals to

feel that art is a charitable extra, but that it makes a significant contribution that it is worth paying for; and because there are artists who do need to be paid, perhaps more than I do. Nearly all my pictures for hospitals are produced as digital prints. This is convenient in that they can be kept clean, have a low insurance value, and are replaceable. What I am paid for in fact (as for illustrations in a book) is the right to reproduce the drawings, of which I keep the originals. In this case I was given to understand that there was only £5,000 available for the project and it seemed to me that the money would be best spent on enough dragons to go all along the corridor and on getting them printed and presented in the best possible fashion by Alexis Burgess [Burgess Studio] and his design group, who have looked after me very successfully on previous occasions.

Ideas for this project immediately flew into Blake's head, as they so often seem to do with a new commission, and he came up with nine images: one smaller print in which the dragon theme is established, followed by eight large prints.

In this set the dragon is both a reassuring presence, giving rides to children or reading them stories, and a patient himself, with perplexing spots and drooping ears, or a bandaged tail. Of course, Blake makes sure that the patient is surrounded by sympathetic adults, and children. The message, for both patients and their families, is that you will be taken care of in this place, whoever you are and whatever your condition.

Ribeiro describes the day of installation as an amazing transformation of the space: 'We hung the work during the last session of appointments. At the end of the day the clinicians emerged delightedly onto the corridor: "'I had no idea it would change the space so much," said the lead consultant. "I'm so looking forward to coming to work tomorrow."' Ribeiro feels that the work brought out 'the childlike' in the staff:

They all rushed down to see the work, from different departments … they took time looking at it in great detail, discussing it with each other. It has really changed their environment, to have this kind of art in their working spaces; they work such long hours. I could have watched them looking at it forever – it was real wonderment.

Ribeiro believes that the wonder was also at the fact that someone as famous as Blake would be prepared to contribute in this kind of way to a hospital corridor.

The value of all these hospital projects to the staff, whose daily working climate is the underlying needs, demands, frustrations and anxieties of patients and families, should not be underestimated. These people, who see the art every day, find that both its positive mood and the (related) fact that Blake has been personally involved, even for a short time, with their working life, heartening and motivating.

Young people were also the beneficiaries when Blake contributed his presence rather than his work, in a very different setting. Dalwardin Babu, a now retired Chief Superintendent in the Metropolitan Police, needed some help. In 2000 he was working in the King's Cross area of London, at the time a territory disputed over by the rival white and Asian teenage gangs of the Regent's Park Estate or haunted by

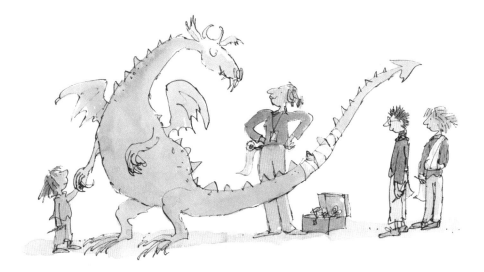

the sex-workers of York Way. After one particularly tragic gang murder of a young teenager, Babu's job was focused on reducing gang-crime, and he brought a rather unusual policing style to this task. Instead of the rotating-door of arrest and youth courts, he decided to use tactics of engagement. He took a group of white and Asian boys to Belfast 'to see what can happen'. He says, 'For a lot of them that was their summer holiday . . . a weekend away to Belfast was what they wrote about when they went back to school.' And, in travelling around the schools of the borough, he noticed that there was one thing these young people did have in common: the students were reading the Roald Dahl novels, and enjoying Blake's illustrations, so he decided to run a reading project around these books, bringing boys and girls together in school as well as involving police officers and local business people.

Babu and his young daughter had met Blake at the National Gallery earlier in the year where Blake had been giving a drawing performance in connection with the exhibition *Tell Me a Picture*. Babu remembers 'the way he captured the figures so well, you can feel the goodness, you can feel the badness!' and he recalls Blake's generosity when they queued for a book to be signed at the end of the session: 'Quentin was so lovely because we took an old battered book that [my daughter] had read and we apologized, and Quentin Blake said, "No, no I love it because it means you've read it."' It was this warm reaction that made Babu decide to ask Blake there and then whether he would give this talk to his King's Cross gang members, and he said, 'Yes I'd love to.' The resulting appearance is warmly recalled by Babu and in vivid detail:

The kids were so excited, you could hear a pin drop . . . they had their books in their hands and you could see when Quentin was drawing the BFG that they were turning the pages to look at the drawings in their own books . . . Quentin is so modest, he doesn't realize . . . he doesn't have to do these things but he does them for the young people there and he really gets it . . . Several years later, I met a group of youngsters, and – I'm quite emotional about this – I was with my daughters in the car, and these youngsters called out my name . . . As a police officer you're always a bit worried when that happens: is this someone you've put away? And I was with the girls and being very protective; but it was a lad shouting out in delight, 'Do you remember when Quentin Blake came to our school?'

Blake had of course visited many schools by 2000, and in 2014 he still does visit his local primary, Bousfield. But 2000 was the year of the Children's Laureate and he had decided that his priority would be to promote illustrated books, and illustrators, in a more far-reaching way – he would bring his message to adult audiences; it would in any case be quite impossible to go to all the schools that wanted him to come to them. But he made an exception for Babu and the gangs of King's Cross, and has since made two further visits; one to Tottenham and another when everyone came to the police station in Harrow: 'We had the children from local schools all in the canteen – we had shut the canteen down – and these officers who would normally whinge and moan about not having their canteen, they all came along. By the end there was a . . . bun fight about who was going to give Quentin a lift home.'

Babu says that as a result of these projects the local level of violence 'plummeted', and he has the statistics: 'There were 177 incidents in the six months preceding the King's Cross project and in the following six months there were only four.' He adds, with feeling: 'For me if there were more people like Quentin Blake who would give unconditionally – he never asks for anything – if there were more people like him, I think the world would be a much better place.'

Blake and his art have also helped make a gallery in Hastings and, by extension, the town too, more accessible places. Blake has always loved Hastings and has a home there. The Jerwood Gallery opened in 2012, in a new building in the Old Town, and in a climate of loud and heartfelt local opposition. A campaign 'Say NO to Jerwood on the Stade' has been objecting ever since 2009 when plans were first announced to build a gallery on the seafront. The council was to build a home for the Jerwood collection of Modern and Contemporary British art next door to the Stade, that evocative stretch of shingle at the eastern end of the town, where fishing boats pull up on the beach and strangely tall and thin weatherboarded huts known as net shops rise up like a small black seaside forest. The hostility was not so much – as in many 'anti-art' protests – towards the idea of an art gallery in Hastings; rather more, it was objecting to its proposed location: the fact that it would be next door to a piece of familiar fishing heritage and that its footprint would occupy a portion of the existing seafront coach-park, which, the group claimed, brought both visitors and much-needed income to the town.

Once the gallery did open, one of the principal tasks for its new director Liz Gilmore would therefore be that of persuading local people to step over the threshold: both those people for whom the building of the gallery now represented a political defeat and those for whom the collection itself was perhaps a barrier. She realized that, for example, abstract Terry Frosts and Prunella Cloughs, or John Bratby in 'Kitchen Sink' mode, might seem 'indigestible' to some audiences. Instead, she says, she would aim to create an appetite for engagement with the collection through its exhibitions programme. Having seen Blake perform at the gallery at an event for the Hastings Storytelling Festival, it occurred to her that she could invite him, as an artist with an accessible aesthetic, to cast a glance at the collection, to 'illustrate it'. Audiences would then find other reasons to visit the gallery and, with luck, they would also see the collection itself with new eyes.

Artists on the Beach was the small but happy outcome of this strategy. In it, Blake chose ten works from the collection and for each one he made a portrait of the artist in a beach setting with Blakean details relating to their own stories, and a short piece of text. Enlarged prints taken from these drawings were hung together in one room and Blake's idea was that, with the help of a trail, his pictures would encourage visitors to find the relevant works in the rest of the gallery. As already suggested, the Jerwood collection could be considered somewhat specialist for the non-specialist gallery visitor, but for Blake it did have some relevance. In the 1960s and 70s he had, alongside his illustration work, quietly been making easel paintings in oils.

Alfred Wallis

This was a period when many of the Jerwood artists such as Burra (also a local artist for much of his life), Clough, Bratby and Spencer were also active and Blake had been aware of and interested in their work at the time: 'It was like revisiting one's past, to catch up with them again.'

Gilmore was delighted with the exhibition, and indeed with the whole process – Blake was a 'dream' to work with, there was a 'humility and quietness' about his approach, and she recognized his ability to be responsive to the context of the gallery, and to the needs of inexperienced audiences. And the result was increased visitor numbers and, she says, the feeling that the gallery had spoken to people in a different and welcome way. Blake is now busy with ideas for a new exhibition for 2015, which will also use the activities of the town as a starting point for work, which, he hopes, will be equally inviting to its residents.

The ways in which Quentin Blake the person and the work he creates make people feel better is both subtle and powerful: readers of all ages, families, patients, working people, individuals, including people with very little connection to the art world, all seem to find something consoling, delightful, truthful about the work and the man alike. We must never forget that Blake started out as a cartoonist who was perfectly capable of making fun of people and situations, and he is an admirer of satirists, from the *Charlie Hebdo* artists to Hogarth, but, he says, he couldn't do such work himself. ('Perhaps I'm too timid,' he says; 'there are some people I'd love to offend but I'm not sure I've got the right tools to do that.') His favourite Hogarth print is not *Gin Lane* but *Strolling Actresses Dressing in a Barn*. This image of a group of impoverished actresses using a draughty barn as a changing room does, according to Blake, 'offer

to be satirical' but what he sees is also their plight, the fact that they have completely inadequate costumes to play the roles of gods and goddesses they have to represent, and are sitting darning stockings and drinking gin to kill the pain of toothache. Blake finds satirical drawing wonderful but in a way more straightforward than what he tries to achieve in his empathetic work. What he does works because his version of humour is neither lampooning nor sentimental, and so we can safely feel a part of it. To repeat Kathrine O'Brien's works addressed to Blake: 'You do have a knack of putting us all in the pictures.'

Part 3

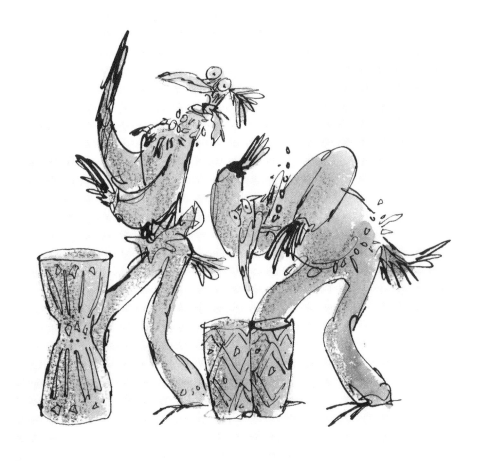

Art and life

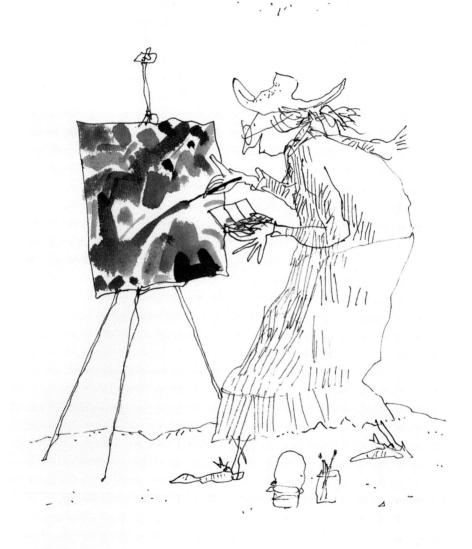

9 *Patrick, Zagazoo* and new-found lands

There is a fashion among couples looking for readings for their wedding ceremonies to choose passages from children's books. Favourite titles range from Dr Seuss's *Oh the Places You'll Go* to Margery Williams' *The Velveteen Rabbit* (Princes William and Harry read alternate lines from it at their cousin Zara Phillip's wedding), Antoine de Saint-Exupéry's *The Little Prince*, A. A. Milne's *Winnie the Pooh* and Frances Hodgson Burnett's *The Secret Garden*. One reason for this trend, according to Maria Nikolajeva,[1] may be that for adults, children's books strongly represent shared experience: often, as we saw in the chapter called 'Giving', they trigger powerful childhood memories, from a time when they didn't yet know each other. An alternative motivation, argues Nikolajeva, might be that children's books are so well geared to expressing thoughts and life-philosophy in a highly concise way: they are ideally suited to texts for a wedding, which for many young adults may be the first time they mark a significant life-step in public.

Why might it be, given Blake's renown, that the books he authors himself do not feature in any of these top-ten wedding-reading lists (although couples do often write to him asking for a picture) . . .? Popular and recognizable as his style is, perhaps the characters he creates don't enter public consciousness in quite the same way as

From a series of drawings for the Kershaw Ward, 2006

Winnie the Pooh or the Little Prince have done; and, as concisely written as his texts are, they do not provide epithets or passages that deal explicitly (and conveniently for these purposes) with love or wisdom; they are not so much the kind of words that people seem to want at weddings. He does and can do character, of course – just think of Mrs Armitage or Mr Magnolia – but these figures are not cuddly, they are a bit too scratchy to be favourite soft toys. Neither are they animals or children, or the kind of characters children so readily identify with. Maybe this is because what Blake has always been most interested in is the situations in which his characters find themselves, and in framing narratives for these. It is in the way that he captures such things with his imagination and his pen that his philosophy is in large part to be found. But this is a philosophy which cannot easily be isolated from his work, or indeed from his person; it is one, though, which would, I suggest, be of use to any couple starting a life together, or indeed to anyone at any stage of their life. It is a philosophy of empathy with people and the situations in which they find themselves, and it contains an understanding that gentle humour has optimism at its core. Blake's optimism is not Panglossian, based on ignorance and foolishness, but on the simple premise that making people smile can make them feel better. I think this philosophy is there in the work from the earliest part of his professional life. It's here in this picture from *The Wonderful Button* (1961), illustrating a story written by Evan Hunter (aka the crime writer Ed McBain), where an unhappy king learns how to be happy from a small boy, here shown offering the king his cloak with generous arms, while hard black trees and footprints in the snow suggest the king's emotional emptiness.

It's here in the understanding Blake has of this girl in a factory bus pondering her future, in *Home and Other Stories*, an educational publication from 1967. A slight little image, but there's something so expressive about the head in the hand, the weight of the bag on her lap and the other isolated faces.But it can just as well be found in a folk-tale image of a cold sad hen from *The Bear's Winter House* (text by John Yeoman, 1969), or in this picture of a batty Aunt Belinda addressing her plants in *The Family Album* (text also by Yeoman, 1993).

Each of these characters is immersed in their own situation, humorous or otherwise, but however absurd or pathetic, they are never mocked – somehow we can only feel glad that Aunt Belinda exists.

And the hen was unhappy on her perch because the strong wind blew through all the cracks in the hen-house and made her sneeze.

Perhaps his world-view can best be summed up in two books from different ends of Blake's career, *Patrick* (1968) and *Zagazoo* (1998).

As we saw, Blake talks about Patrick as the book he wanted to do to exploit the recent introduction of cheap full-colour printing – he would write a story where colour would be essential to the narrative. But we could take another view of it: Patrick is an innocent fairy-tale sort of boy with no back-story or context – he just sets out to buy a violin, which he finds in a second-hand stall in a street-market (Blake does like a good market, street or covered, especially in France). In the next spread we see him delighted with his purchase; on the left he runs so fast he almost takes off, and on the right he stands and blows the dust off his new violin.

The idea of an old instrument that hasn't been played for years is a magical one in itself, a kind of resurrection – and in this book, where colour is the thing, the grey-ochre dust of the right-hand image stands in symbolic opposition to the next page: when Patrick does start to play, the fish leap from the pond, now joyously multicoloured.

The magic of Patrick's violin music becomes stronger: the trees grow not only fruits but buttered toast, cakes and jellies; when Patrick plays, pigeons turn into birds of paradise, black-and-white cows into dancing spangled creatures, and, even better, a poor tramping man's pipe into a blazing fountain of fireworks. Best of all, when a tinker, thin and sickly (with 'a cough, a cold and a stomach ache'), hears the music, he becomes pinker of cheek, his suit takes on a zany stripe, and his stomach rounds (as Blake then thought, symbolic of his return to health – today he fears the anti-obesity lobby might have something to say about this representation). The procession of the 'changed' then rolls away in a warm, elated glow which is also felt by the reader. A single-theme story written for young children in simple language, this book can also be understood by the reading adult as something much more subtle about the transformative power of music: it transports you and excites feelings of every hue, and, of course, here for 'music' you can also read 'art', since you can't hear Patrick's violin-playing but you can see its effects.

Blake has, as we know, no direct experience of the parental perspective on children growing up – indeed, the starting point for *Zagazoo* was, according to him, based on precisely this ignorance, and particularly on his view of the behaviour of (some!) children in restaurants – 'I've always wondered how children who behave so monstrously grow into such reasonable and likeable adults'[2] – which makes the cheerful and in the end empathetic treatment of this fundamental subject even more remarkable.

First, it suggests in the subtlest of ways that to be good parents you need to be a good couple: so you do things together, whatever they might be. In Blake's imagination, George and Bella make model aeroplanes, do the dusting and eat strawberry and vanilla ice-cream; I doubt if he's done any of those very much, except possibly for the ice-cream, but he realizes how different every couple's list will be.

George and Bella have a baby, to their astonishment: the metaphor of a baby arriving in a bright parcel perfectly describes a pregnancy confirmation that you weren't expecting but are delighted about. And the symbolism continues with the growing child taking the form of an animal for each new phase – Blake chooses these with typical imaginative truthfulness: a vulture (nights of hungry squawking) – a warthog (messy), an elephant (clumsy), a dragon (dangerous and destructive). The parental point of view is beautifully envisioned, as if from experience: for first-time parents everything is indeed a shock; the ways in which your child tests every new boundary as he explores the world can never be anticipated; you are constantly confounded and perplexed and you cannot imagine how the situation could ever improve. By far the worst stage is when the pink and loving baby you once had turns into an alien hairy creature.

This spread is a brilliant representation in word and image of the simultaneous comedy and despair of being a teenage boy and being his parents: the hairy creature, now even bigger and stranger (but not happy either, so the child's point of view is also

present) and the parents, with fading clothes and hair turning grey from worry, who clasp each other in a gesture of mutual hopelessness.

The resolution arrives quickly, in the turn of a page, just as it can do in life: the monster suddenly becomes a perfect young man; he finds a girlfriend, and the signs are that they will have a good and fruitful relationship, since they both enjoy fixing motorcycles. The cycle, it seems, might be complete. But no . . . for the story to be truly three-dimensional, and because this is Quentin Blake, we need the now grown-up children's perspective on their parents, who in turn have become two wrinkled but contented old pelicans. To return to Nikolajeva's point, this is a highly concise book, which deals with almost everything important in family experiences in 32 pages, and

it does so through its light heart as well as through the sense that, whoever you are and wherever you are in the cycle, the author understands you.

These two picture-books seem to me to sum up Blake's understanding of the world as he meets it, as an artist and as a person: *Patrick* is about art and its effects, the colour and imagination that artists bring, and *Zagazoo* about a sophisticated but warm view of a, perhaps the first, family predicament. Seen in this way, these two books can seem somehow out of place when you find them next to *Spot* and *The Very Hungry Caterpillar* on a bright red bookshelf in the children's section of the bookshop, because, as good as such books are, their reach is so much more limited.

In *Patrick* the music/art can transform as the best art can; it makes things more beautiful, more intense, more extraordinary, and, especially in Blake's hands, the ever-present humour makes you feel more cheerful too. But Blake's embodiment of these effects in the characters who experience them has an additional outcome, a healing one, a 'making whole' of the reader, who may be a child but also an adult who is wounded, as we all are sometimes, by illness, dissatisfaction or real unhappiness.

Early on, Blake's career took off because he could both draw very well and make people laugh. He became a cartoonist, and some people still use that word to describe him, thinking perhaps of the rapid, entertaining lines and amusing situations that they might see on an 80th birthday card or on the cover of Dahl's *The Twits*.

But, as we have seen, over the 65 years of Blake's career so far, his work, while always keeping these qualities close to its heart, has become something quite other. Like all great artists, Blake would never have stood still artistically. For a person with high-functioning abilities, not just artistic but also literary, the transition from cartooning to illustrating narrative in books was a smooth and obvious one; Blake carries on illustrating books and this art, and its place and value, is still extremely important to him. But Blake has now successfully gone out into the public realm of hospitals, museums, galleries, streets and theatres, and here something else has come into play. Without the help of words or texts, these images need to speak for themselves in their contexts: generically they belong to illustration, to the everyday, so they must both claim attention and be legible to actual and metaphorical passers-by, and this Blake knows how to do supremely well. But to these qualities Blake adds a practically indefinable ingredient, a sense of energetic human flourishing against the odds, a representation of the better self. There are new ideas here and, although the line is recognizably Blake, some of the expressions, interactions and the colours feel different. Without explicit narratives and now articulated for big spaces, in these works we are addressed more personally, more questions are asked, and even more than in *Patrick* or *Zagazoo*, we feel Blake is speaking both to and about his fellow human beings, with all the understanding that 83 years of watching, reading, hearing and seeing and drawing have brought him.

Blake started as a cartoonist but he has now become a poet. Because he has kept on exploring, he is now – in the words of another poet, T. S. Eliot, in his 1940 lecture on Yeats – a poet who 'in his work has remained always young, who even in one sense became young as he aged'

10 Something happening

When thinking about how this book, which doesn't actually have an ending since the work is ongoing, might actually come to a close, I decided that the solution would be to let this young Blake speak for himself about his present activities:

> When I was told I had reached 80 it seemed to me that the thing to do was not to organize a retrospective (I had done that a couple of times already) but to put together a show of new work. No doubt it is because Ghislaine Kenyon is aware of this that I have been given the opportunity to add some notes here, as a sort of coda, to show that there is still something happening even now.
>
> Much of it is the result of some ongoing relationship. One of the most enjoyable of these in recent years has been that with the new Jerwood Gallery on the Stade in Hastings. The exhibition *Artists on the Beach* has already been referred to here, but since then I have been at work on a second exhibition, which will have taken place before the publication of this book. Like the previous exhibition, it has to do with the gallery's relationship with Hastings, though it has a different approach. Called *Life Under Water* it makes use of a device which I have already employed in a set of hospital drawings – the depiction of people in everyday clothes swimming about

From *The Golden Ass*

231

under water with an assortment of fish and seaweed. In the hospital surroundings it suggested, I hope, the situation of individuals finding themselves in a physically and psychologically strange situation. In Hastings it is a way of isolating specific Hastings types (and in Hastings, of course, the fish are everywhere). So there are holidaymakers, schoolchildren, middle-aged ladies, the purchasers of antiques and second-hand books – but also characters with the urge to dress up that Hastings seems to inspire: bikers, pirates, morris dancers, Jack o' the Green. All of which, I hope, helps to tell the local community that the gallery is aware of it, and salutes it.

Another relationship is with my own college, Downing, in Cambridge. The college's symbolic creature is a griffin, and so since when, a few years ago, I found myself back in touch there has been a sequence of various versions of griffins, such as one for the new Gryphon building, and as merchandise. I also find myself at work on a pair of griffins for the Grace Howard Room in the new Howard building, at the opposite end from the brilliant trompe-l'oeil beasts by Francis Terry, the son of Quinlan Terry who designed the building. I hope mine will be a suitable contrast; fairly freewheeling drawings, but nevertheless presented as tapestry hangings.

Another development of great interest to me at Downing is the prospect of a new art gallery. Colleges, by an enlightened ruling of the City Council, are obliged to spend 1 per cent of any budget for building or redevelopment on art. This frequently comes to mean works of art, but Downing's imaginative interpretation has been to have an existing building redesigned as a gallery, with the 1 per cent funding going to a research Fellow who is also a curator of the gallery.

I have been invited to put on an exhibition in this new gallery in 2017. Our idea is that it will celebrate another longstanding relationship, with the Folio Society. Over the past twenty years I have illustrated the *Voyages to the Moon and Sun* of Cyrano de Bergerac, *Don Quixote* and Hugo's *The Hunchback of Notre Dame*. When we came in due course to talk about Voltaire's *Candide*, Joe Whitlock Blundell of the Folio Society proposed that it should be made one of a recently initiated series of deluxe editions; with full-colour printing and leather bindings.

Candide proved to be a success, and in response to an invitation to propose another volume I suggested *Fifty Fables of La Fontaine*. The fables are most familiar to the general reader in versions edited for children, but they were not written for a juvenile audience, and they are not all about animals – although they are all about the failings and idiosyncrasies of humans, treated in an apparently *décontracté* fashion. So I was glad, as someone mostly known as an illustrator of children's books, to make a selection to be illustrated for adults, and in an apparently relaxed way that I hope La Fontaine might have approved of.

I did a full-page illustration for each fable, with a few smaller drawings. There was an interesting contrast with almost any other set of illustrations I have undertaken, as on this occasion the illustrator doesn't have the familiar task of pursuing a narrative, distributing the illustrations through the book, looking for the most effective moment to illustrate. In almost every fable La Fontaine *gives*

you the moment; what you have to do is try to get it right. I enjoyed the activity so much that I frequently found myself doing a drawing again, not because the first version would not pass muster, but simply to see if I could get some further nuance out of it.

A further Folio deluxe edition is still in production as I write this. *The Golden Ass* of Lucius Apuleius was suggested to me by a friend who thought I might enjoy illustrating the story of Cupid and Psyche, which is at the centre of the book. In fact its presence there seems to be fairly arbitrary; Lucius, transformed into an ass, has no part in it, and at least one existing edition silently leaves it out. However, one of the distinctive aspects of the book, not least for the illustrator, is the contrast between the lyrical fairy-tale quality of that story and the detailed and down-to-earth accounts of the other sexual relationships in the book. There is certainly no shortage of moments, and the problem is rather of choosing among them.

The projects mentioned so far are all in response to a specific brief. The prospect of an exhibition at the Marlborough Gallery, where I first showed in 2012, allows me instead the possibility of exploration – for example, I think I will want to take further an existing sequence of drawings of stone heads. I'm not able to explain their significance, though they are evidently in some way invested with feelings. And in the 2012 exhibition there was a set of coloured drawings of the heads of women otherwise submerged in water. I'm not sure what the significance of those is either, but swimming (not so different from flying, as already noted in this book) has been happening in my pictures over a number of years. Perhaps once again it may be interesting to explore the possibilities of partial and total immersions.

But I also hope that there will be things both for this show and for other drawing ventures which I am *not* able to foresee.

Notes

Introduction

[1] Interview in *Mail on Sunday*, 23 January 2000.

[2] Harrison Birtwistle and Fiona Maddocks, *Harrison Birtwistle, Life Tracks* (London: Faber & Faber, 2014), 6–7.

[3] Adam Phillips, *Becoming Freud* (New Haven and London: Yale University Press, 2014), 29.

[4] Arthur R. Chandler, *The Story of E. H. Shepard: The Man Who Drew Pooh* (London: Jaydem Books, 2000).

[5] *Words and Pictures* (Tate Publishing, 2013), *Laureate's Progress* (Jonathan Cape, 2002), *Beyond the Page* (Tate Publishing, 2013).

Chapter 1

[1] Blake, 'Characters in Search of a Story', in *Under the Influence* magazine, No. 12, 2013.

[2] James Wood, *The Nearest Thing to Life* (London: Jonathan Cape, 2015).

[3] Rebecca Steel, http://onestoparts.com/review-quentin-blake-marlborough-fine-art

[4] www.webofstories.com/play/quentinblake/34.

[5] The illustration of classics for the Folio Society (Anglistik, *International Journal of English Studies*, Vol. 5 (2014), Issue 1, 106).

[6] Ibid., 110.

Chapter 2

[1] By Ellen Blance and Ann Cook.

[2] *Words and Pictures*, 50.

[3] *Words and Pictures*, 17.

[4] Programme note for concert by Britten Sinfonia, Milton Court Concert Hall, London, 20 November 2014.

[5] Conversation with Joann Sfar, French Institute, 2009.

[6] Web of Stories, Chapter 1.

[7] Charles Wells, *Past Purple: a History of Chislehurst and Sidcup Grammar School* (Chislehurst Grammar School, 2002), 96.

[8] *Words and Pictures*, 36.

[9] *Words and Pictures*, 36.

[10] *Words and Pictures*, 35.

[11] Ken Robinson and Lou Aronica, *Creative Schools: Revolutionizing Education from the Ground Up* (London: Allen Lane, 2015), x.

[12] www.rca.ac.uk/default.aspx?ContentID=518836

[13] *Oldie*, January 2001, 40.

[14] Letter to J. H. Reynolds.

Chapter 3

[1] Interview with Jonathan Sale, *CAM*, 1998.

[2] An anonymous sixteenth-century picaresque novel.

[3] *Words and Pictures, Laureate's Progress, Beyond the Page.*

[4] Peter Campbell, introduction to Quentin Blake's *The Life of Birds* (London: Doubleday, 2005).

[5] Interview 'Quentin Blake talks to Simon Schama', *Financial Times: Life and Times*, 13 June 2014.

[6] Quentin Blake, *The Life of Birds* (London: Doubleday, 2005).

[7] Quentin Blake, *Nous les Oiseaux* (Paris: Gallimard Loisirs, 2005).

[8] Joann Sfar, *Caravan* (Paris: l'Association, 2005).

[9] Photo credit: an anonymous French Embassy photographer.

Chapter 4

[1] Published by Nicholson and Watson.

[2] Quentin Blake, 'Children's Book Illustration: A Separate Story?' in *Books for Keeps* no. 121, March 2000.

[3] Quentin Blake, *La Vie de la Page* (Gallimard, 1995), 32.

Chapter 5

[1] *La Vie de la Page*, 84.

[2] *Beyond the Page*, 230.

Chapter 6

[1] http://www.telegraph.co.uk/culture/culturepicturegalleries/19010454/Quentin-Blake-Picture-Gallery-html?image=12.

[2] John Ruskin, *The Elements of Drawing* (London: Smith, Elder and Company, 1857), Letter 1, B.

Chapter 8

[1] http://www.thetimes.co.uk/tto/health/article2997900.ece, accessed 8 October 2015.

[2] Richard Cork, *The Healing Presence of Art: A History of Western Art in Hospitals* (London: Yale University Press, 2012).

[3] *Dementia: The One-Stop Guide* (London: Profile Books, 2015), 153.

[4] For example, as described in *The Healing Environment: Without and Within*, ed. Deborah Kirklin and Ruth Richardson (Royal College of Physicians, 2003).

Chapter 9

[1] Director of the Homerton Research and Teaching Centre for Children's Literature.

[2] Interview with Caroline Horn, *Bookseller*, 18 September 1998.

Author's Note

Many people and several organisations have given me invaluable help in the process of preparing this book.

At Bloomsbury first and enduring thanks must go to my publisher Robin Baird-Smith for his trust in the book, and to Jamie Birkett, always an encouraging and patient editor; also to James Watson and Nick Fawcett. I am especially grateful to Mark Bostridge for his clear, wise advice. In Quentin Blake's office his assistants Nikki Mansergh and Cecilia Milanesi have helped me and put up with endless interruptions with good humour. The same is particularly true of Blake's archivist, Liz Williams who has been a real collaborator, always resourceful, always offering me more than I asked for. My gratitude also to the Society of Authors, whose Authors' Foundation Grant helped to see me through what turned out to be a more extended project than I intended.

Numerous people willingly gave me precious time to talk about Quentin Blake, or helped me in other ways, including Dalwardin Babu, Christine Baker, Stephen Barnham, Angela Barrett, Charles Beauchamp, Ean Begg, Pascal Bourgignon, Alison Britton, Emma Chichester Clark, Connie Cooling, Amanda Conquy, Liccy Dahl, Gilles Dattas, Julia Eccleshare, Sue Evans, Dan Fern, Christopher Frayling, Liz Gilmore, Jean Gooder, David Gordon, Theresa Heine, Ann Howeson, Bruce Kinsey, Béatrice Lebahar, Fiona McCarthy, Helen McKenzie Smith, Belinda Matthews, Russell Mills, Ann Newton, Neil Parkinson, Hedwige Pasquet, Madeleine Rahtz , Nick Rhodes, Lucy Ribeiro, Anne Riou-Chartier, Michael Rosen, Geneviève Roy, Neil Salmon, Jean-Marc Sandeau, Joann Sfar, Julia Shuff, Annie Simon, Julian Spalding, Jane Stanton, Julia Stanton, Donald Sturrock, Jo Whitlock Blundell, Jake Wilson and John Yeoman. In this list is also Linda Kitson, who must be singled out for being so perceptive, lucid and positive and for making me laugh when necessary. My husband Nicholas Kenyon, an author himself and an imaginative critical reader, has been wonderfully supportive from beginning to end.

But of course this book would never have been written without Quentin Blake. I know that having someone else write about him (when he can do it so well himself) was not familiar or easy territory, but he has been generous beyond measure, with his images, his office and his archive. At the age of 82 the well-spring of his art remains as vigorous as ever, as does his support for the work of other people and organizations, and he is involved in an astonishing number of projects. But he has given me countless hours of his time and I left every interview enlightened and entertained. I am deeply grateful for his creative and stimulating involvement in my project.

Acknowledgements

All artwork © Quentin Blake unless otherwise stated. Page numbers refer to locations in the book.

Text credits

By kind permission of Web of Stories, www.webofstories.com, pp. 43, 68.

Financial Times [Source: Simon Schama 2014, [Financial Times / FT.com] 13/06]. Used under licence from the Financial Times. All Rights Reserved, p.109.

By kind permission of the Estate of Peter Campbell, pp.110-11.

By kind permission of Daniel Pennac/Gallimard, pp.111, 136-7.

By kind permission of Camberwell Press/Estate of Russell Hoban, pp.114-118.

Photo credits

Quentin Blake on the set of *Jackanory*,1977, BBC Enterprises, pp. 6, 33.

Quentin Blake with Roald Dahl At Gipsy House, 1983, © RDLE (from the Roald Dahl Museum archive), p.7.

'Tell Me A Picture', exhibition at the National Gallery, 2000, © Brian Voce, p.8.

Quentin Blake drawing live on stage at the Hay Festival, © Linda Kitson, p.9.

Quentin Blake in Genoa, p.11.

Quentin Blake with his mural at the Unicorn Theatre, 2010, © Linda Kitson, p.11.

Quentin Blake at the Petit Palais, Paris 2005, © Catherine Helie/Gallimard Editions, p.14.

Quentin Blake in his studio, © Linda Kitson, p.26.

The Book Bus in Africa, by kind permission of The Book Bus, p.175.

The Book Bus in Ecuador, by kind permission of The Book Bus, p.176.

A parade of schoolchildren with Clowns in Rochefort, France, 2001, Quentin Blake, p.86.

Quentin Blake outside the Quentin Blake art building at Chislehurst & Sidcup Grammar School, p.91.

The Blake Society Dinner, Downing College, Cambridge, 2014, unknown photographer, p.91.

Exhibition 'Les Demoiselles des Bords de Seine' at the Petit Palais, Paris, 2006, © Christophe Foin, p.139.

Photo of the exterior of Angers maternity hospital, showing the decorated façade, 2011, p.211.

Image credits

Corky and Loopy, from *Angel Pavement* by Quentin Blake (Jonathan Cape, 2004), p.23.

Book cover, *The Birds* by Aristophanes (Lion & Unicorn Press, 1971), Royal College of Art, p.24.

From *How Tom Beat Captain Najork and his Hired Sportsmen* by Russell Hoban (Walker Books, 2013), Quentin Blake / Walker Books, p.27.

'Feeling his age' from a series of drawings of Insects, 2009, p.29.

Stratford Johns et al, from *Punch* magazine, c.1978, Punch Ltd, p.32.

Eating People is Wrong by Malcolm Bradbury (Penguin, 1962), Penguin Books , p.35.

The Loved One by Evelyn Waugh (Penguin, 2000) Penguin Books, p.35.

'Girls and Dogs 1', lithograph printed by Pauper Press, for Marlborough Fine Art, 2012, p.36.

'Companions #3', original artwork for Marlborough Fine Art, 2012, p.37.

'Companions #11', original artwork for Marlborough Fine Art, 2012, p.36.

Poster for the exhibition 'Nos Compagnons' at Galerie Martine Gossieaux, Paris, 2014, p.38.

From the series 'Nos Compagnons', exhibited at Galerie Martine Gossieaux, Paris, 2014, p.39.

From the series 'Vehicles of the Mind', 2014 (unpublished), p.40.

From *The Enormous Crocodile* by Roald Dahl (Jonathan Cape, 1978), Random House; the Roald Dahl Literary Estate, p.42.

'The Prince beheading the Ugly Sisters', from *Roald Dahl's Revolting Rhymes* by Roald Dahl (Jonathan Cape, 1983), Random House; the Roald Dahl Literary Estate, p.44.

'The Three Bears', from *Roald Dahl's Revolting Rhymes* by Roald Dahl (Jonathan Cape, 1983, Random House; the Roald Dahl Literary Estate, p.45.

From *Patrick* by Quentin Blake (new ed. 2010), Random House, p.46.

Corky and Loopy, from *Angel Pavement* by Quentin Blake (Jonathan Cape, 2004), Random House, p.47.

From 'The Blue Belt' from *Quentin Blake's Magical Tales* by John Yeoman (Pavilion Books, 2011), Anova Books, pp.49,50.

Cover artwork for *The Winter Sleepwalker* by Joan Aiken (Jonathan Cape, 1994), p.51.

From *The Winter Sleepwalker* by Joan Aiken (Jonathan Cape, 1994), © Random House, p.51.

'The Marchioness and her garter', from *Candide* by Voltaire (The Folio Society, 2011) The Folio Society, p.53.

'The Guinean Slave', from Candide (The Folio Society, 2011), The Folio Society, 2011) Quentin Blake / The Folio Society, p.53.

Artwork for RCA Rector's Dinner 2009, showing Christopher Frayling, by kind permission of Christopher Frayling, p.55.

Invitation card handwritten by Quentin Blake, by kind permission of Christopher Frayling, p.55.

Design for a wedding invitation, private commission, 2011, by kind permission of Jake Wilson, p.55.

Fax from Quentin Blake, 2009, p.56.

'Regency': private commission for Hoare's Bank, London, 2014, by kind permission of Hoare's Bank, p.57.

'The Victorian Era', private commission for Hoare's Bank, London, 2014, by kind permission of Hoare's Bank, p.57.

From the series of pictures for the corridors of the Kershaw Ward, for the Nightingale Project, 2006, p.58.

Thank you card to Quentin Blake from the YCN, 2011, p.59.

Item on the theme of 'Q' sent to Quentin by Australian illustrators, 2002, p.59.

From *The Rights of the Reader* poster by Daniel Pennac, Gallimard Jeunesse, p.60.

From *Monster Goes to School* by Ellen Blance & Ann Cook, 1973, Longman, p.62.

Drawing of F. R. Leavis in Cambridge, p.71.

Book cover: *The Boy Who Sprouted Antlers* by John Yeoman (Faber & Faber, 1961) © Faber & Faber, p.72.

From *Tristram Shandy* by Laurence Sterne, illus. Brian Robb (MacDonald & Co. 1949) , MacDonald & Co; estate of Brian Robb, p.73.

Life Drawing, produced from memory and using a plastic quill, p.74.

From *The Geek* magazine (Vol 4, No. 8, April 1977) - Illustration Dept, Royal College of Art, RCA; © Joyce Mason, Ian Pollock, p.81.

From *The Geek* magazine (Vol 4, No. 8, April 1977) - Illustration Dept, Royal College of Art, RCA; © Anne Howeson, p.82.

From *Michael Rosen's Sad Book* (Walker Books, 2004), Walker Books, p.87.

Newscutting from an unknown paper showing 'Quentin' marked on a map, 2002, p.89.

Artwork for 'Life under Water: A Hastings Celebration' exhibition at the Jerwood Gallery, 2015, p.92.

Drawing created at La Résidence Française during a fundraising dinner for the French Institute, October 2014, p.94.

Cover, *The Twits* by Roald Dahl (Jonathan Cape, 1980), © Random House, p.97.

Cover, *Matilda* by Roald Dahl (Puffin Books), Penguin, p.97.

Cover, *Arabel's Raven* by Joan Aiken (Frances Lincoln, 2015), Frances Lincoln, p.97.

Cover, *Don't Put Mustard in the Custard* (Andre Deutsch, 1985), © Andre Deutsch, p.97.

From *Esio Trot* by Roald Dahl (Puffin Books, 2013), Roald Dahl Literary Estate; Penguin, p.99.

From *Voyages to the Moon and the Sun* by Cyrano de Bergerac (The Folio Society, 1991) The Folio Society, p.101.

From *The Golden Ass* by Apuleius (The Folio Society, 2015), The Folio Society, p.102.

From *The Wild Washerwomen* by John Yeoman and Quentin Blake (Andersen Press, 2009), p.104.

From *How Tom Beat Captain Najork and His Hired Sportsmen* by Russell Hoban (Walker Books, 2013), Walker Books, p.104.

From *Great Day for UP!* by Dr Seuss (HarperCollins Children's Books, 1997) © HarperCollins Children's Books, p.106.

From *Mister Magnolia* by Quentin Blake (Random House, 2010), Random House, p.107.

From *Nous les Oiseaux* by Quentin Blake (Doubleday, 2005), Gallimard, p.111.

From *Caravan* by Joann Sfar (L'Association, 2005) © Joann Sfar/L'Association, pp.113-14

Contents page, *Woman with a Book* by Quentin Blake (foreword by Russell Hoban; Camberwell Press, 1999) , p.115.

Hand-written dedication by Russell Hoban to Quentin on the title page of Hoban's book, 'Riddley Walker' (1980) © Estate of Russell Hoban, p.118.

Cover of *Une Promenade de Quentin Blake au pays de la poésie française* (Gallimard, 2003) © Gallimard, p.120.

Cover of bound book of lithographs, *Honoré Daumier*, © Nicholson & Watson, 1946, p.123.

Cartoon from *Punch*, 'A propos des Maîtres', p.126.

From *Une Promenade de Quentin Blake au pays de la poésie française*, p.129.

From *Cockatoos* by Quentin Blake (Jonathan Cape, 1992), Random House, p.132.

From *Patrick* by Quentin Blake (Jonathan Cape, 1968) Random House, p.133.

From the series 'Nos Compagnons', exhibited at Galerie Martine Gossieaux, Paris, 2014, p.134.

From *Nous les Oiseaux* by Quentin Blake (Doubleday, 2005) Gallimard, p.136.

Drawing of Joann Sfar when he was presented as Chevalier des Arts et des Lettres, p.138.

Double-page article from *Charlie Hebdo*, August 2013, © Charlie Hebdo/Catherine Meurisse and Jean Harambar , p.142-3.

'La dédicace', from the literary supplement of *Le Figaro*, 2012, © Quentin Blake / Figaro, p145.

From the series for Angers maternity hospital, France, 2011, p.146.

From the series 'Our Friends in the Circus', 2009, p.148.

Cover of *The Spectator* magazine, 20 November 1959, © The Spectator, p.149.

Mortimer, from *Arabel's Raven* by Joan Aiken (Frances Lincoln, 2015), Frances Lincoln Children's Books / Estate of Joan Aiken, p.150.

From *Featherbrains* by John Yeoman (Hamish Hamilton, 1993), Hamish Hamilton, p.151.

From *The Heron and the Crane* by John Yeoman (Andersen Press, 2011), Andersen Press, p.151.

From *Loveykins* by Quentin Blake (Jonathan Cape, 2002), Random House, pp.151-2.

From *The Birds* by Aristophanes (Lion & Unicorn Press, 1971), Lion & Unicorn Press, Royal College of Art, p.154.

From *The Life of Birds* by Quentin Blake (Doubleday, 2005), Transworld, p.155.

From *On Angel Wings* by Michael Morpurgo (Egmont, 2006), Egmont, p.156.

Cover, *Beyond the Page* by Quentin Blake (Tate Publishing, 2012), © Tate Publishing, p.157.

'Harp' *from A Band of Angels* (Gordon Fraser Gallery, 1969), p.158.

'Badminton' from A Band of Angels (Gordon Fraser Gallery, 1969), p.158.

'Pancakes' from *A Band of Angels* (Gordon Fraser Gallery, 1969), p.158.

From *Un Bateau dans le Ciel* by Quentin Blake (Rue du Monde, 2000) © Rue du Monde, p.159.

From *Rosie's Magic Horse* by Russell Hoban (Walker Books, 2012), Walker Books / Estate of Russell Hoban, p.160.

From *Zagazoo* by Quentin Blake (Jonathan Cape, 1998), Random House, p.161.

From *Clown* by Quentin Blake (Jonathan Cape, 1995), Random House, p.161.

From the series of drawings for the Kershaw Ward, 2006, p.162.

From the series 'Sixty New Drawings' for the Nightingale Project, 2006, p.163.

Photo of the Angers sketchbook in Quentin Blake's studio, c. 2009, p.164.

'Transforming Tomorrow' from 'Cambridge 800: An Informal Panorama' - artworks for Cambridge University's 800th anniversary, 2009, p.165.

Artwork for exhibition 'Quentin Blake: Illustrateur', 2002, p.166.

Artwork for 'Life under Water: A Hastings Celebration' exhibition at the Jerwood Gallery, 2015 , p.171.

Diary of World Parrot Day 2004, for *The Spectator*, p.172.

'Northern Lights', design for a card for Survival International, p.174.

Roald Dahl's Marvellous Children's Charity crocodile logo, 2010, p.177.

Orientation map for The Roald Dahl Museum, Great Missenden, 2005, p.178.

Logo for the South Kensington Kids' Festival, organised by the French Institute, p.179.

From 'The Five Strange Brothers' in *Quentin Blake's Magical Tales* by John Yeoman (Pavilion Books, 2010), © Anova Books, p.184.

From *The Five of Us* by Quentin Blake (Tate Publishing, 2014), Tate Publishing, p.187.

From *The Story of the Dancing Frog* by Quentin Blake (Jonathan Cape, 1984), Random House, p.189.

From *Michael Rosen's Sad Book*, by Michael Rosen (Walker Books, 2003), Walker Books/Michael Rosen, p.190.

Cover of *Clown* by Quentin Blake (Red Fox, 1998), © Random House , p.191.

From *Clown* by Quentin Blake (Jonathan Cape, 1995), Random House, p.191.

From *Clown* by Quentin Blake (Jonathan Cape, 1995), © Random House, p.192.

Crumpled and flattened artwork drawn for fan – 'Any chance of getting this ironed out?', p.195.

From the series 'Welcome to Planet Zog' for the Alexandra Avenue Health & Social Care Centre, Harrow, 2007, p.196.

From the series of drawings for the Kershaw Ward, 2006, p.198.

From the series 'Life under Water' for the Gordon Hospital, 2009, p.200.

From the series for Great Ormond Street Hospital, 2015, p.201.

Artworks for Courtfield Medical Practice, 2013, pp.204-05.

Additional artwork for the series 'Life in Vincent Square' for the Eating Disorders Unit, 2011, p.206-7.

From the series for Angers Maternity Hospital, France, 2011, pp.209-11.

Artwork for the Neonatal Unit at Angers Maternity hospital, 2012, p.212.

From the series 'Welcome to Planet Zog' for the Alexandra Avenue Health & Social Care Centre, Harrow, 2007, p.213.

From a series of dragon murals for The Dragon Centre at St George's Hospital, 2014, p.215.

'Alfred Wallis', from the exhibition 'Artists on the Beach' at the Jerwood Gallery, Hastings, 2014, p.218.

From 'A Barbican Ornithology', 2012 - a series of drawings for a pillar in the Managing Director's office, p.221.

From a series of drawings for the Kershaw Ward, Kensington and Chelsea Mental Health Centre, 2006, pp. 58, 222.

From *The Wonderful Button* by Evan Hunter (Abelard Schuman, 1961) p.224.

From *Home and Other Stories* by Joan Tate et al (Almqvist & Wiksells, 1972) Almqvist & Wiksells, p.225.

From *The Bear's Winter House* by John Yeoman (Andersen Press, 2009), Andersen Press, p.225.

From *The Family Album* by John Yeoman (Hamish Hamilton 1993), Hamish Hamilton, p.225.

From *Patrick* by Quentin Blake (Jonathan Cape, 2010), Random House, p.226.

From *Zagazoo* by Quentin Blake (Jonathan Cape, 1998) Random House, p.227-8.

From *The Golden Ass* (The Folio Society, 2015), The Folio Society, p.230.

Artwork for 'Life under Water: A Hastings Celebration' exhibition at the Jerwood Gallery, 2015, p.232.

'Death and the Woodsman' from *Fifty Fables of La Fontaine* (The Folio Society, 2013), p.234.

Design for the Bibliothèque Jeunesse, 2015, p. 236.

Index